El Encanto

I WAS CUBA

I WAS CUBA TREASURES FROM THE RAMIRO FERNÁNDEZ COLLECTION

BY KEVIN KWAN

WITH QUOTATIONS FROM THE WORK OF REINALDO ARENAS

INTERVIEW WITH RAMIRO FERNÁNDEZ BY PETER CASTRO

CHRONICLE BOOKS
SAN FRANCISCO

One afternoon several years ago, I found myself sitting in the middle of Ramiro Fernández's living room in New York, completely transfixed as he brought out box after box of photographs from Cuba—the collection seemed limitless, and my wonder increased as each box opened to reveal yet another stack of astonishing pictures. What struck me from the start was how this collection completely diverges from the sort of images one often sees of Cuba: mid-century American cars stranded in time, streetside portraits of dignified citizens, the ubiquitous crumbling *palacio*. Ramiro's collection focuses instead on the unexpected and the vernacular—family pictures, obscure postcards, casual snapshots—off-the-cuff images that reveal something more immediate, more intimate about the place. Yet even in the most unstudied snapshot, Ramiro's distinctive curatorial eye is apparent. Somehow, every image he chooses is imbued with a certain cinematic quality—a nineteenth-century *carte-de-visite* subtly reveals a secret of its sitter, a mundane car accident at an intersection in Varadero upon closer examination becomes a Buñuelesque tableau.

With this book, I have sought to re-create the experience of what it was like to see this idiosyncratic collection for the first time, as the images spilled out of those brown archival boxes in all their random glory. Here is a visual narrative, a dream journey through Cuba across the ages that transcends chronology or classification. Cross-dressing showgirls share the stage with Castro's revolutionaries, who themselves are the latest in a long parade of soldiers from earlier revolutions in Cuba's history. We weave joyfully through teeming Havana streets out into the wildness of the countryside and detour back again, tantalized by speed, light, and sound. We experience Cuba in a way we have never seen it before.

That first day, I realized why these pictures resonated so strongly with me, even though I had no family connection to Cuba. When I was eleven, I too left the country of my childhood, unable to ever return. Even at that age, I had the prescience to spend my last day photographing my street, the gardens, the sky. Knowing I might never see the sunset in this way again, I urgently wanted to collect as many images as I could. In Ramiro, I had found a kindred spirit. Here was someone who had spent the better part of three decades painstakingly seeking out any images that reminded him of the country he was forced to leave behind. Ramiro's pictures show us the Cuba he lost, but rediscovered. They show us that we are all, in our own ways, always searching for home.

KEVIN KWAN

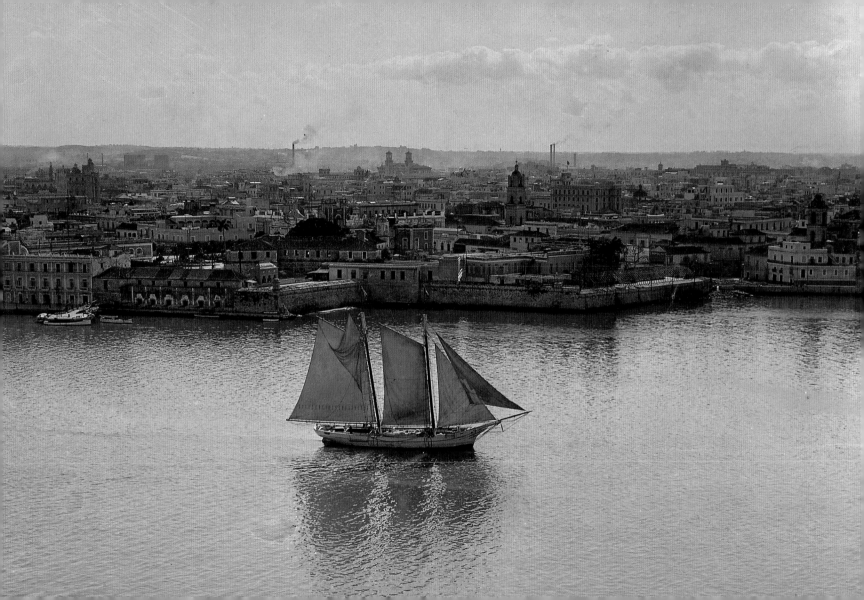

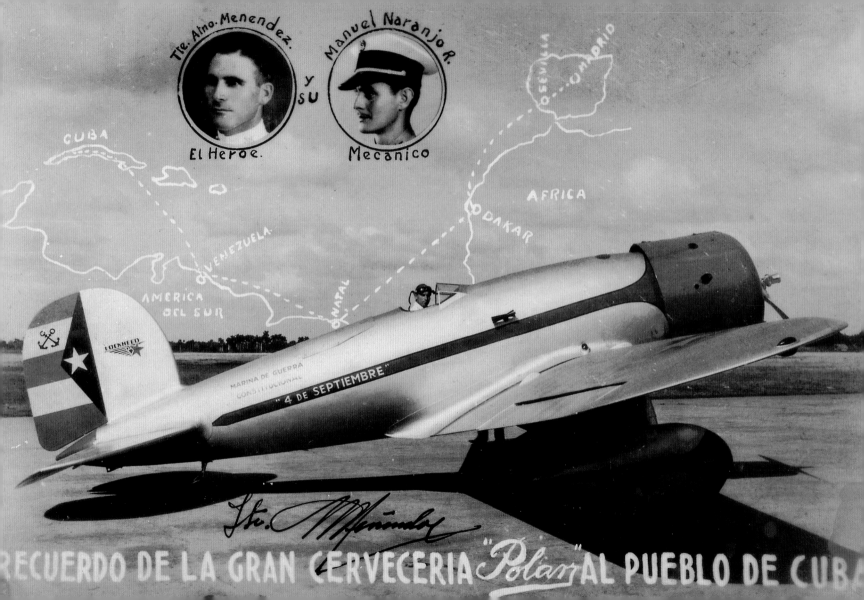

Tte. Alm. Menendez. y su Manuel Naranjo R.

El Heroe.

Mecanico

CUBA

OMADRID

OSEVILLA

AFRICA

ODAKAR

VENEZUELA

AMERICA DEL SUR

NATAL

LOCKHEED

MARINA DE GUERRA CONSTITUCIONAL

"4 DE SEPTIEMBRE"

RECUERDO DE LA GRAN CERVECERIA "Polar" AL PUEBLO DE CUB

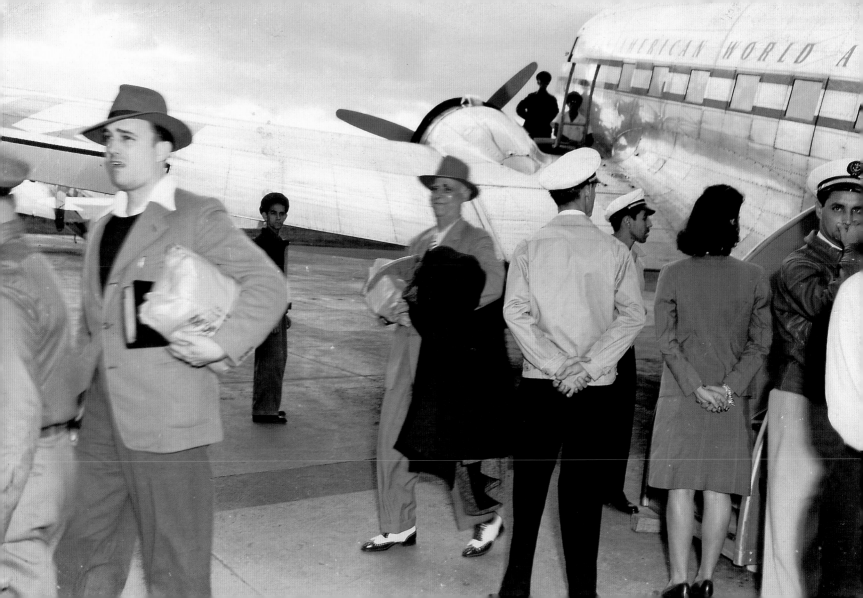

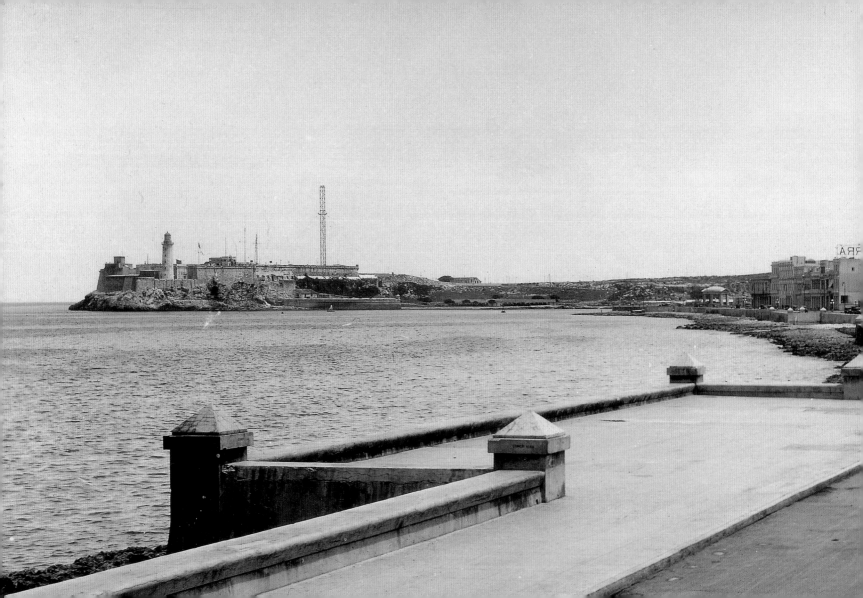

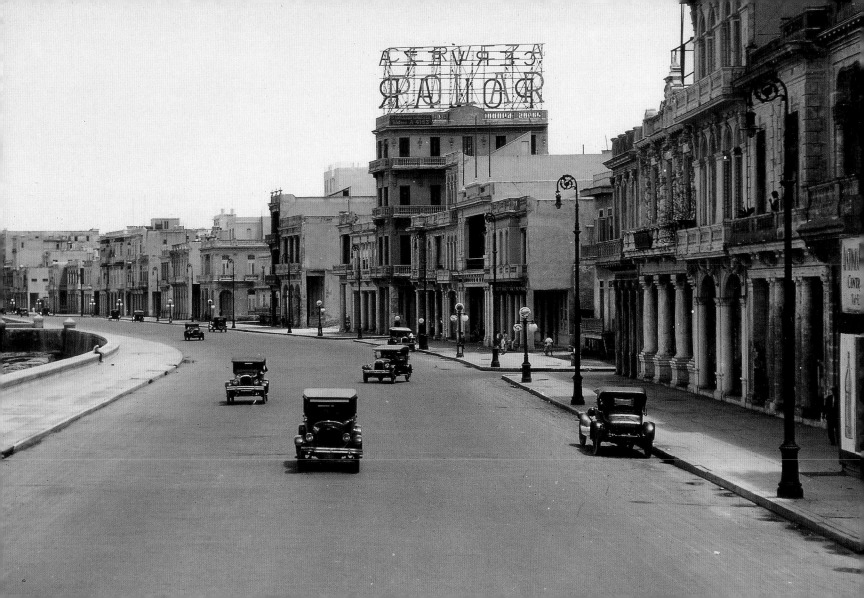

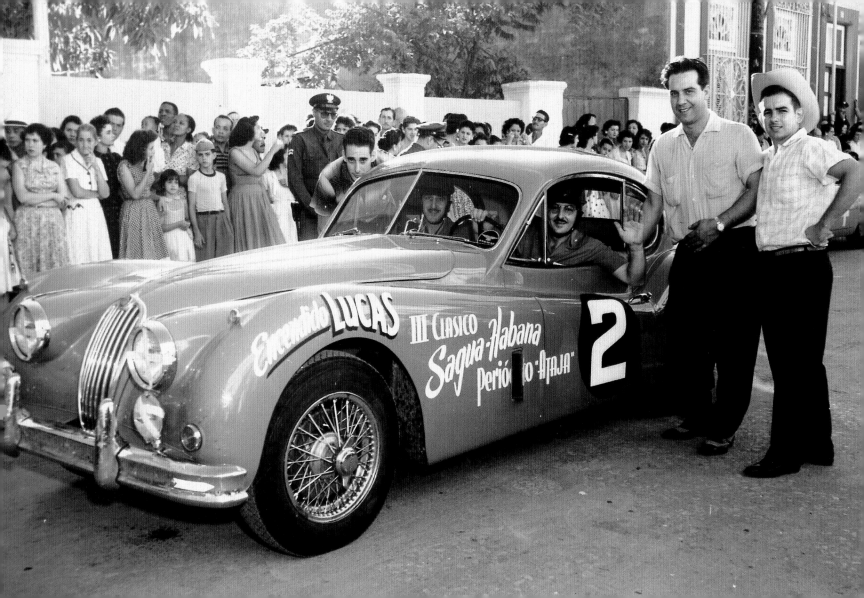

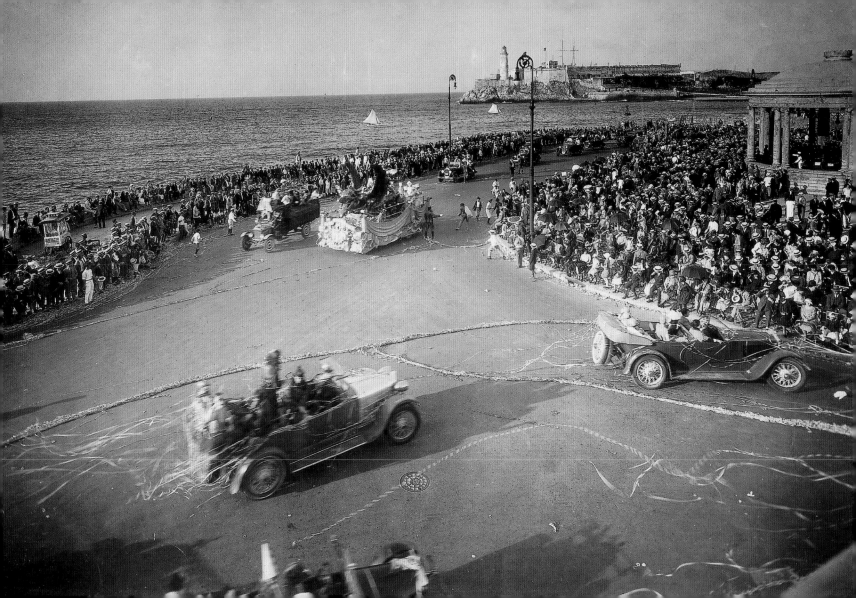

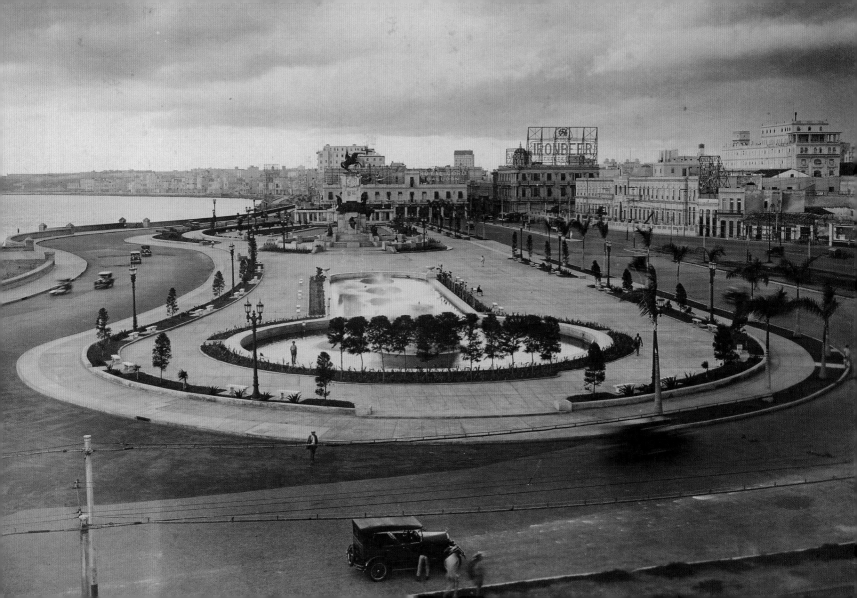

HAVANA IN THE GRAND MANNER!

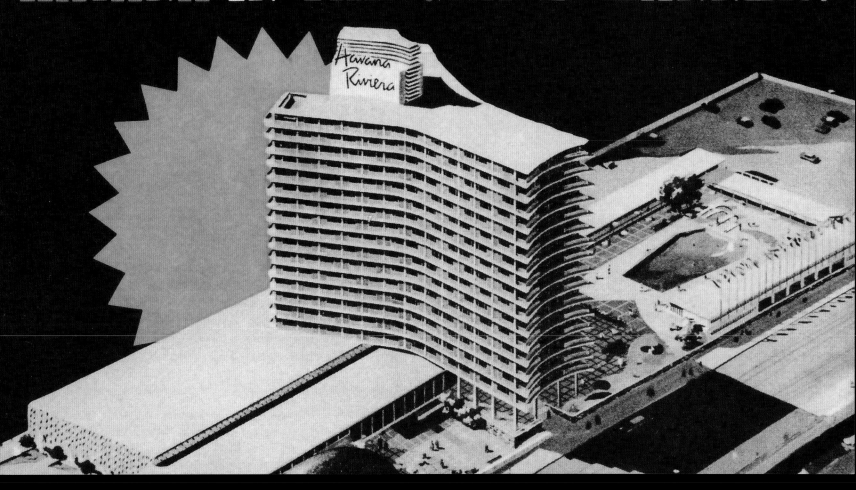

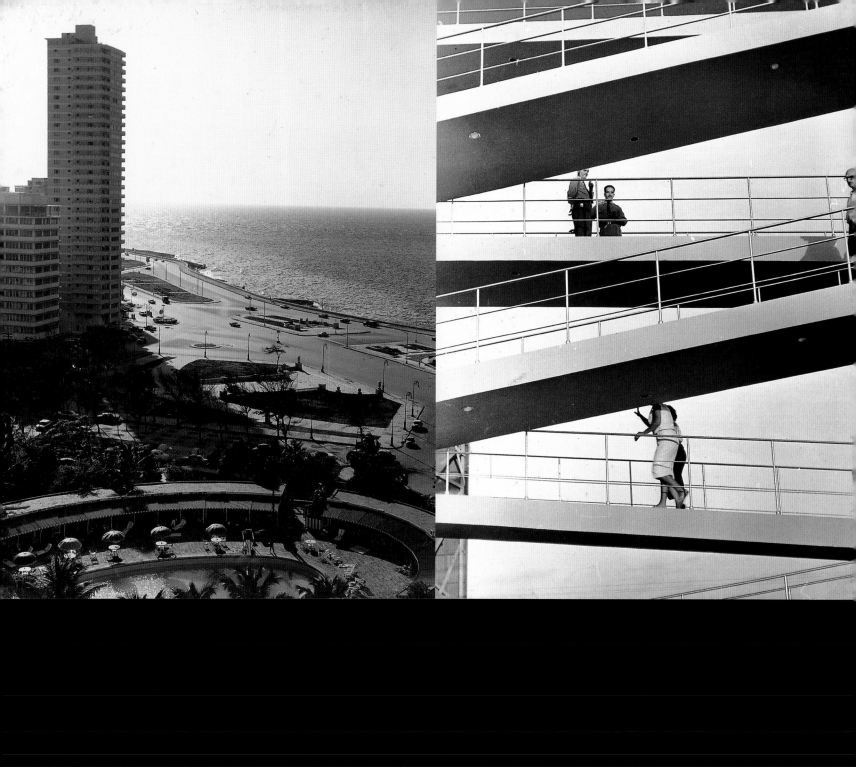

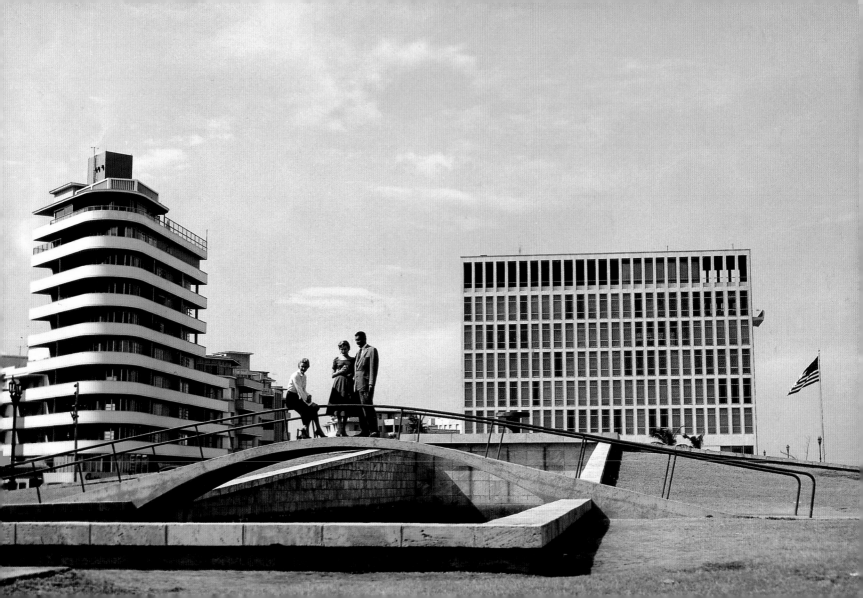

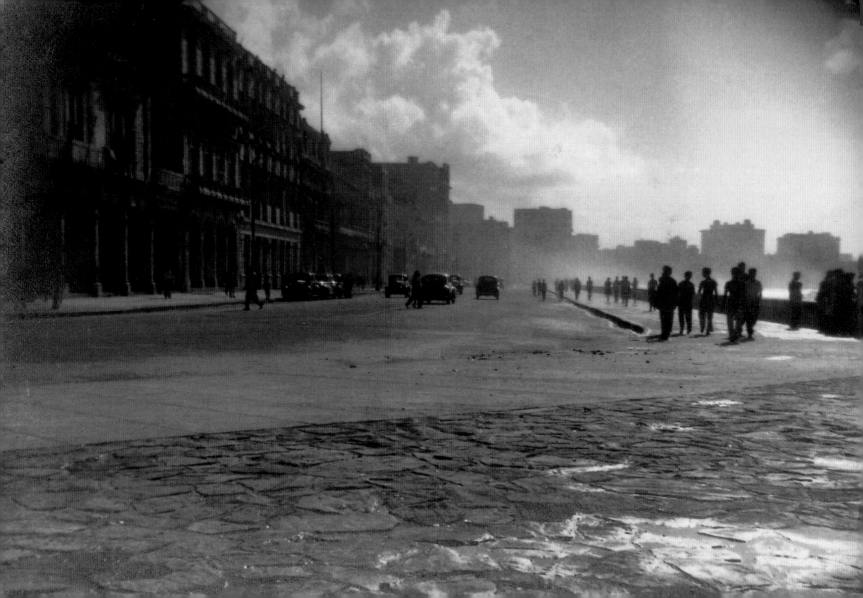

PEOPLE WALK, CAREFREE, THROUGH THE LABYRINTH OF LIT PATHS,

FORMING SMALL GROUPS AND DISPERSING, FORMING OTHER

GROUPS AGAIN IN THE SHADY SPOTS OF SOME OTHER PROMENADE;

WHILE OTHERS CONTINUE UNTIL THEY REACH THE COAST, LETTING

THE INS AND OUTS OF THE TIDE WET THEIR FEET.

From "Final de un cuento" in *Adiós a Mamá* ("End of a Story" in *Mona and Other Tales*)

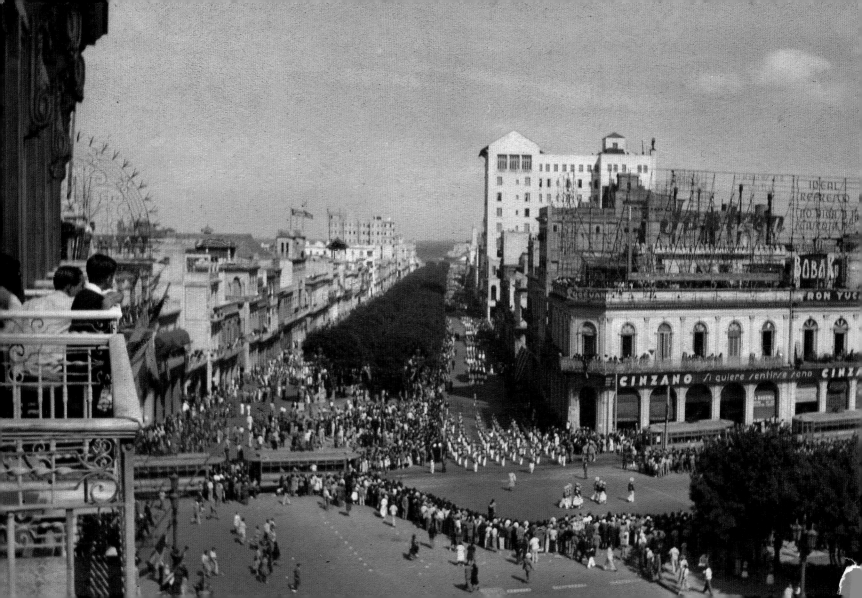

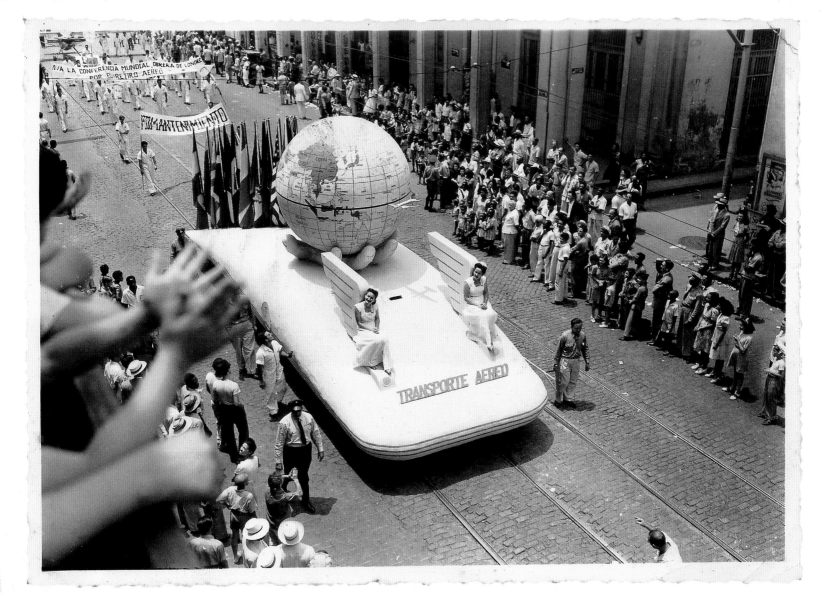

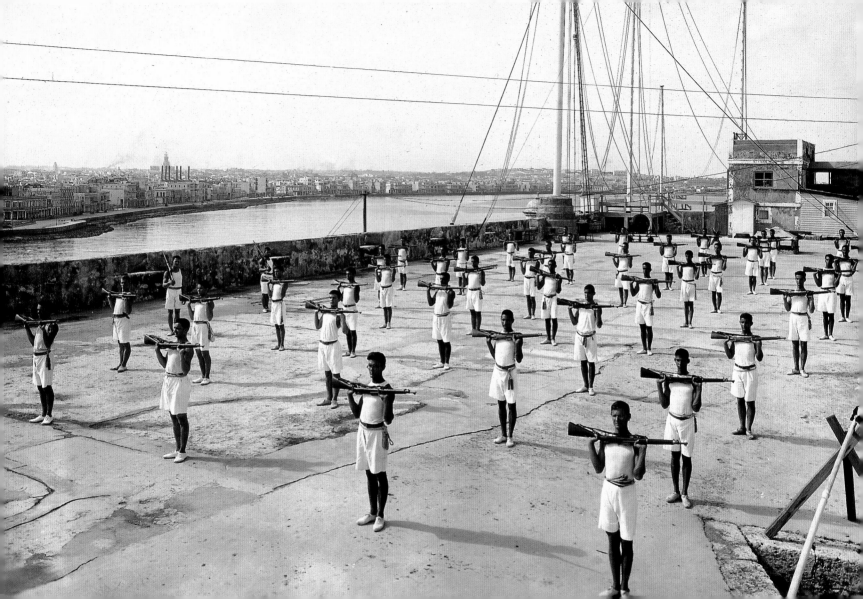

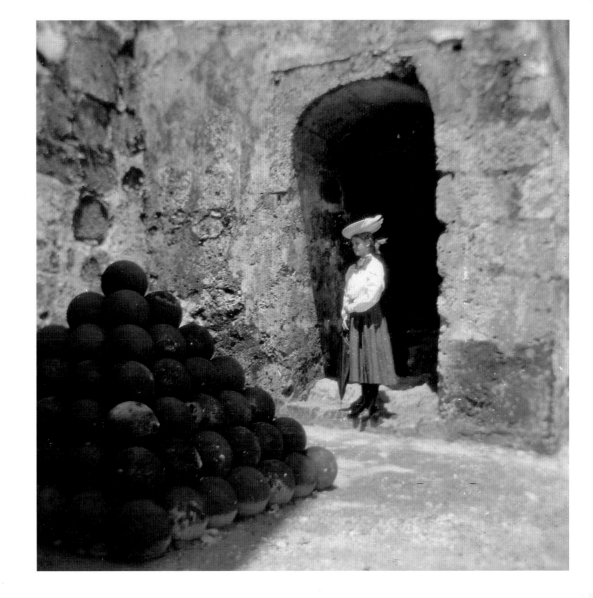

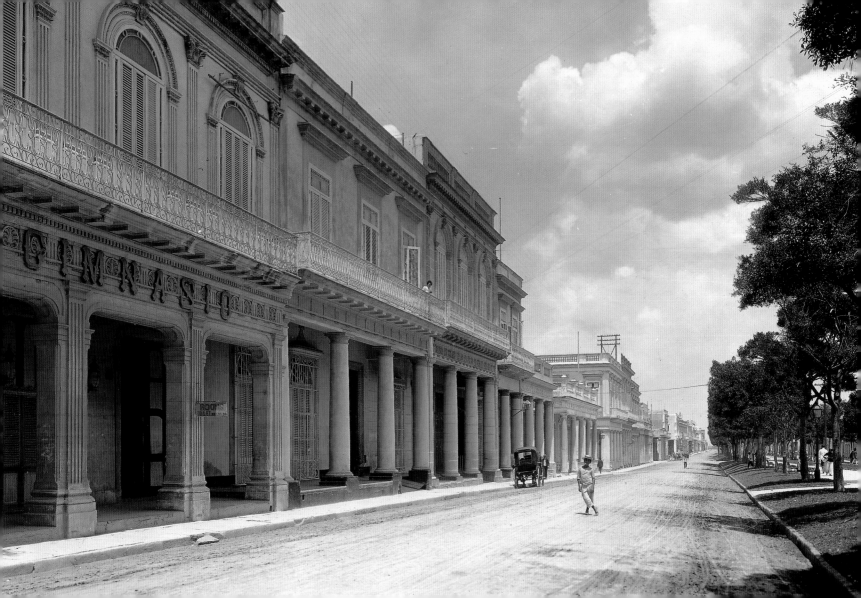

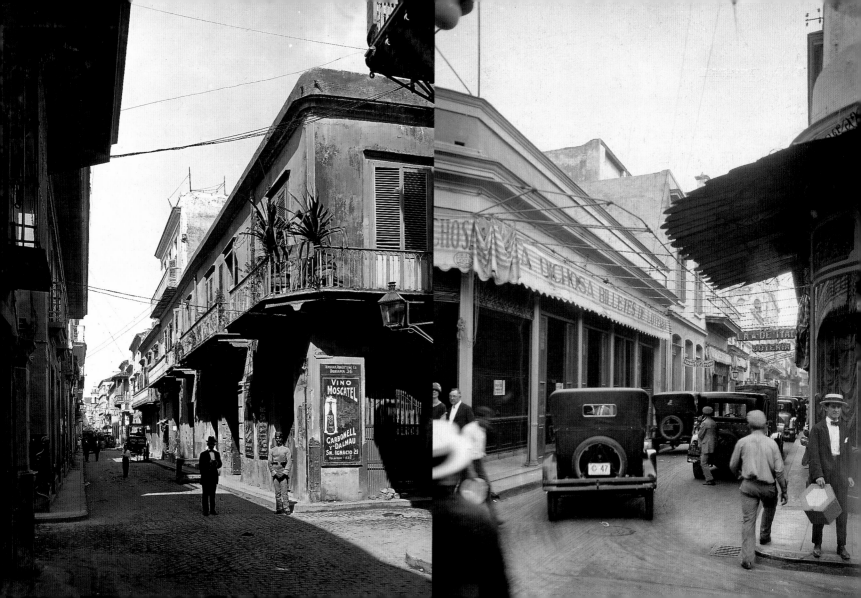

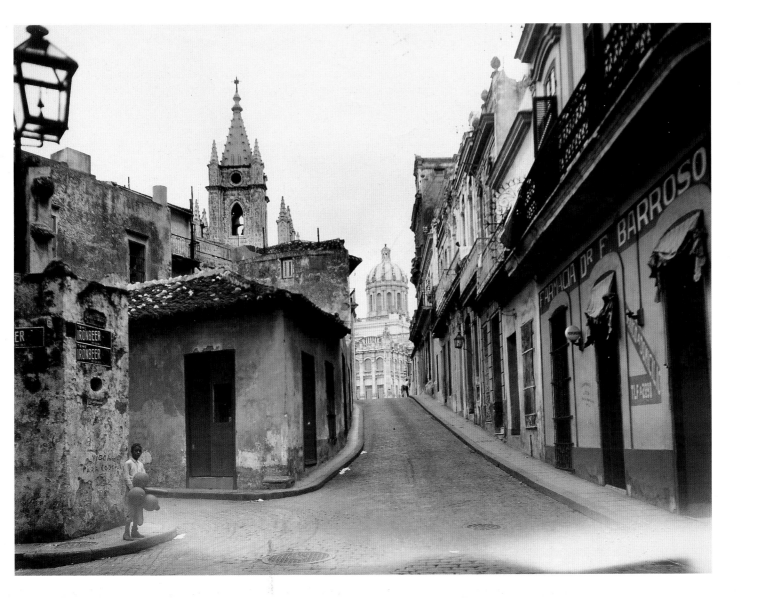

FROM ALL OVER THE CITY OF HAVANA ONE PERCEIVES A RUMOR

OF TREES AND CONVERSATIONS, OF PLENITUDE AND FRESHNESS.

From "Final de un cuento" in *Adiós a Mamá* ("End of a Story" in *Mona and Other Tales*)

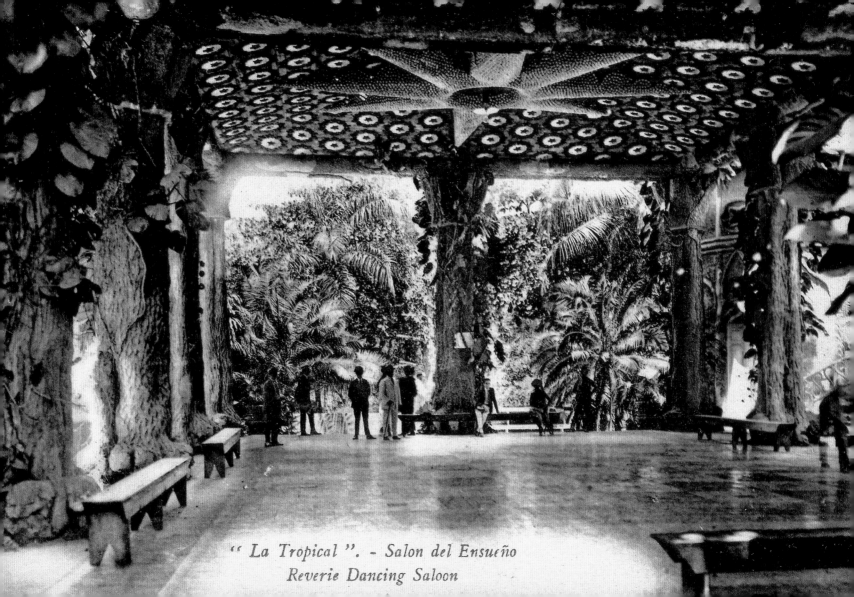

" La Tropical ". - Salon del Ensueño
Reverie Dancing Saloon

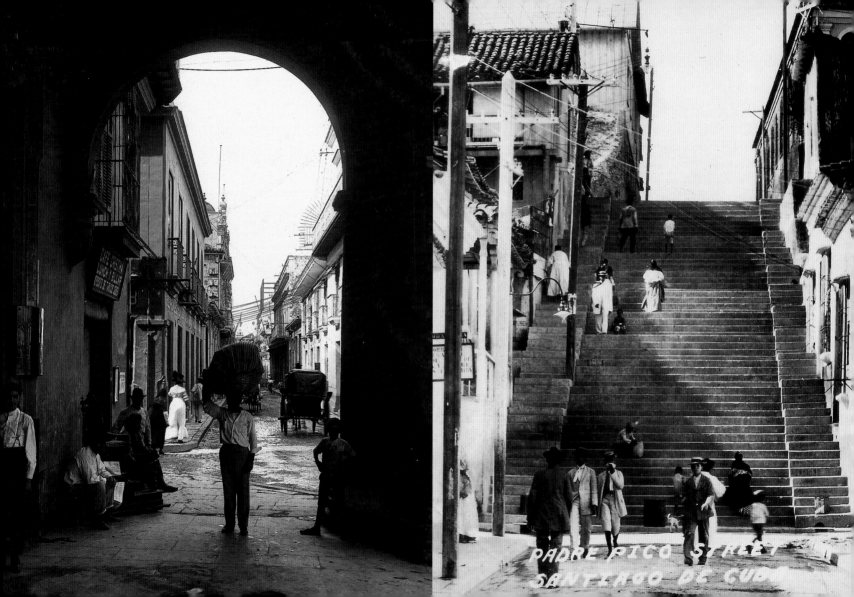

PADRE PICO STREET
SANTIAGO DE CUBA

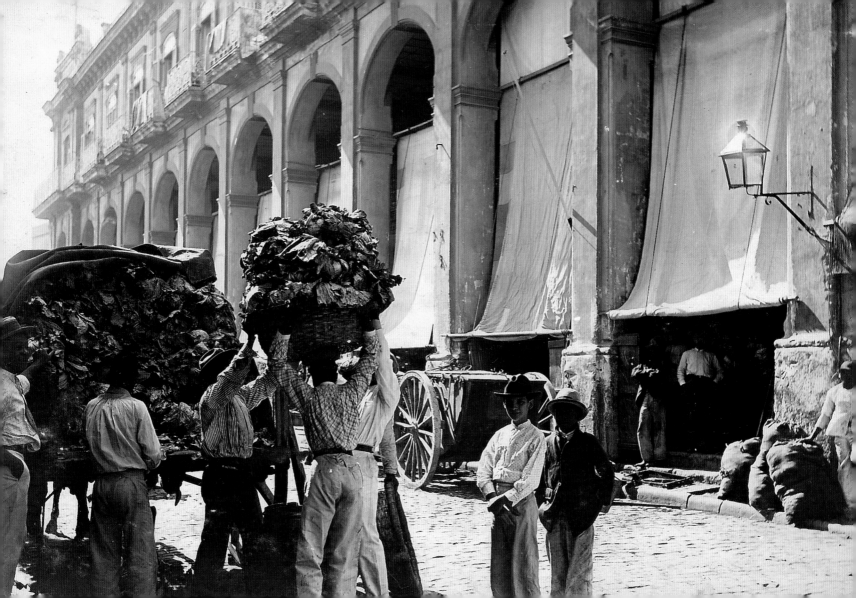

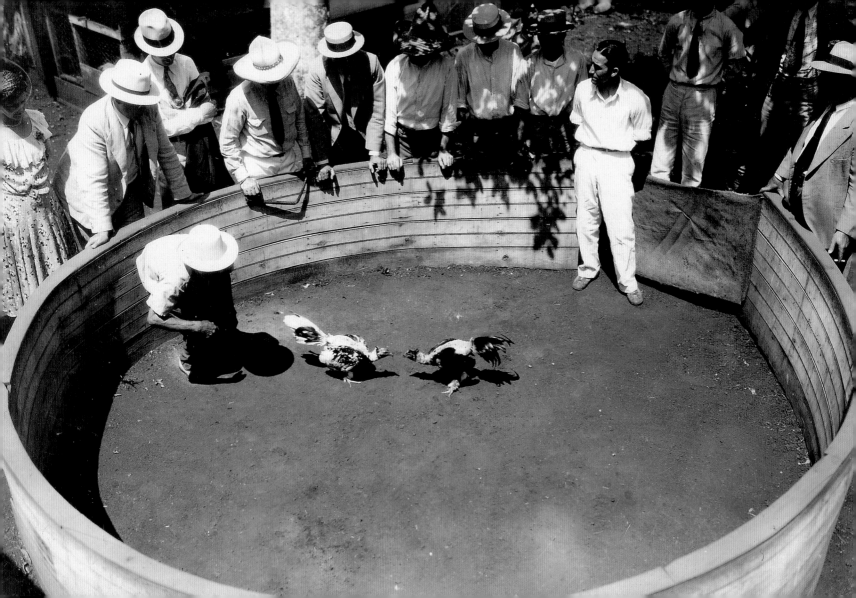

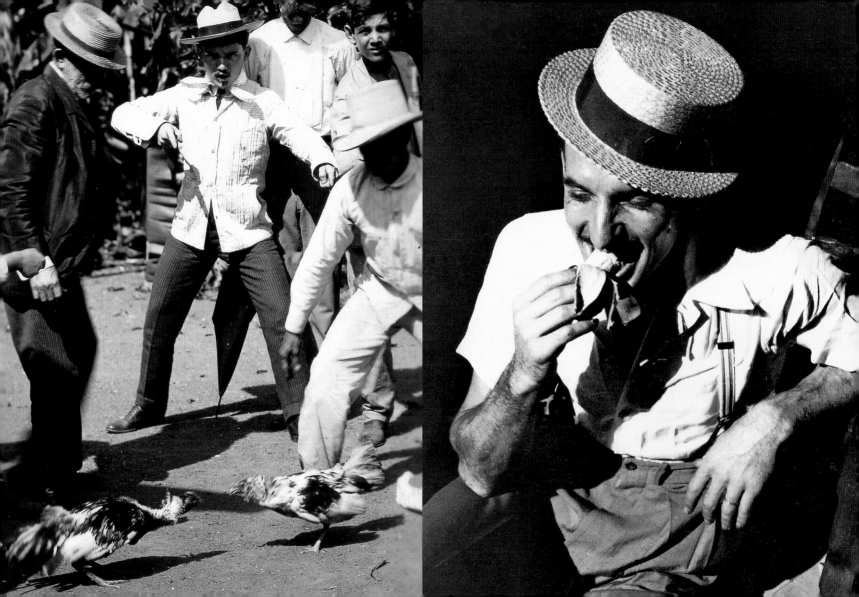

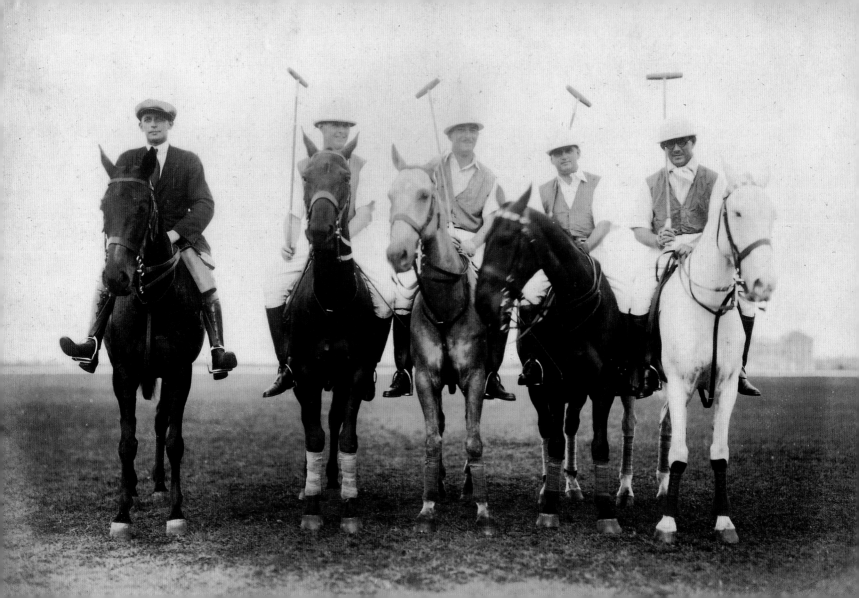

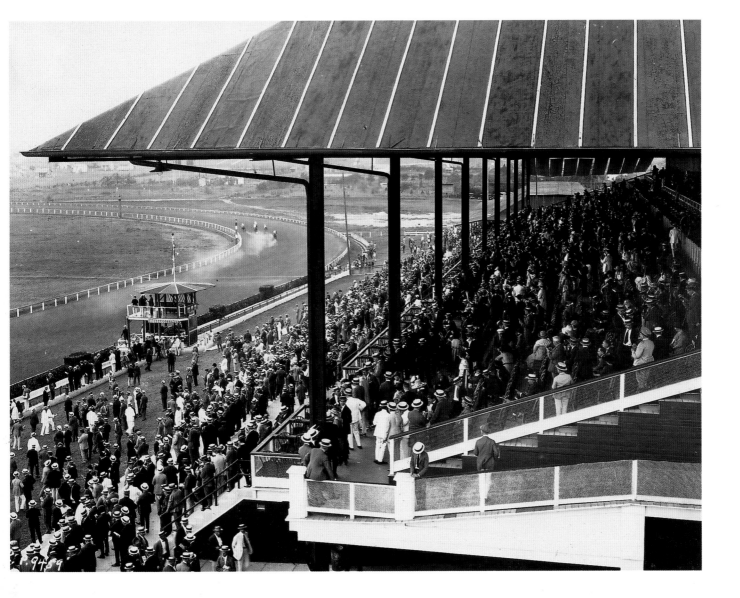

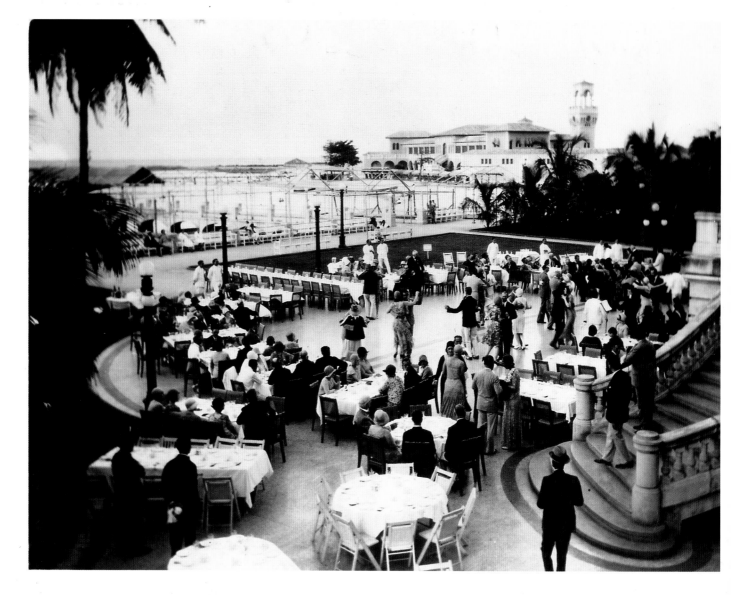

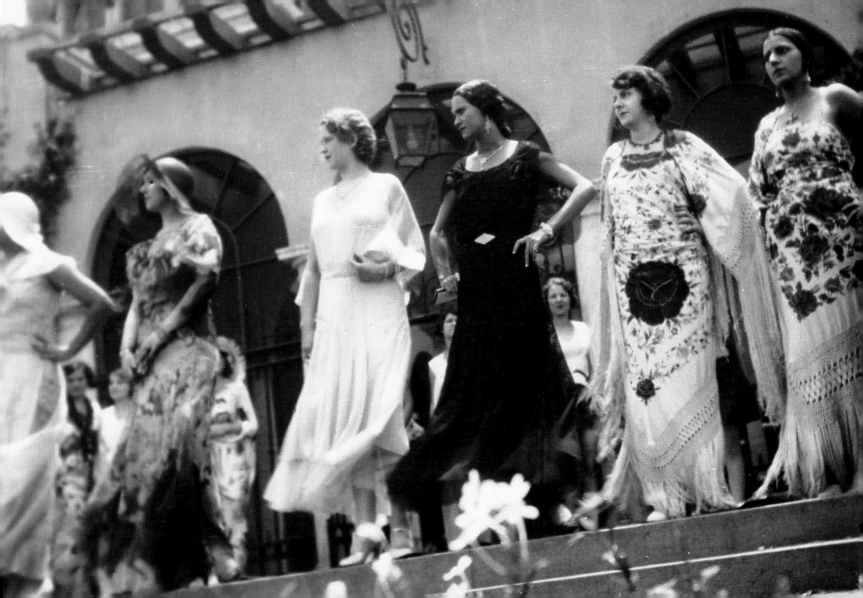

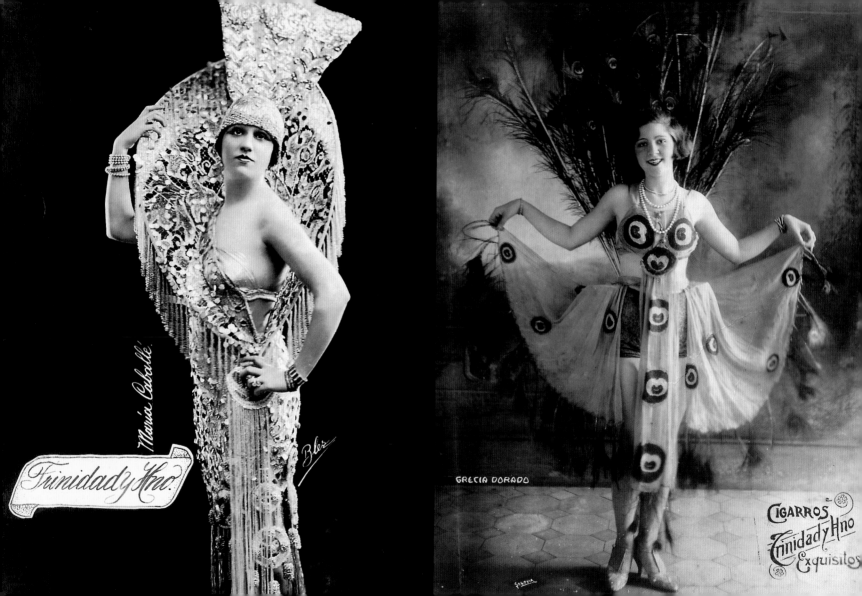

María Caballé

Blez

Trinidad y Hno.

GRECIA DORADO

CIGARROS
Trinidad y Hno
Exquisitos

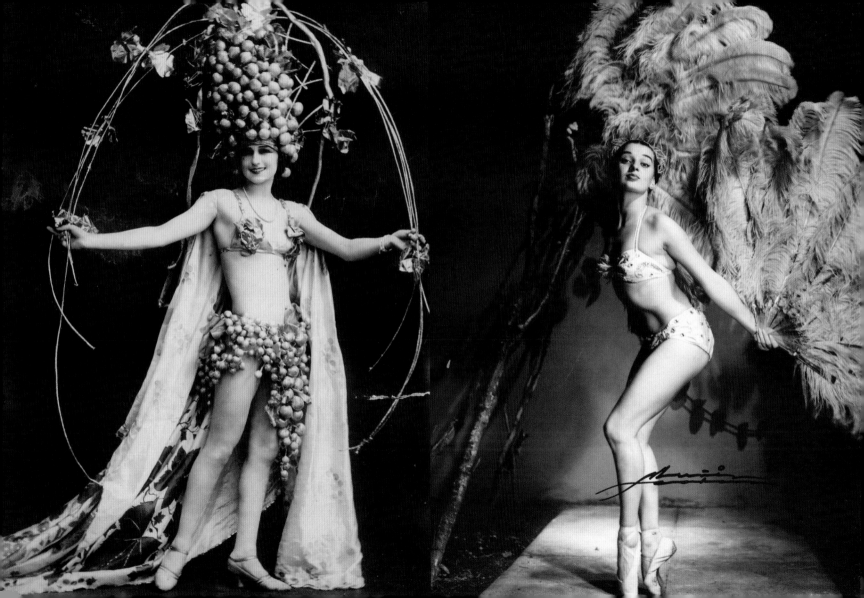

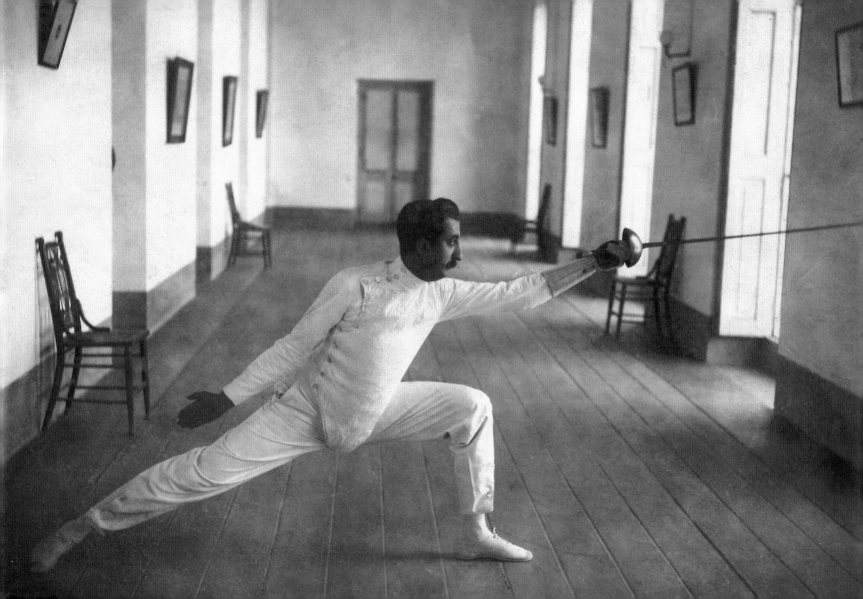

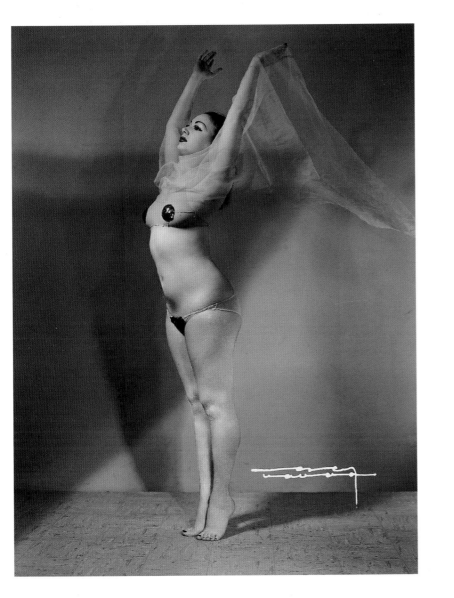

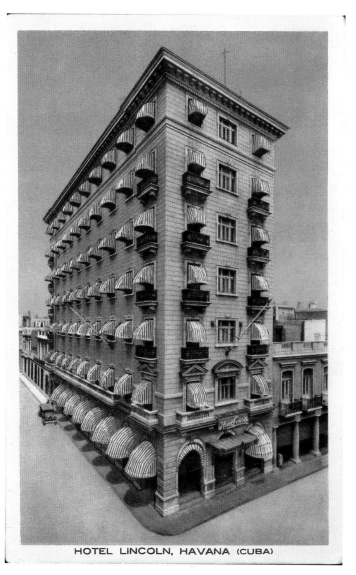

HOTEL LINCOLN, HAVANA (CUBA)

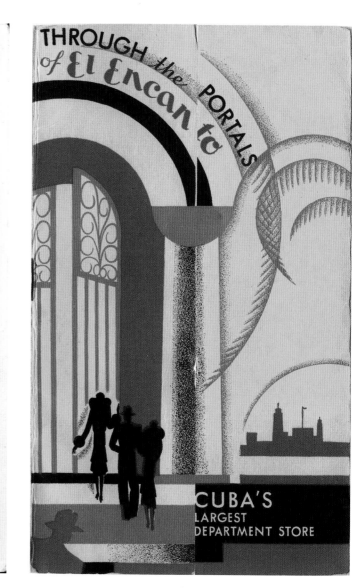

THROUGH the PORTALS of El Encanto

CUBA'S LARGEST DEPARTMENT STORE

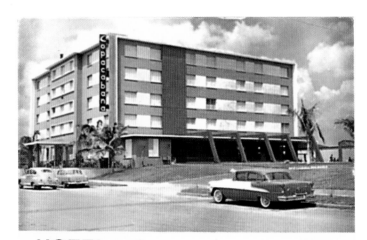

HOTEL
Copacabana
MIRAMAR, HAVANA, CUBA

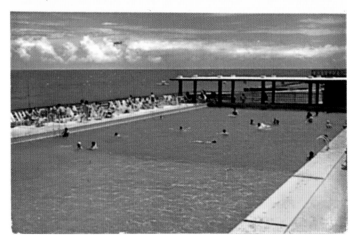

COK

25.93 M.
11.570 KCS.
HABANA,
CUBA

PALACIO DE LOS DEPORTES

Esto certifica que *Mr J. R. Townsend, Jr.*

ha reportado nuestros programas.

WHAT IT MEANS TO BE CUBAN REVEALS ITSELF THROUGH
LIGHT (SINCE WE DO NOT HAVE A JUNGLE OR A PARTICULAR
ARCHITECTURE), IN A PARTICULAR HUE AND RHYTHM,
AN EVER-CHANGING, LUMINOUS OR SOMBER MIRAGE.

From *Necesidad de libertad (Need of Freedom)*

Our night at...

TROPICANA

HAVANA'S FABULOUS NIGHT CLUB & CASINO

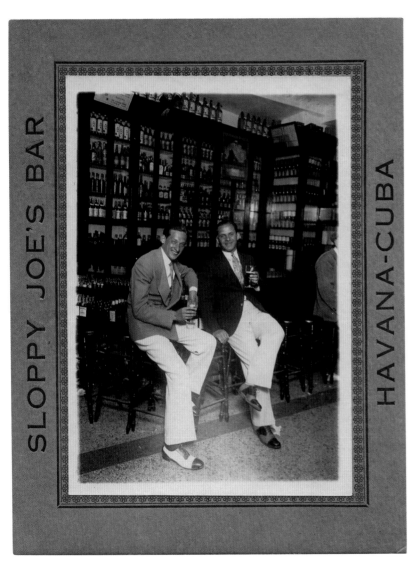

SLOPPY JOE'S BAR HAVANA-CUBA

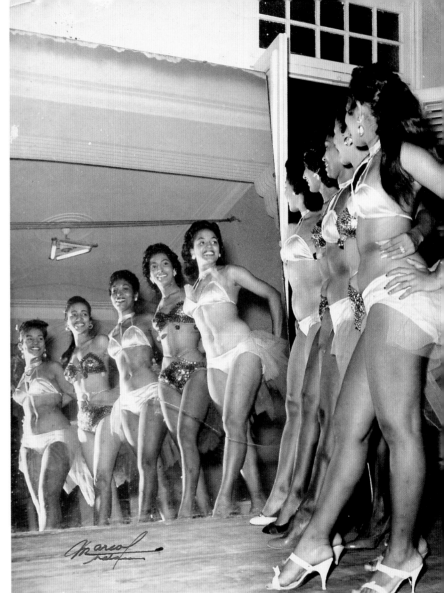

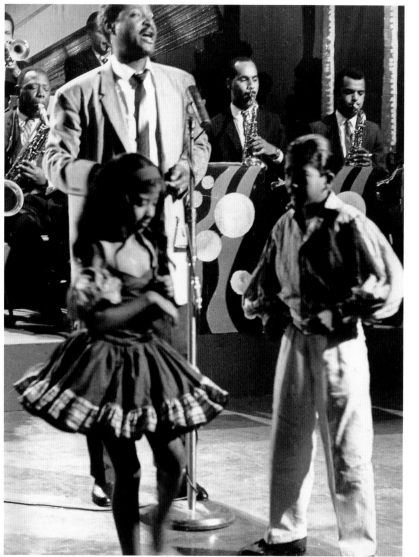
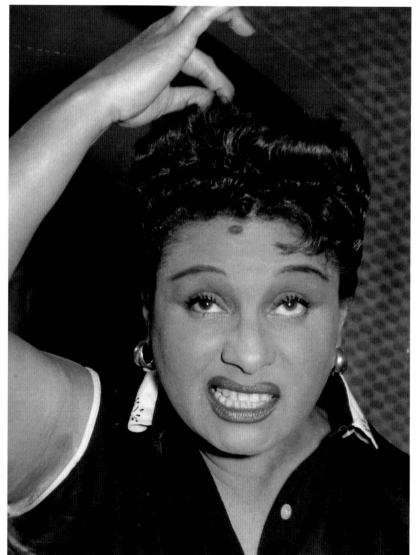

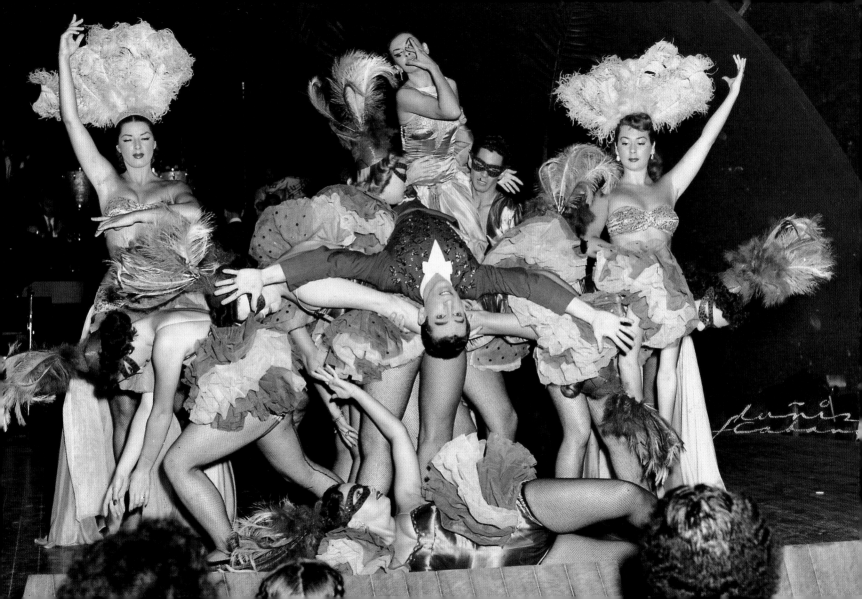

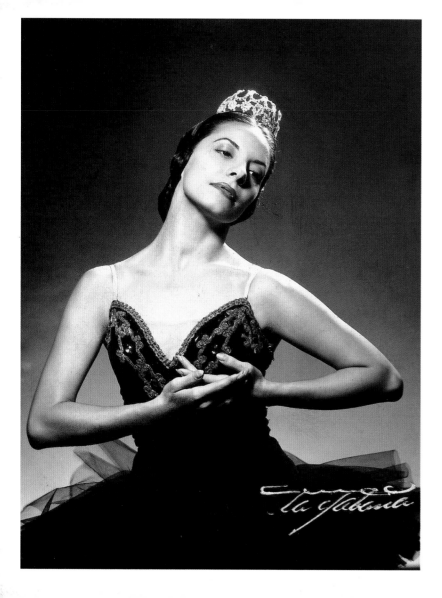

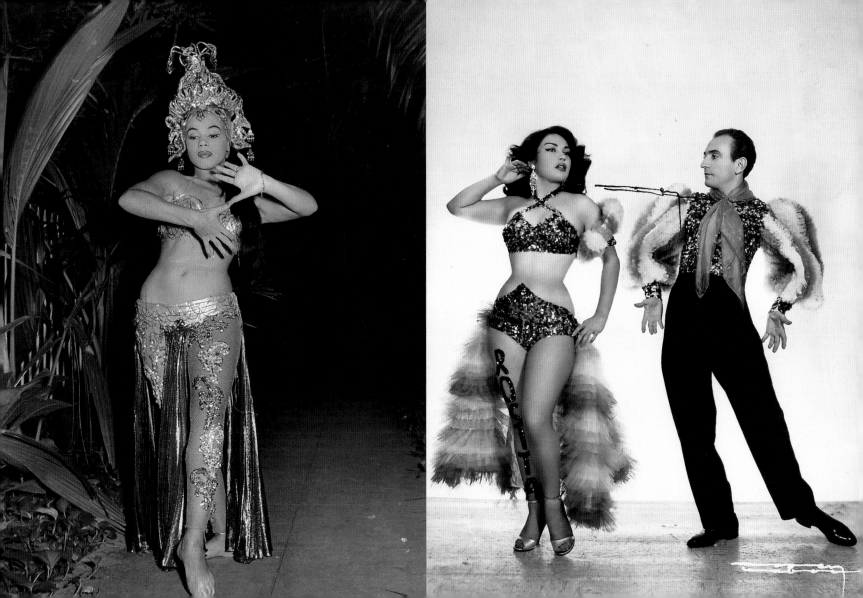

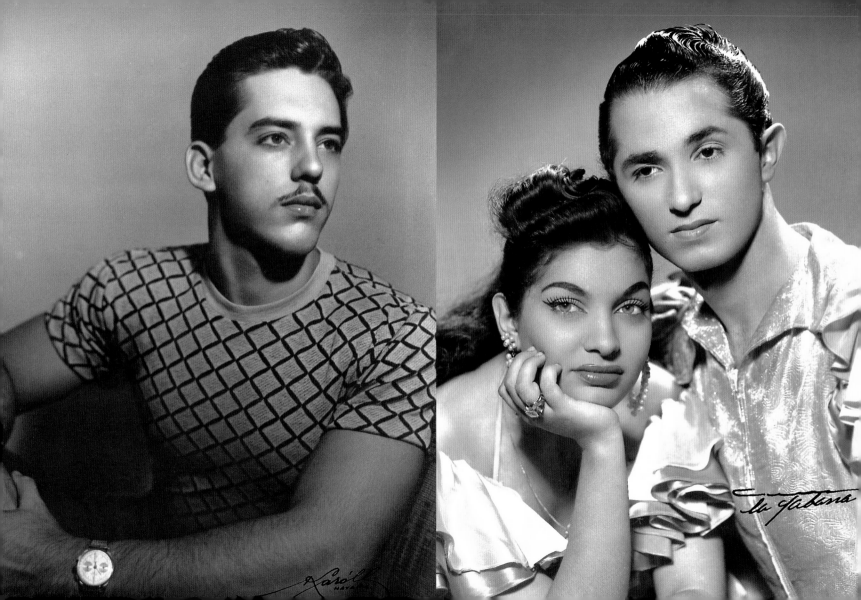

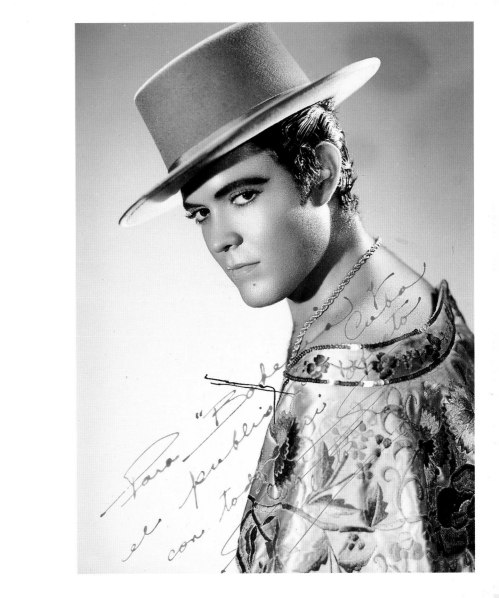

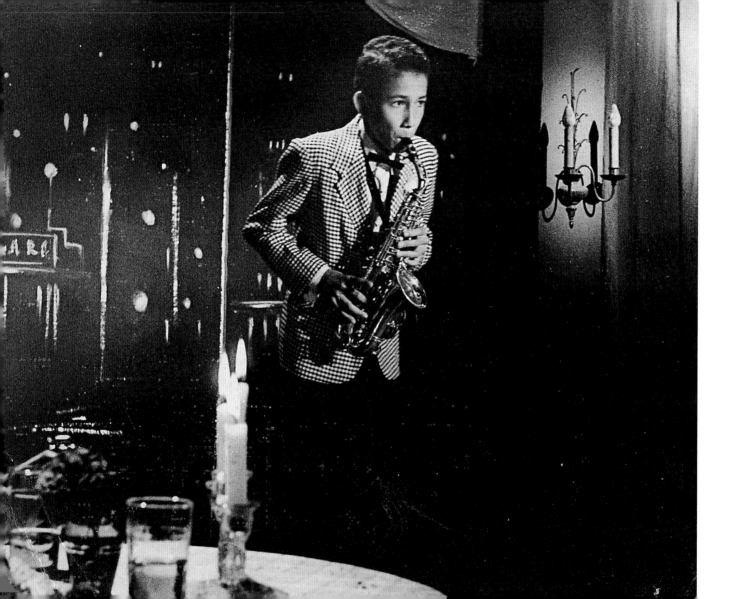

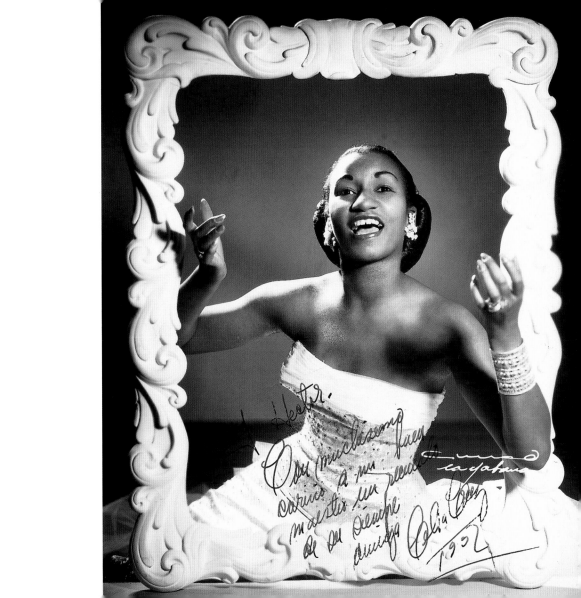

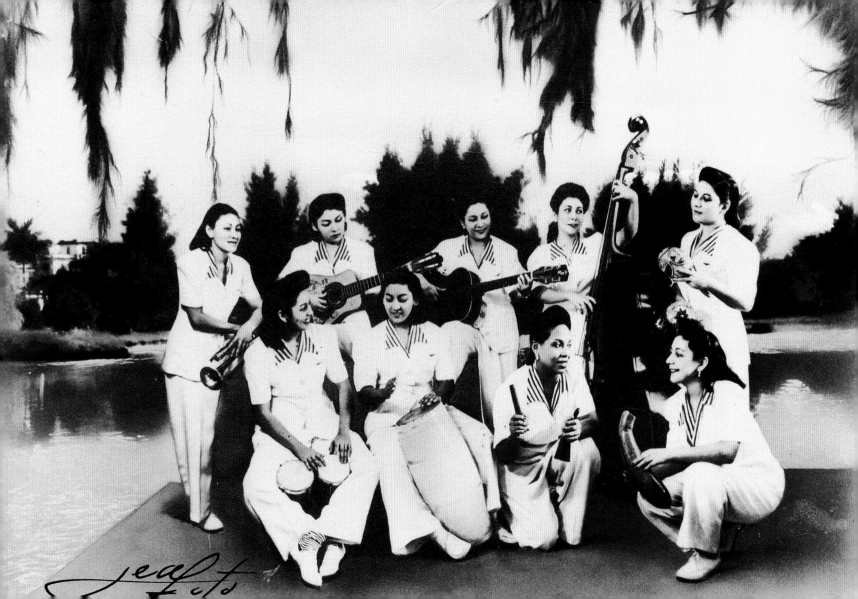

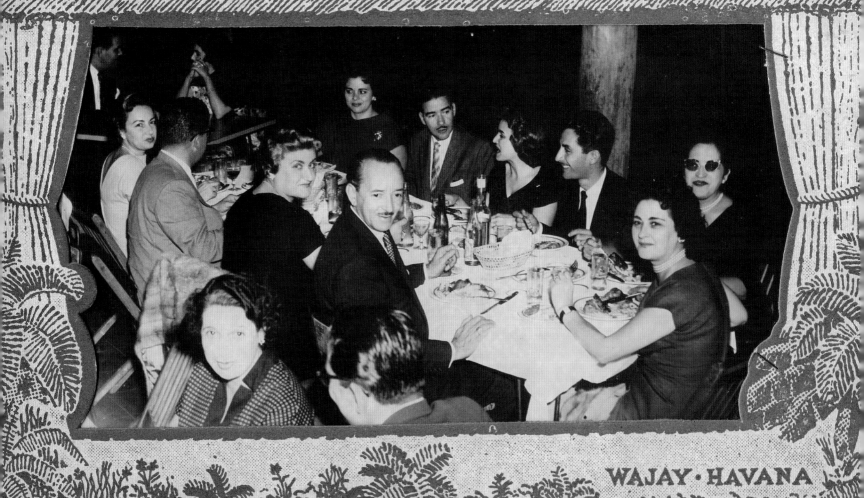

RANCHO LUNA

WAJAY · HAVANA

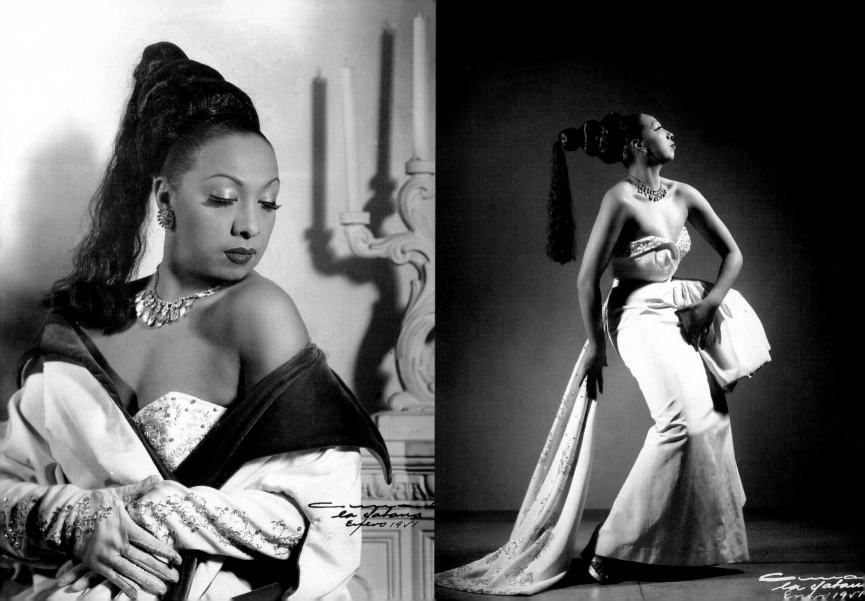

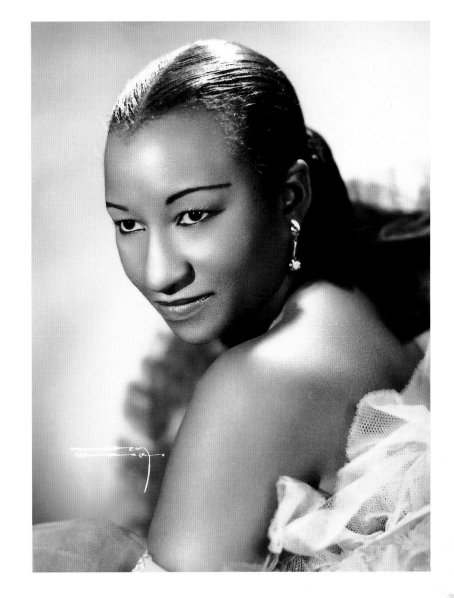

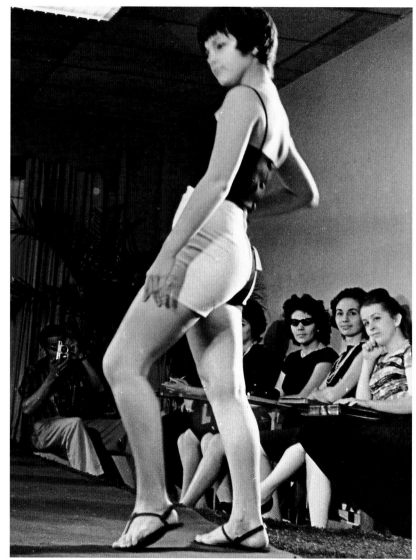

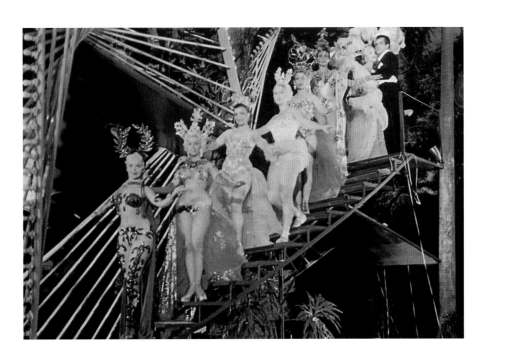

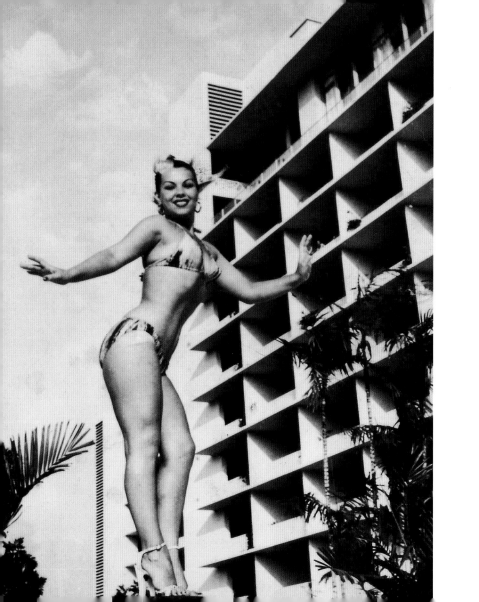

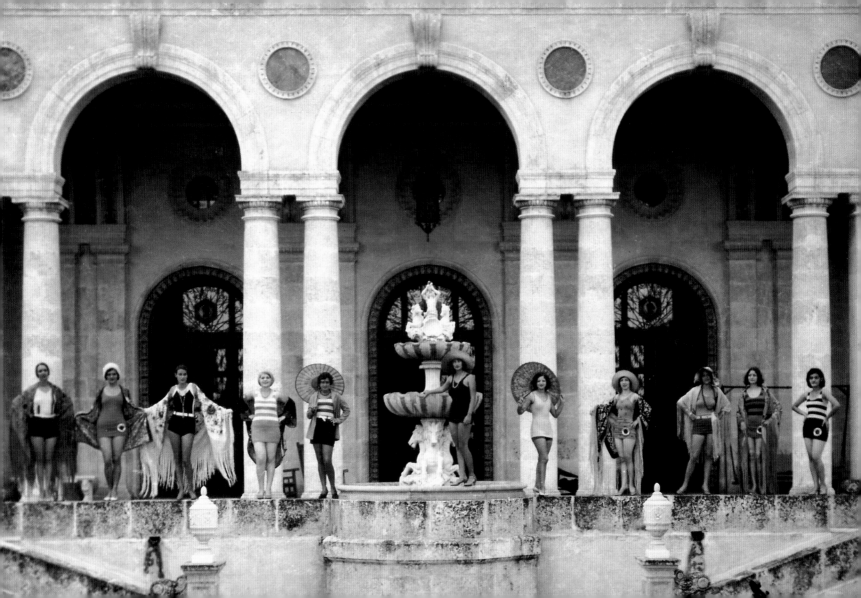

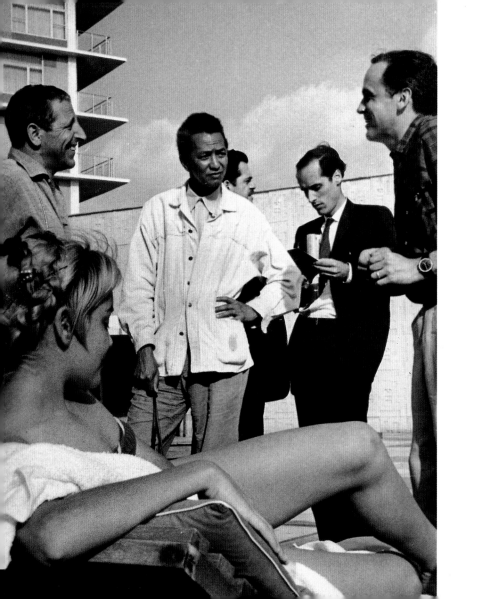

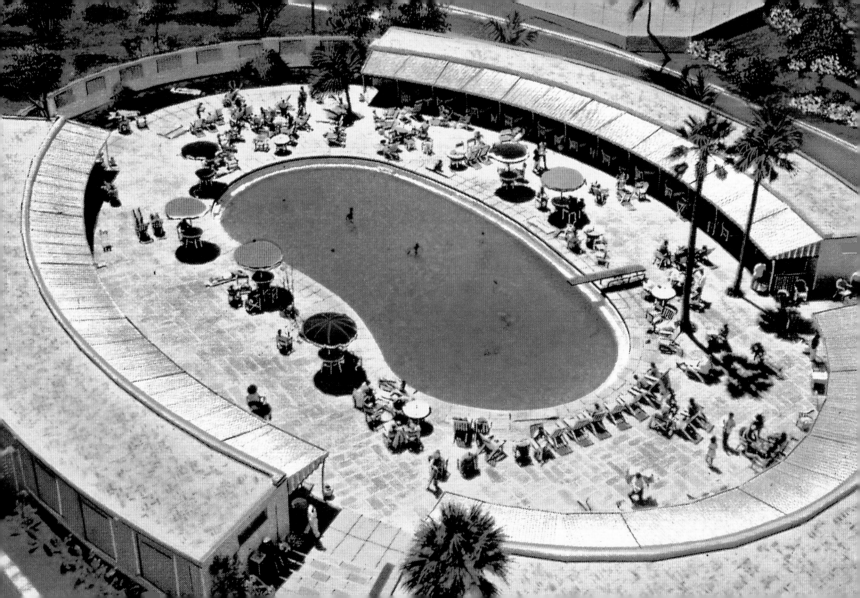

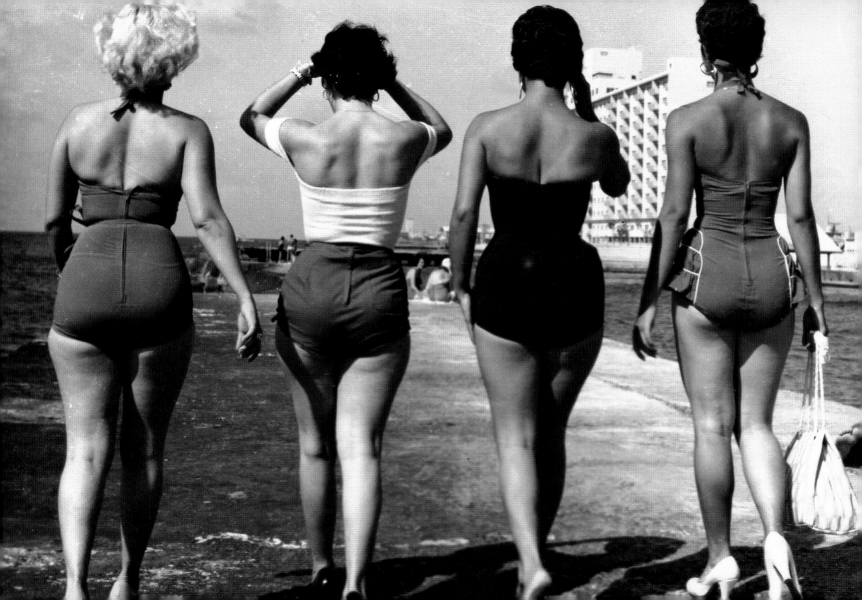

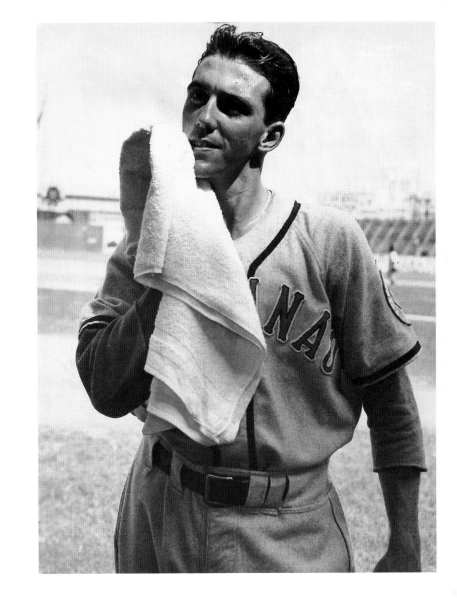

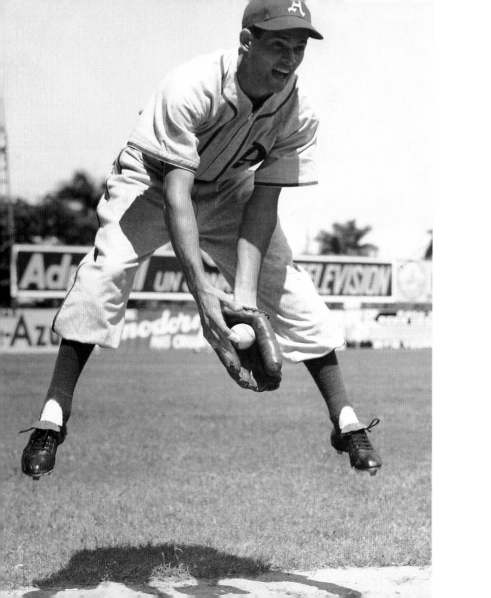

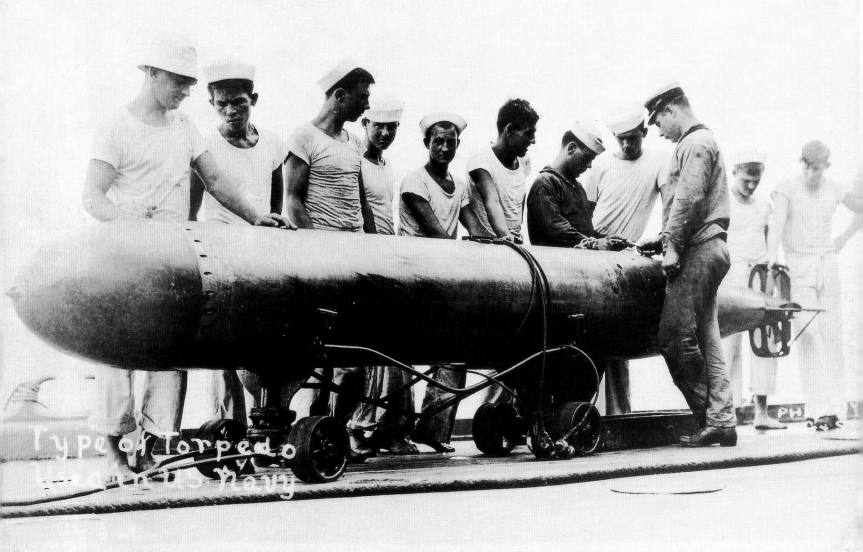

Type of Torpedo Used in U.S. Navy

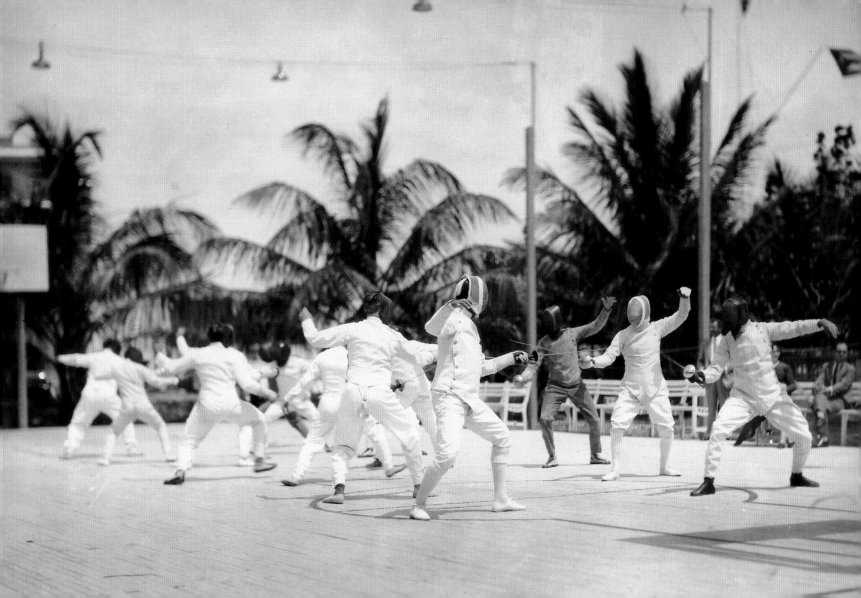

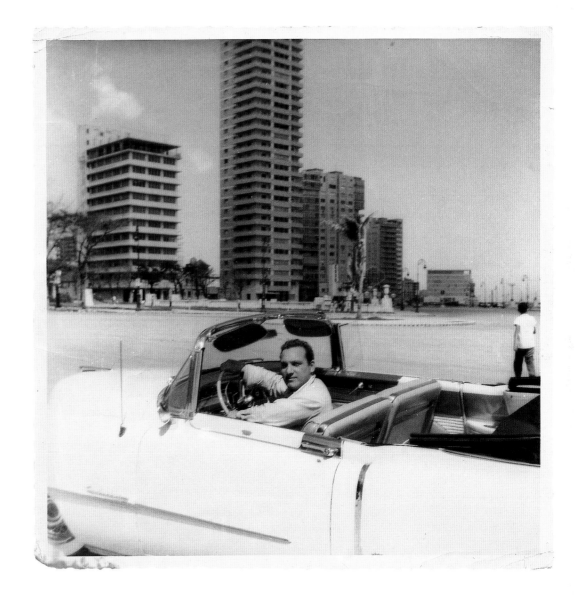

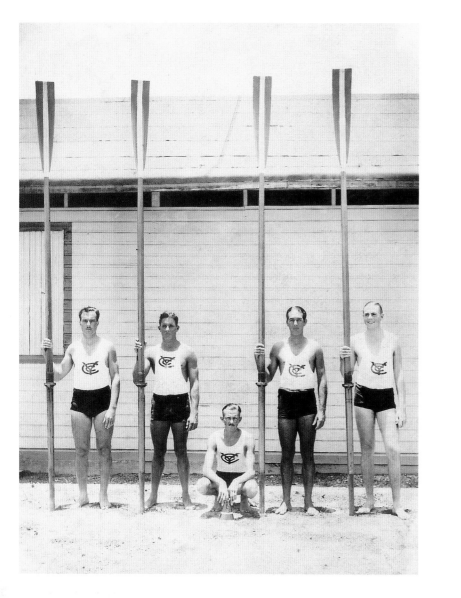

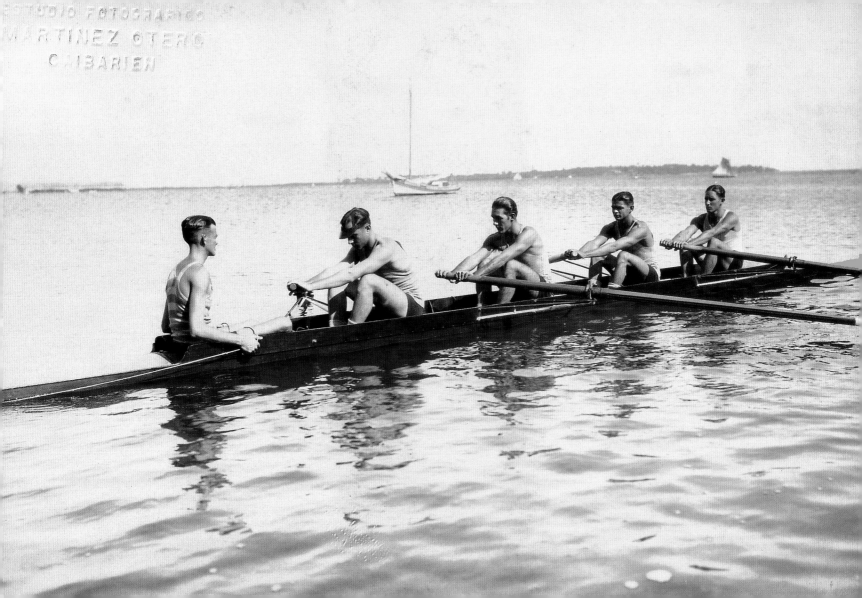

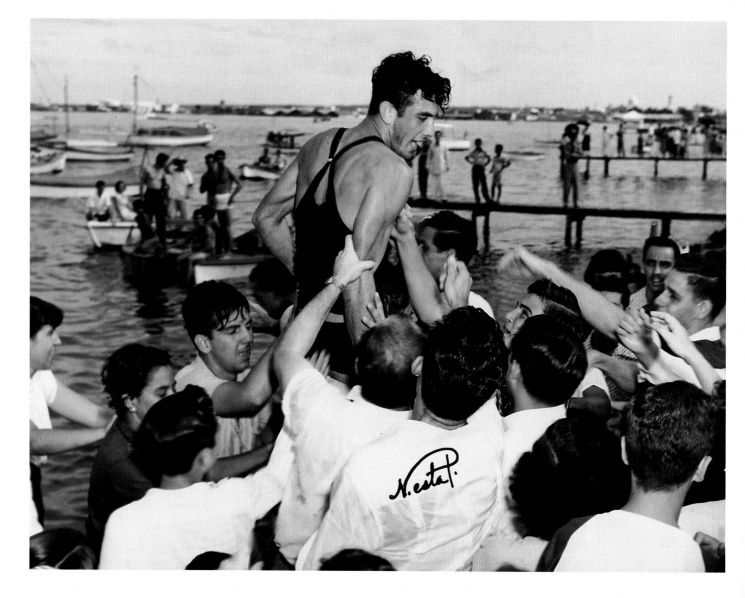

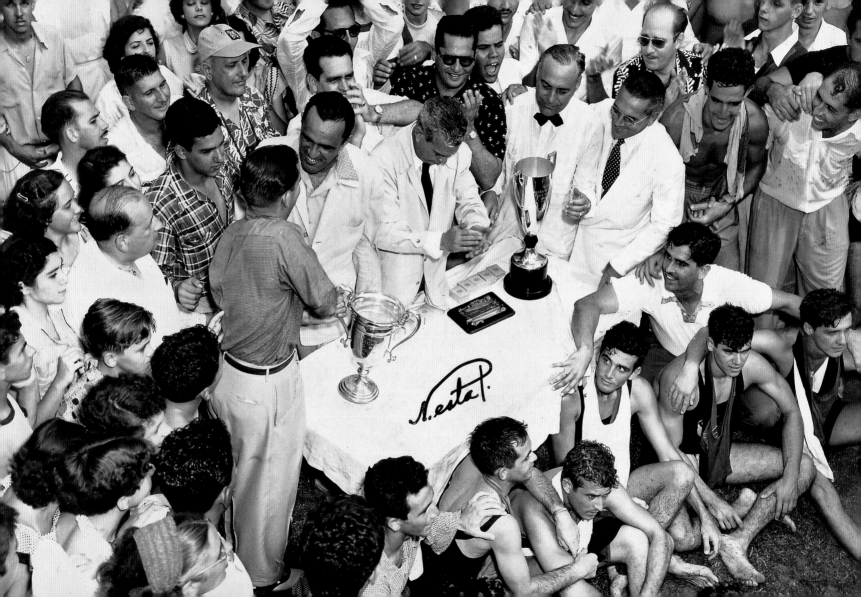

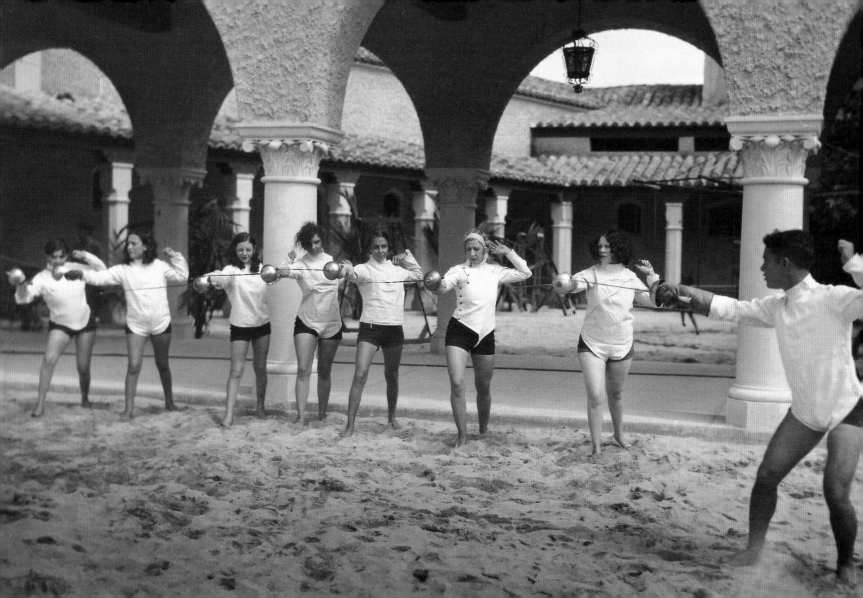

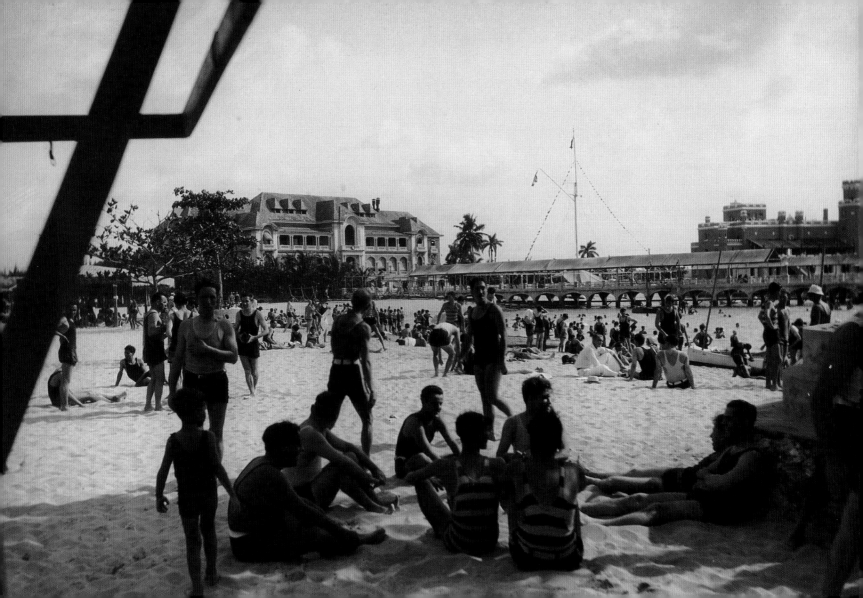

IN SUMMER, THE ISLAND, LIKE AN ELONGATED METAL FISH,

SCINTILLATES, GIVING OFF THREATENING FIERY FLASHES.

IN SUMMER, THE SEA HAS ALREADY STARTED TO VAPORIZE,

AND A SIZZLING, BLUISH CLOUD COVERS THE WHOLE CITY.

From *El mundo alucinante (Hallucinations, or The Ill-fated Peregrinations of Fray Servando)*

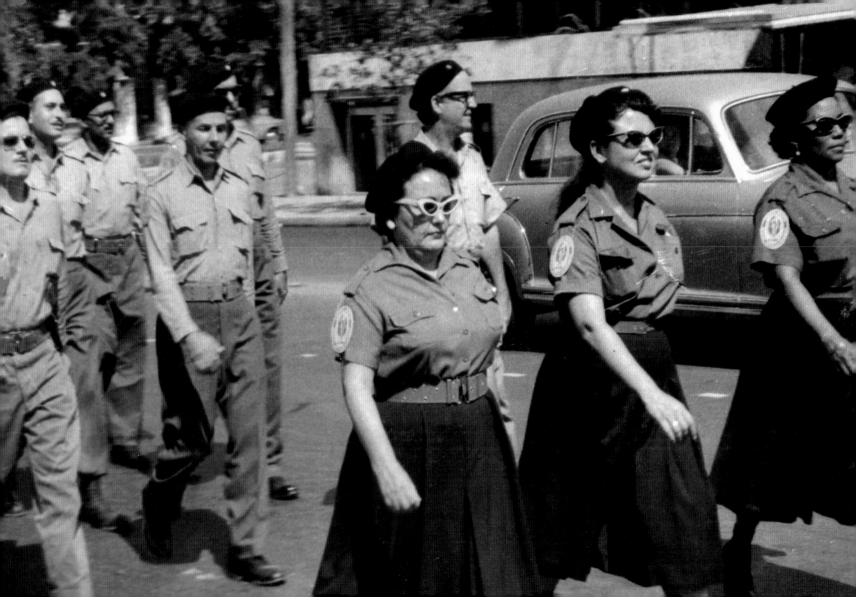

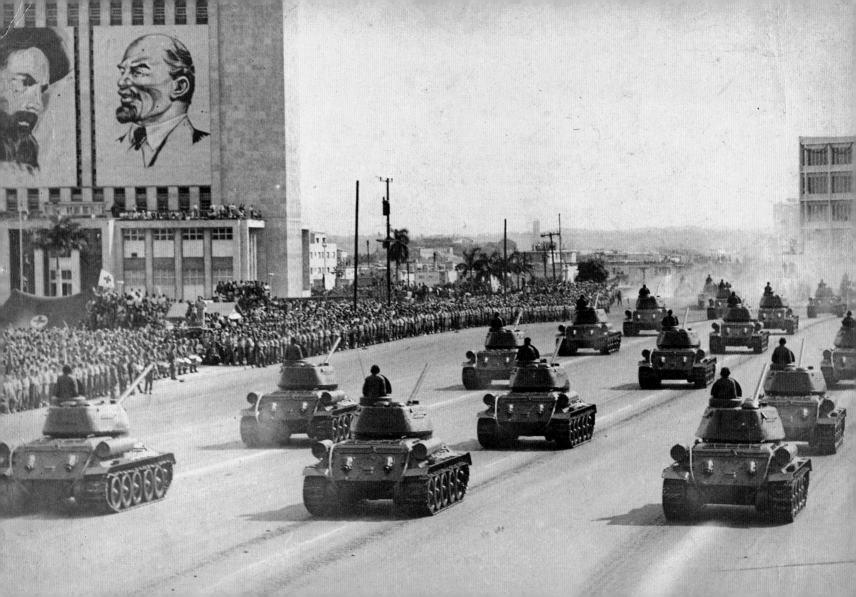

OPPRESSION BECOMES INTOLERABLE FOR THE POET BECAUSE

THE ABSOLUTE EXPRESSION OF FREEDOM IS IN THE IMAGINATION.

THE POET WHO DOES NOT KNOW FREEDOM, IMAGINES IT . . . AND

TRANSFORMS HIS VISION INTO A PALPABLE REALITY OR PERISHES.

Reinaldo Arenas to Juan Abreu in *A la sombra del mar (In the Shadow of the Sea)*

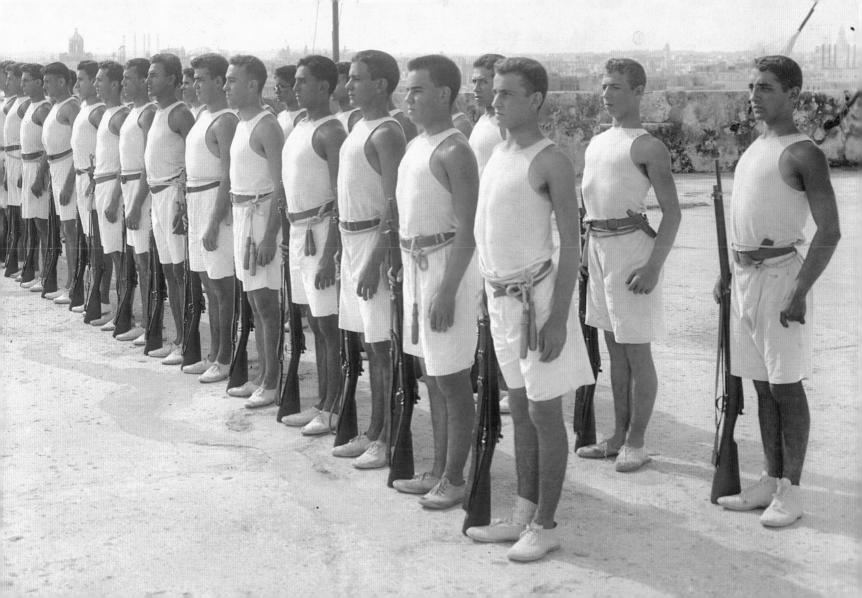

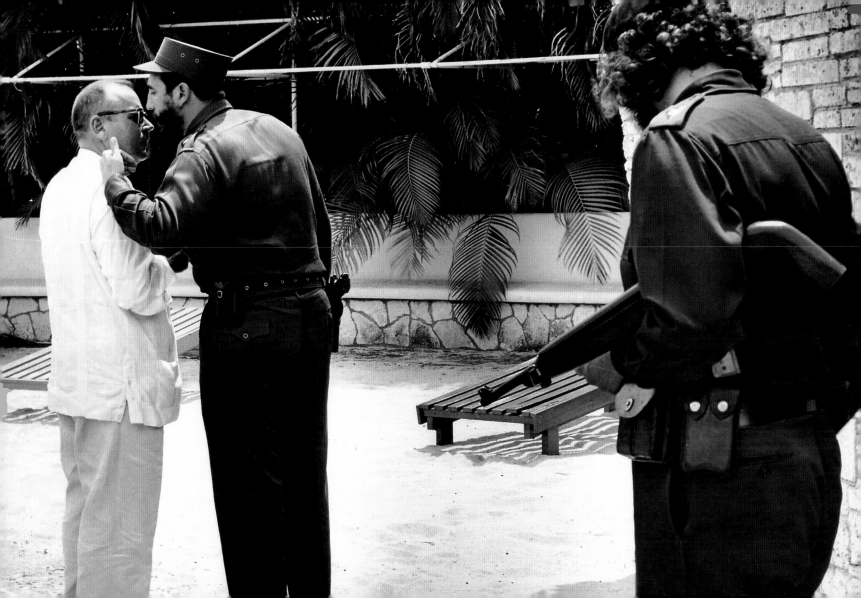

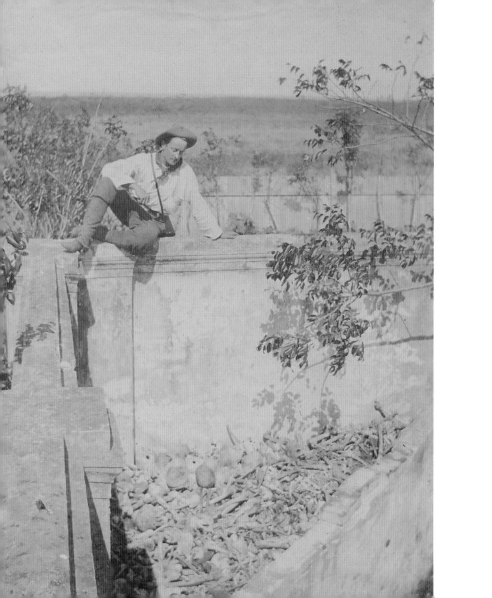

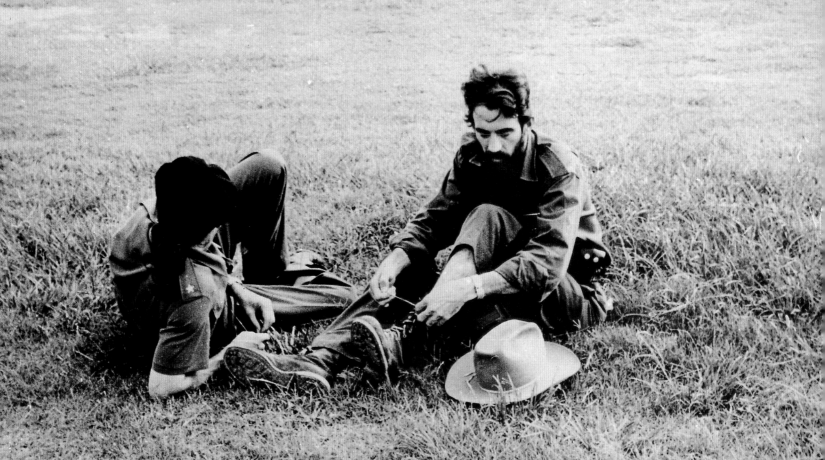

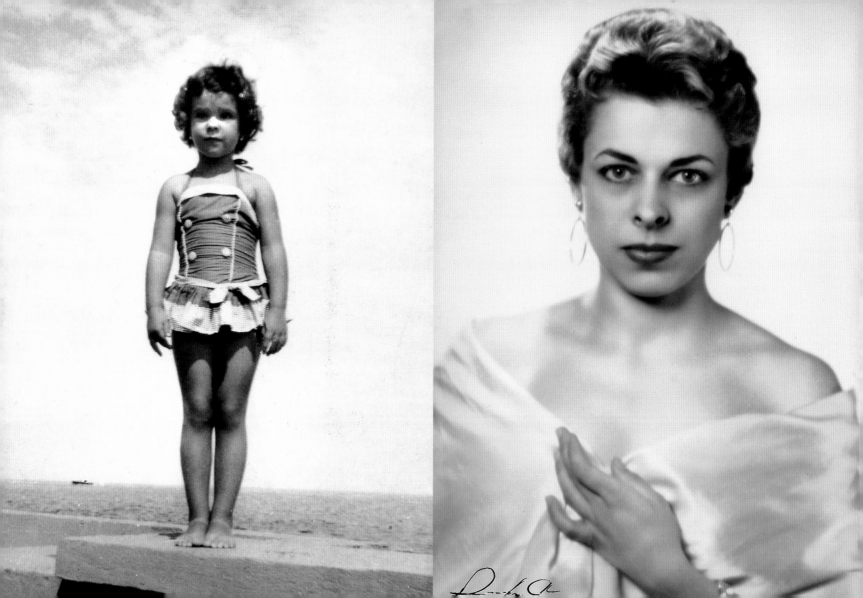

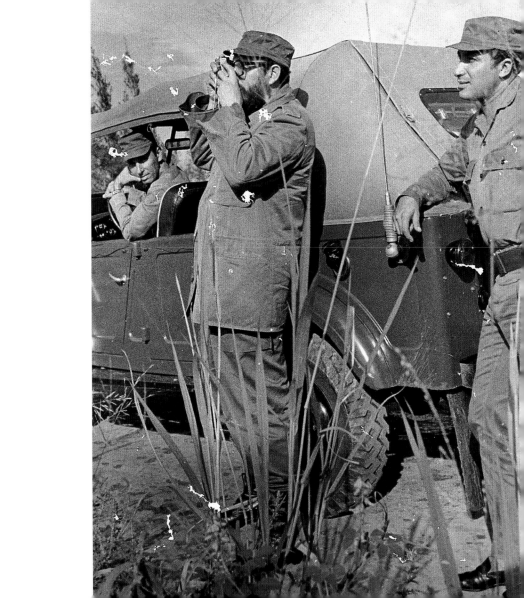

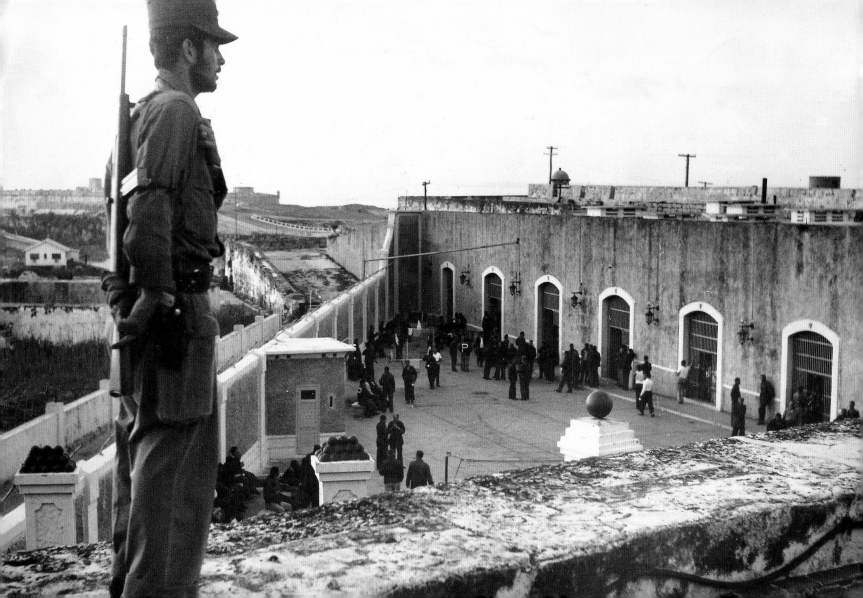

"Waiting to be shot. Adios!!!

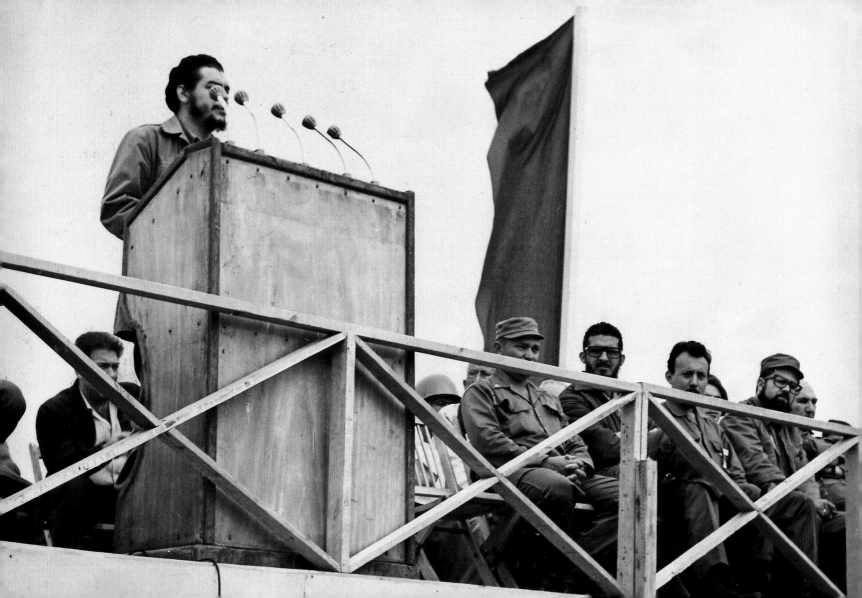

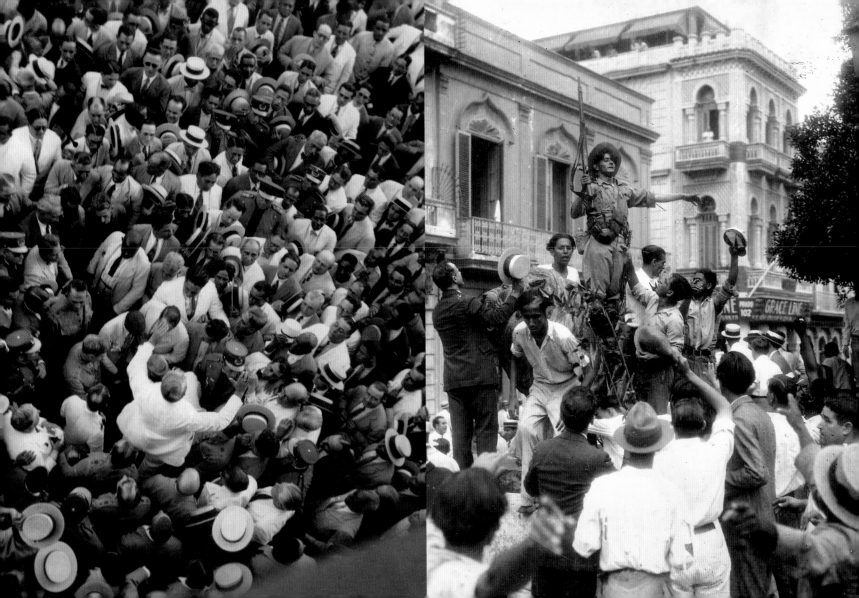

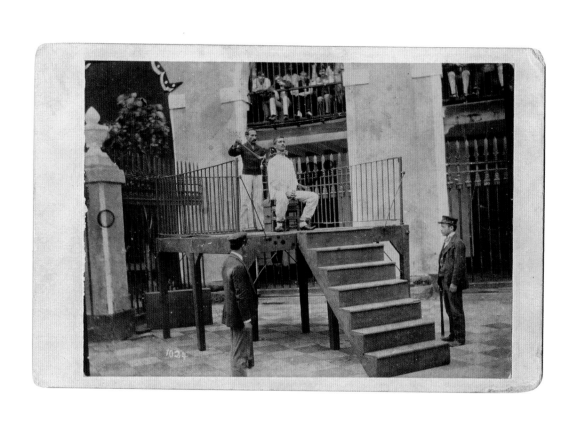

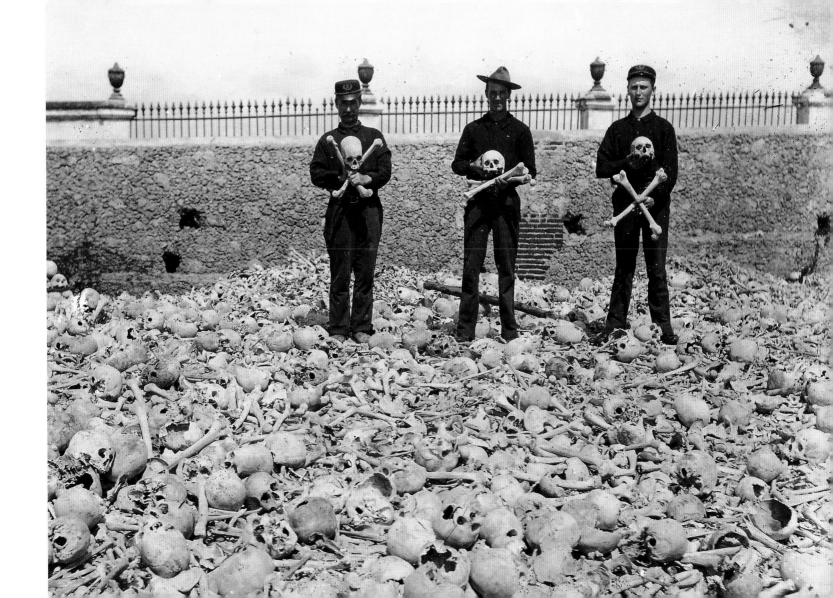

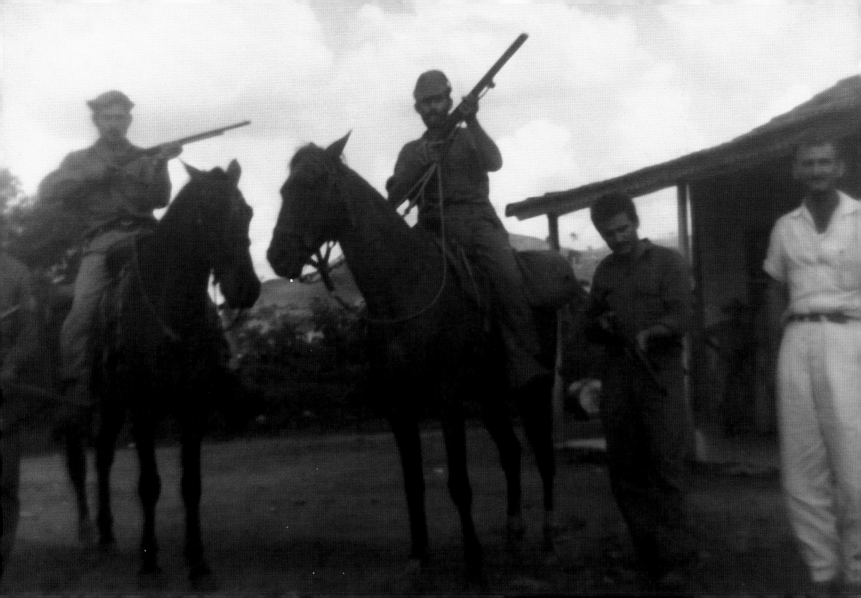

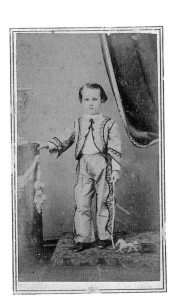

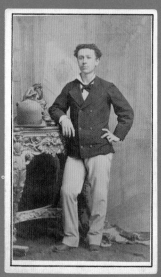

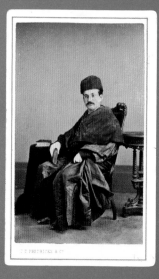
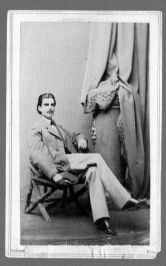

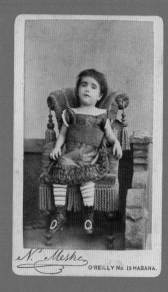
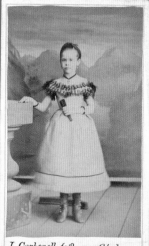

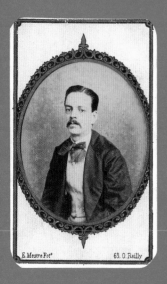

E. Mestre Fotº 63. O'Reilly

Para Margara

Calle de O'Reilly, 62. HABANA
Rue de Rivoli, 79. PARIS.

Me lo dió el 20 de Mayo
á los 21 años 1871

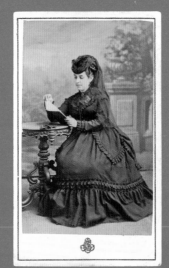

FERNANDEZ
FOTÓGRAFO
Con Rl. Privilegio
O'Reilly 66
HABANA.

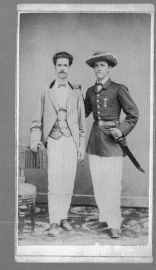

J. H. NORMAND
FOTOGRAFO
MATANZAS.

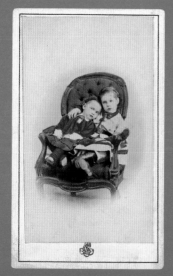

C. D. FREDRICKS & Cª
Calle de la Habana. 108
HABANA
NEW-YORK. — PARIS
587 Broadway. Passⁱ du Havre 31

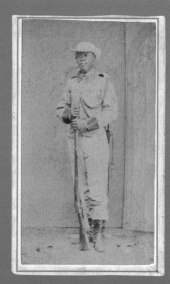

GALERIA FOTOGRAFICA
EL PALACIO DEL ARTE
Calzada de Galiano numero 86
entre S. Rafael y S. José
HABANA

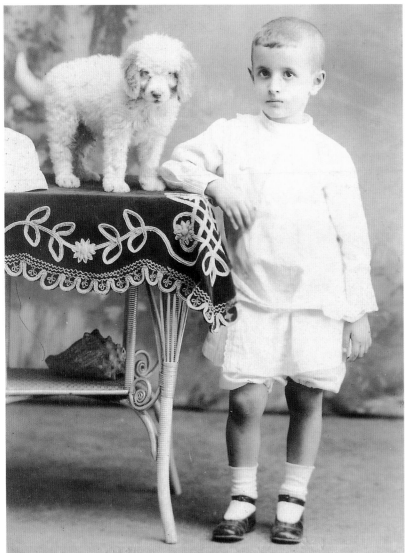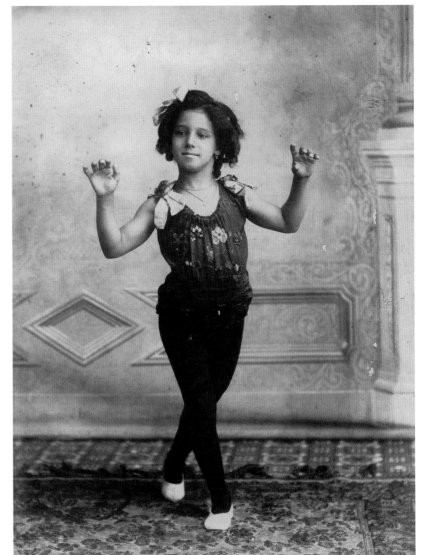

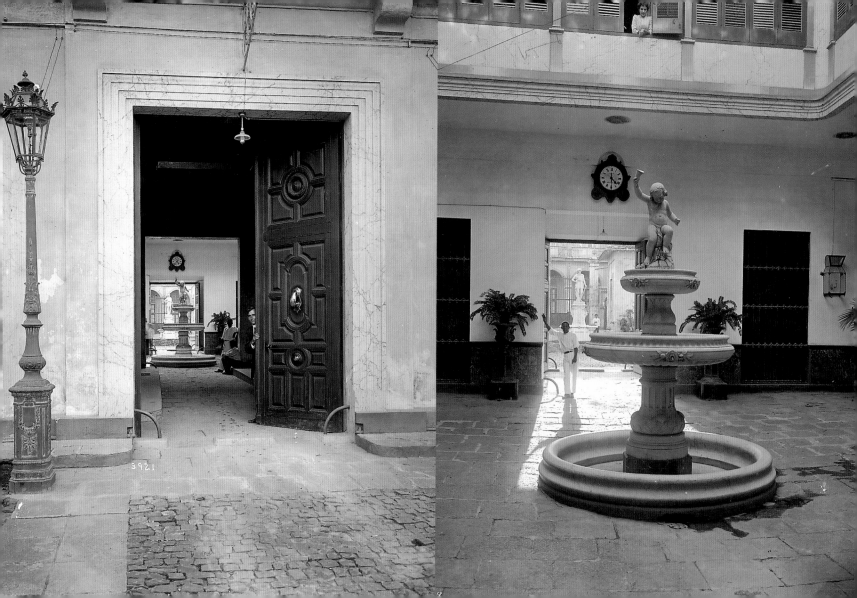

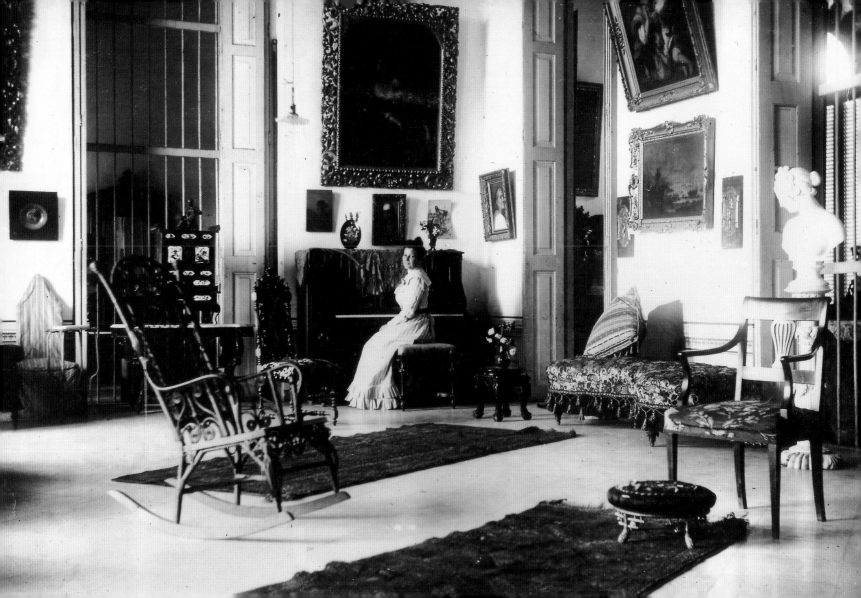

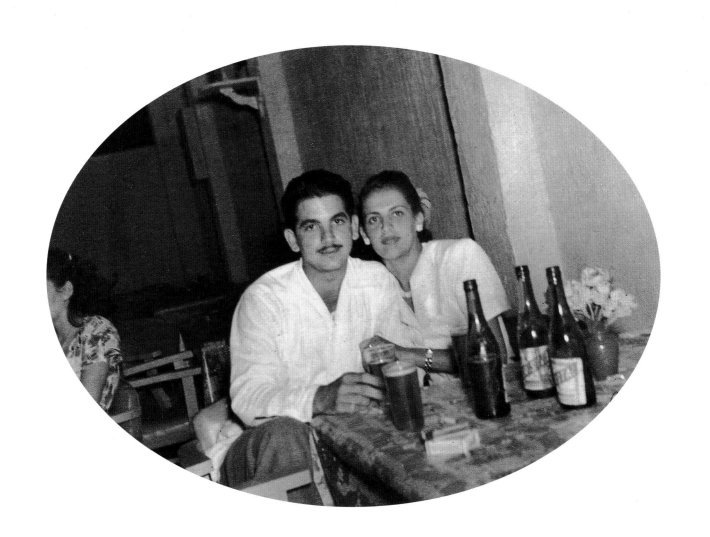

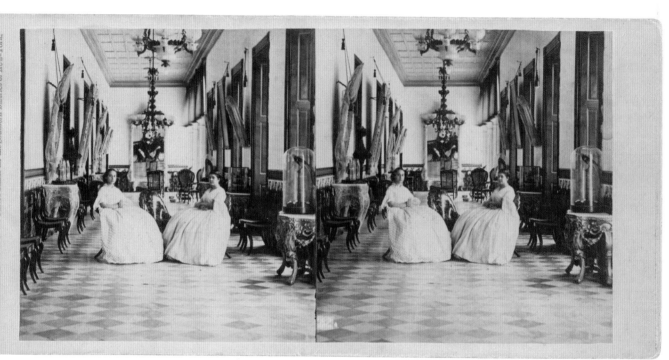

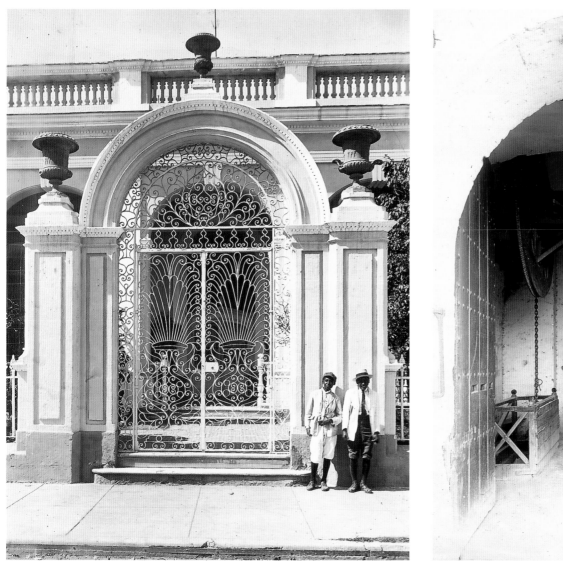

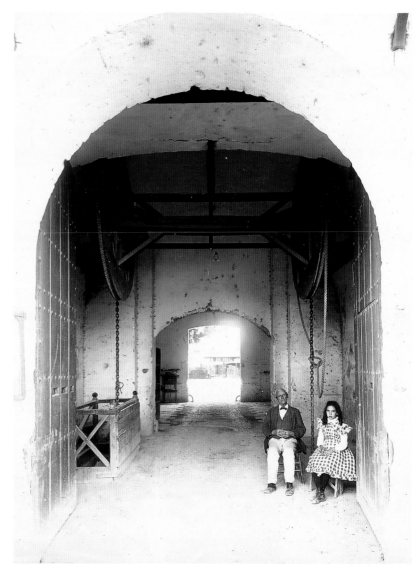

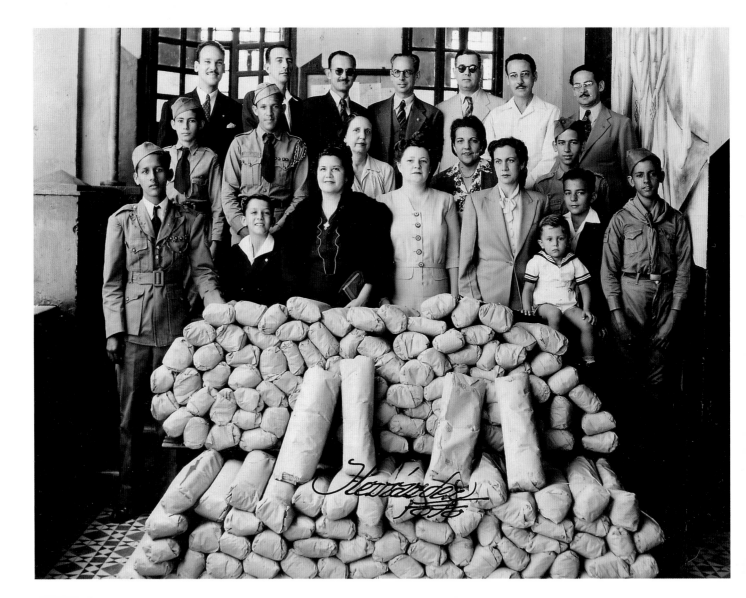

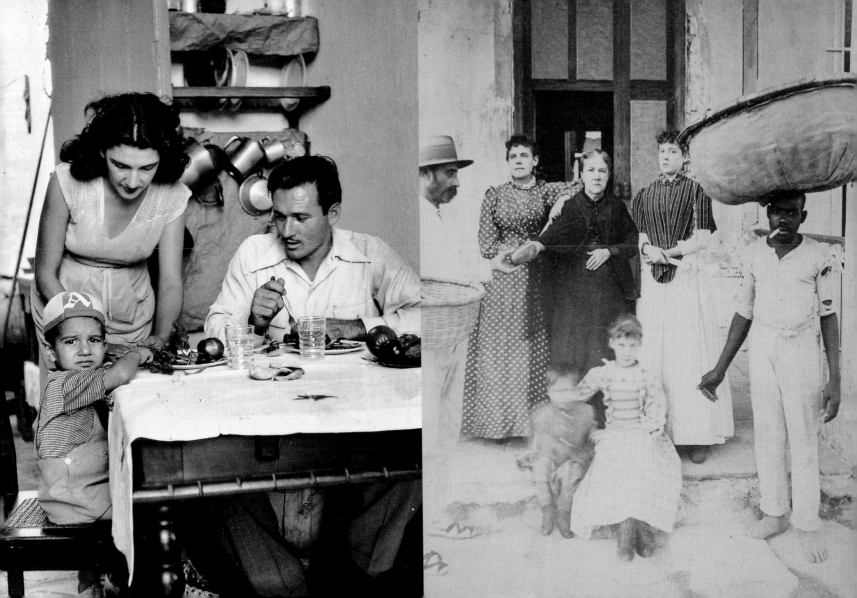

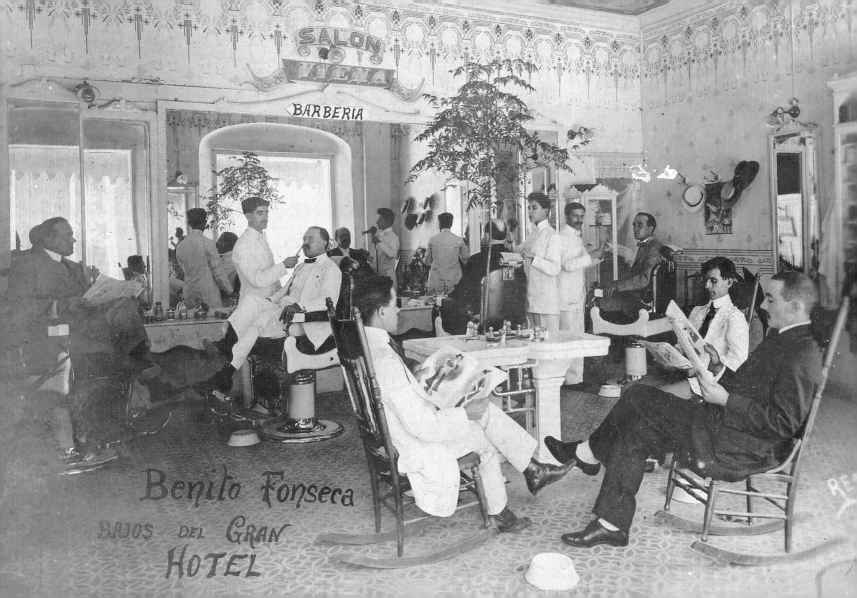

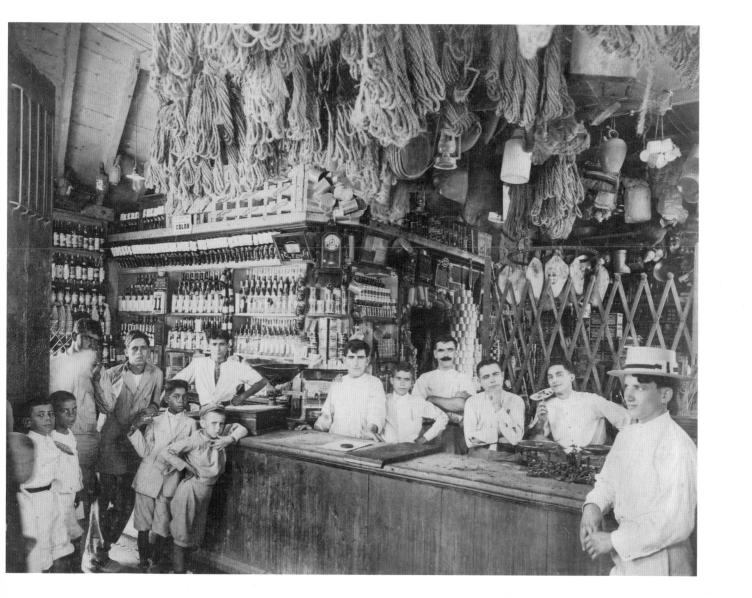

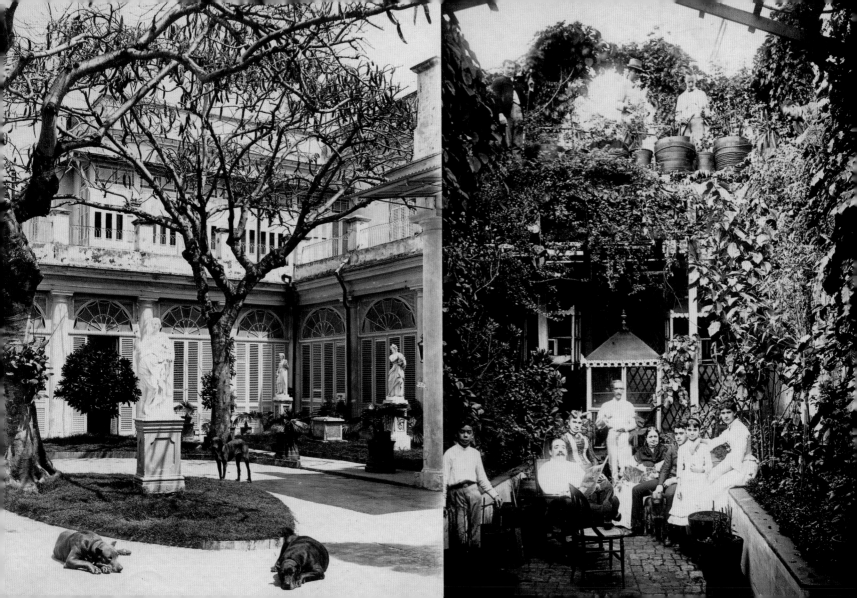

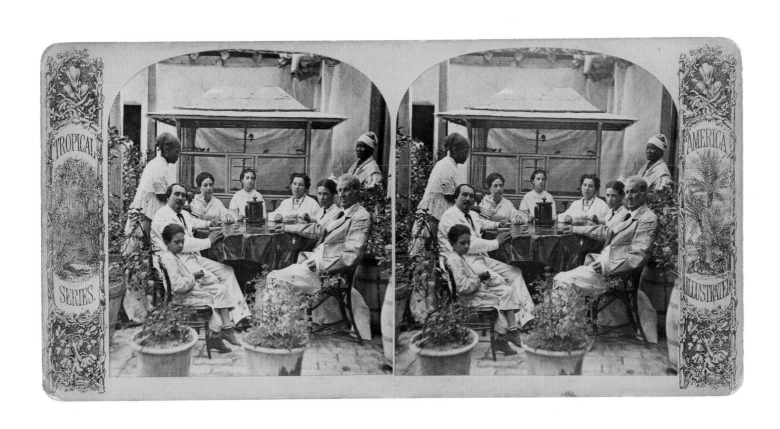

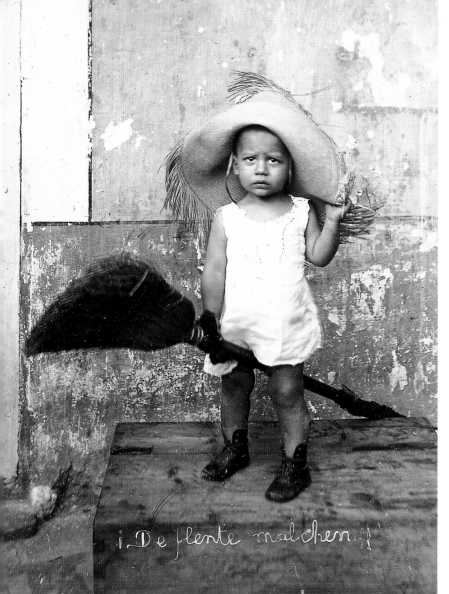

¡De frente mal chen!

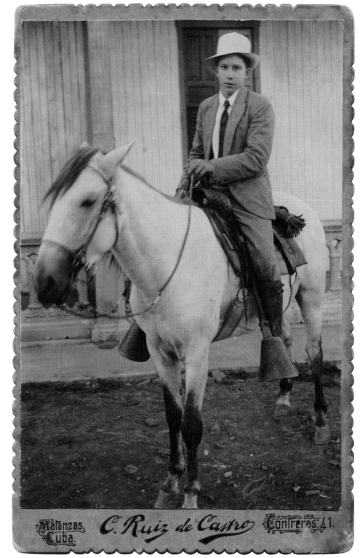

Matanzas
Cuba.

C. Ruiz de Castro

Contreras 41.

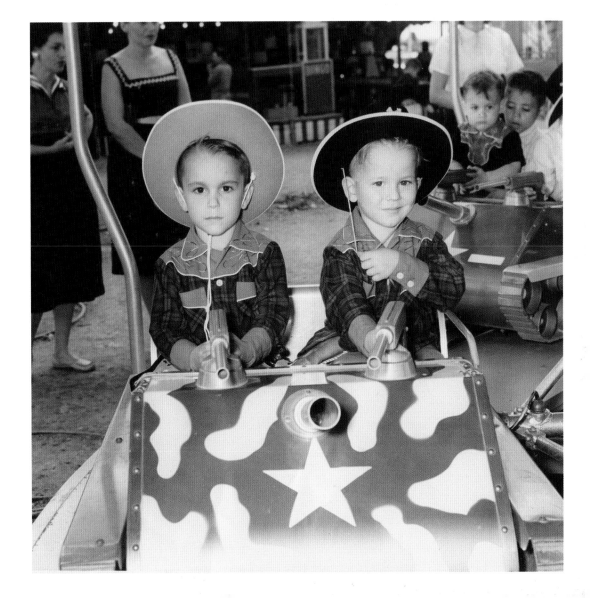

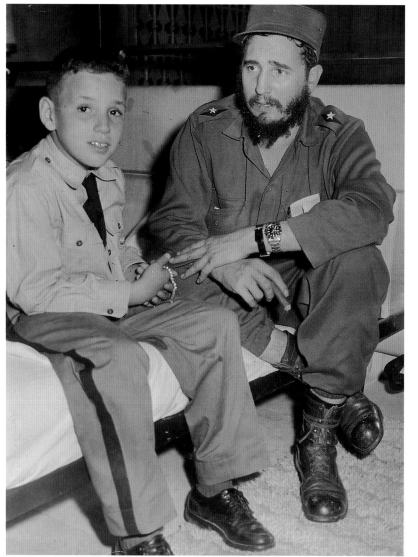
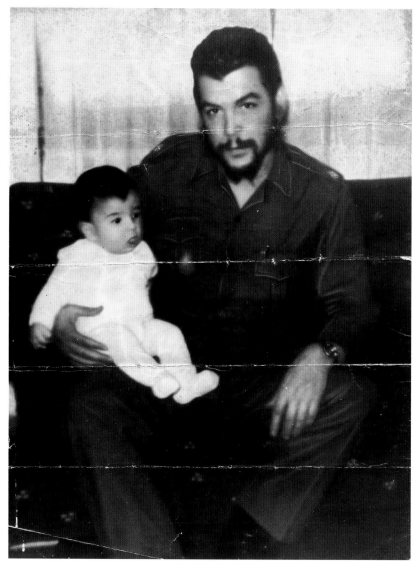

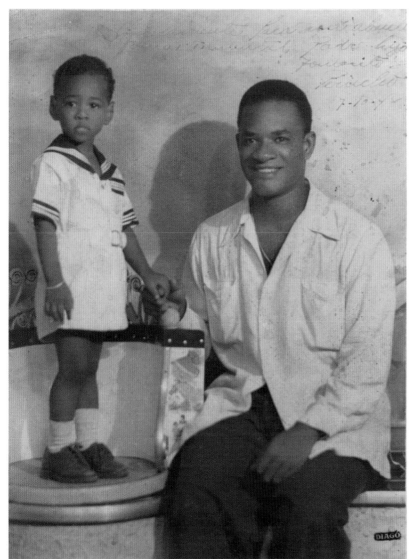

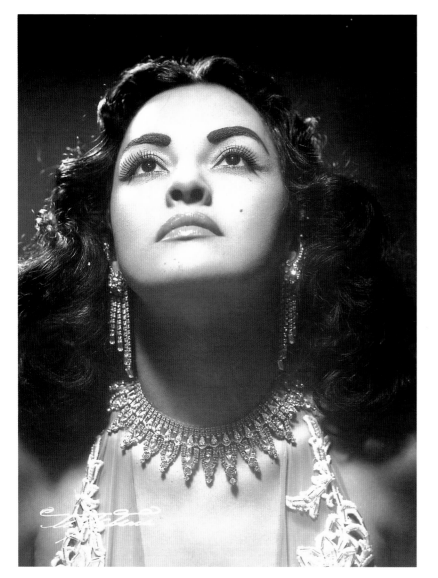
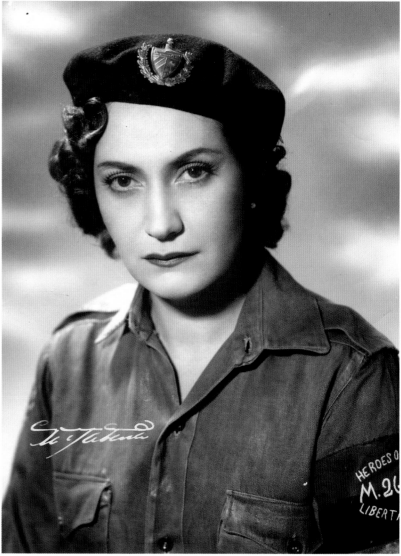

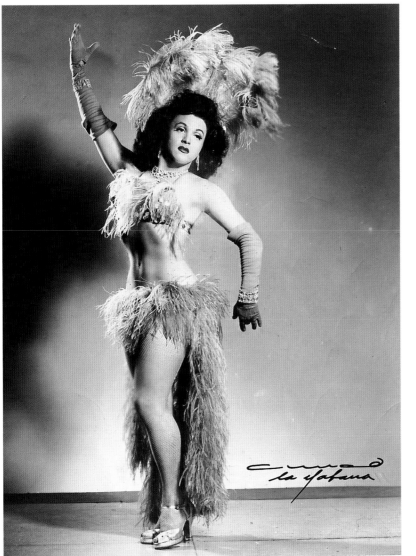

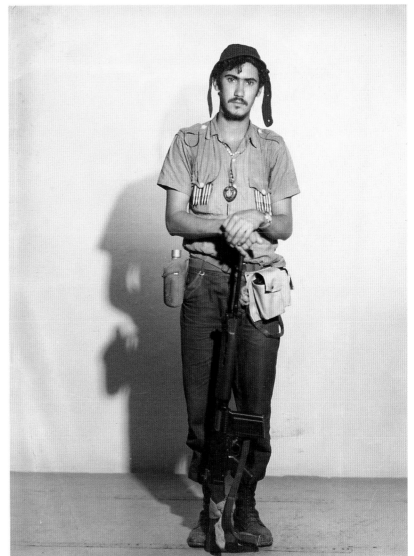

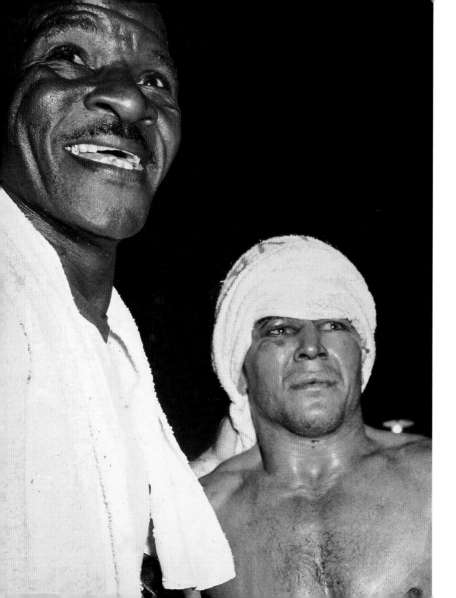
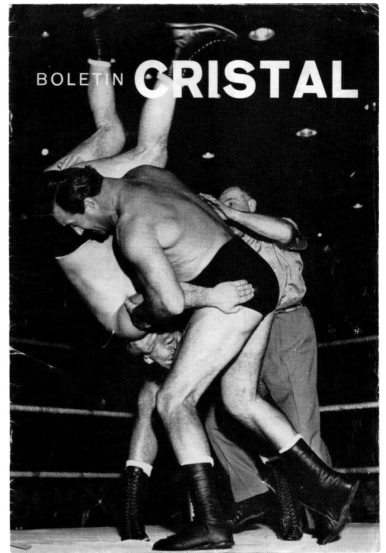

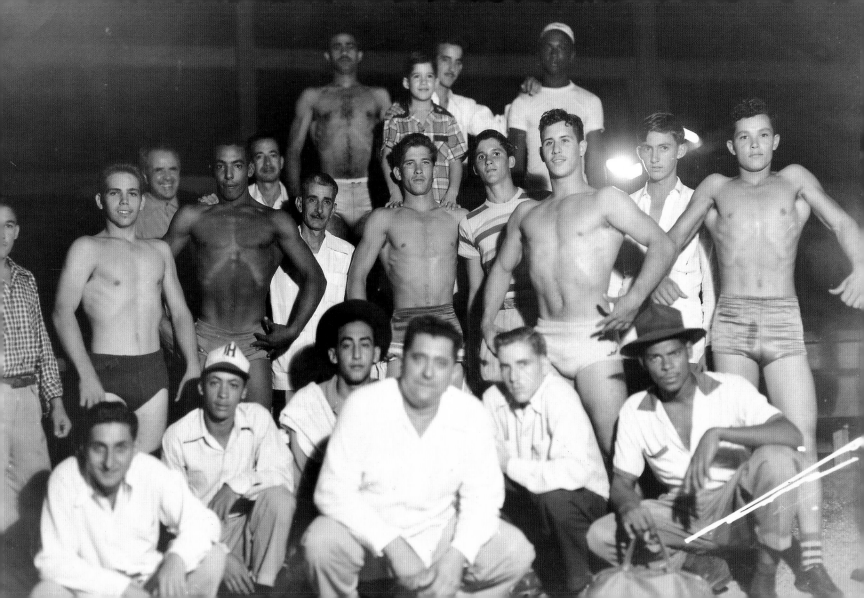

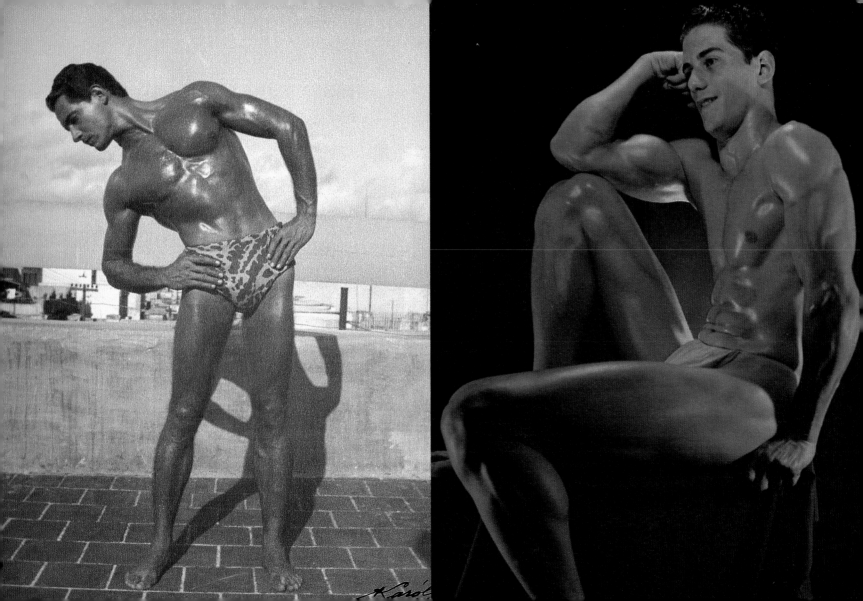

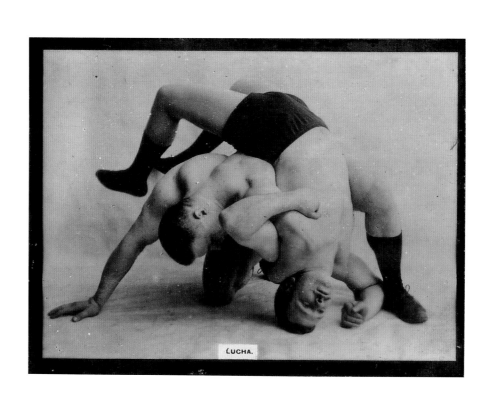

LUCHA.

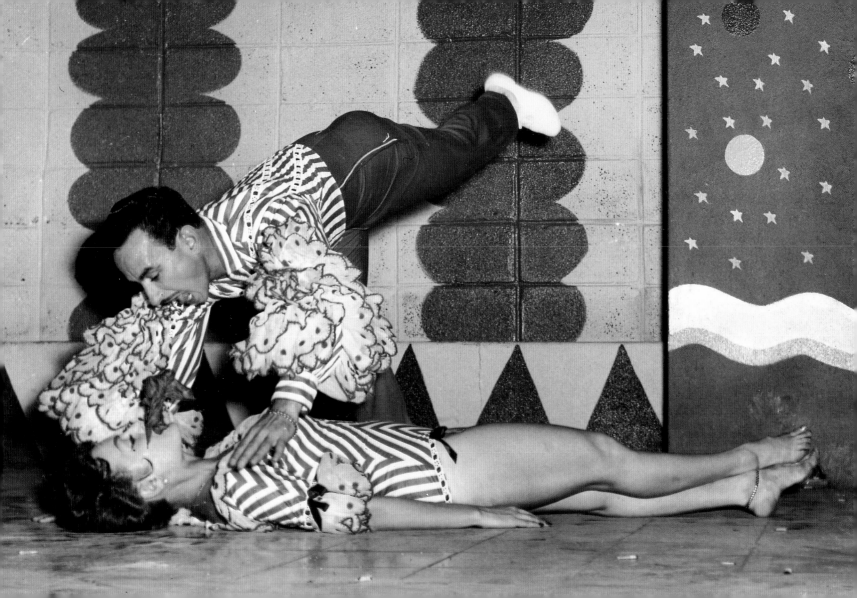

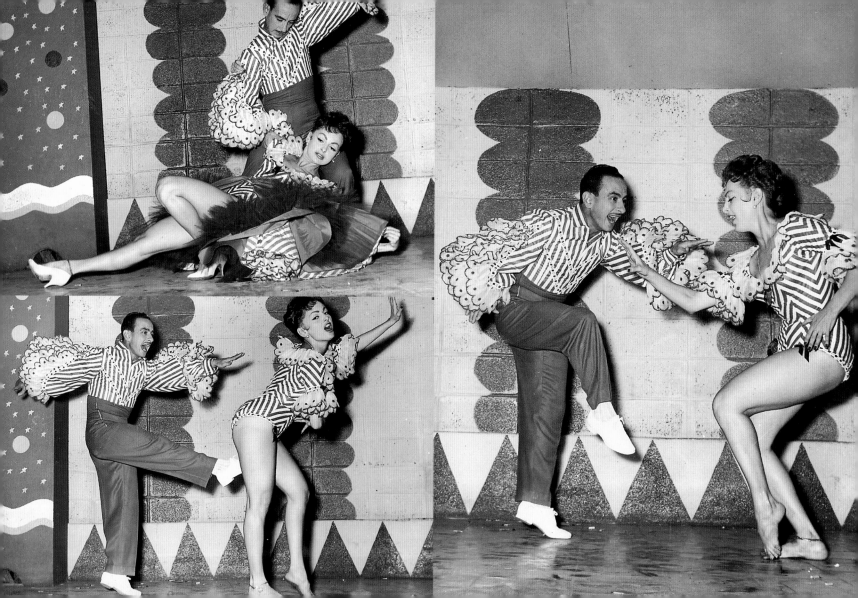

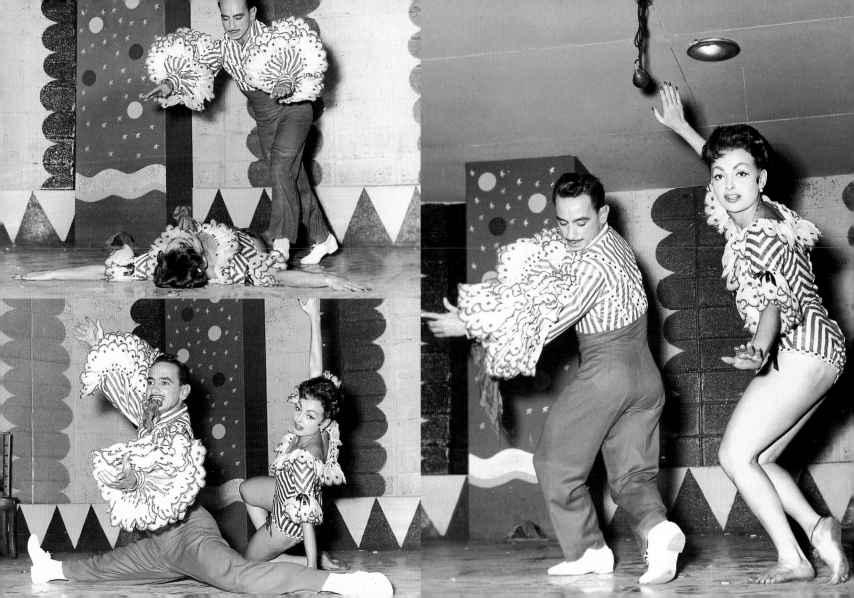

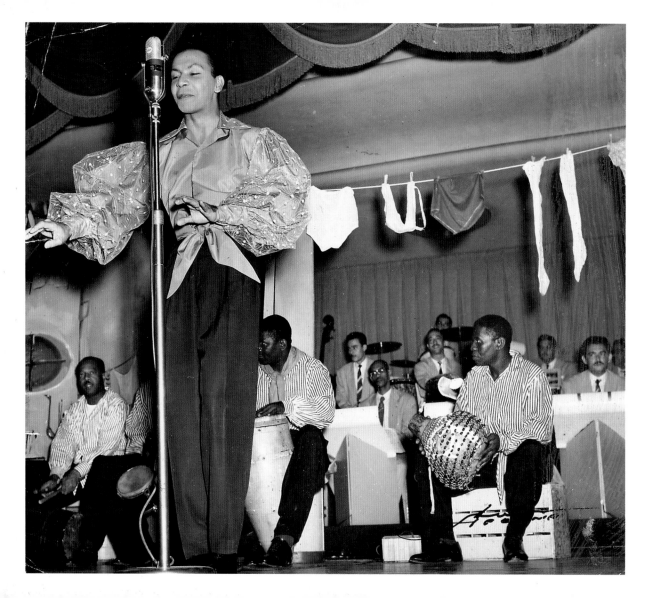

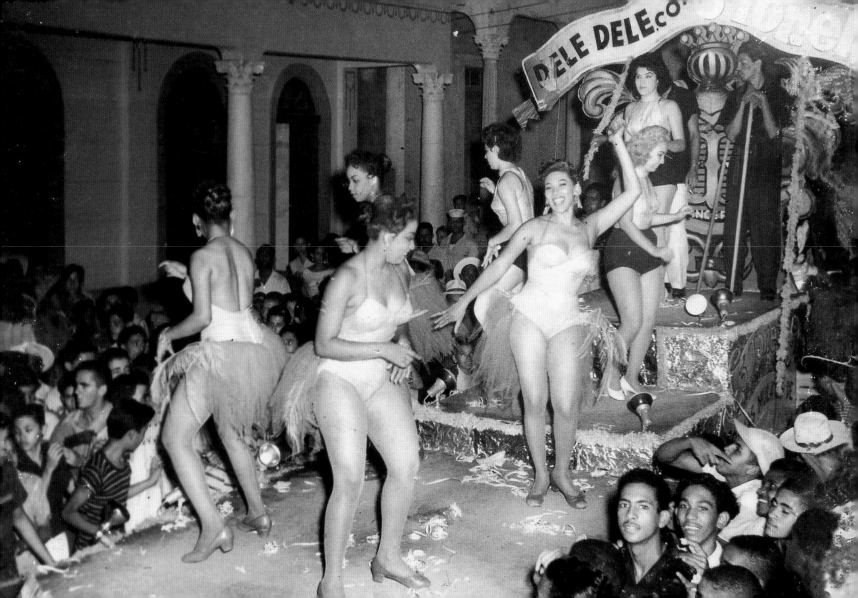

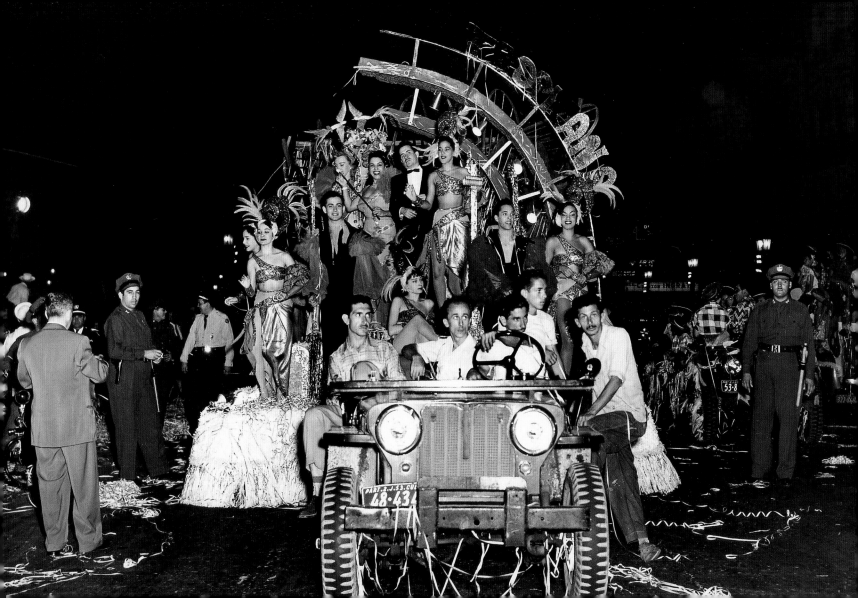

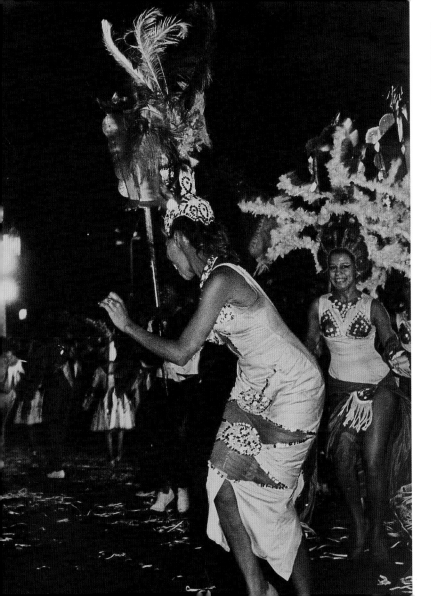
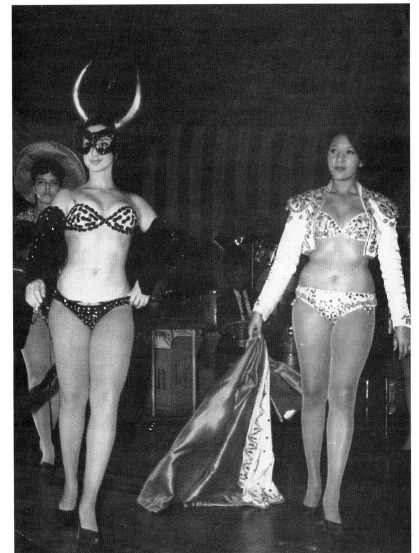

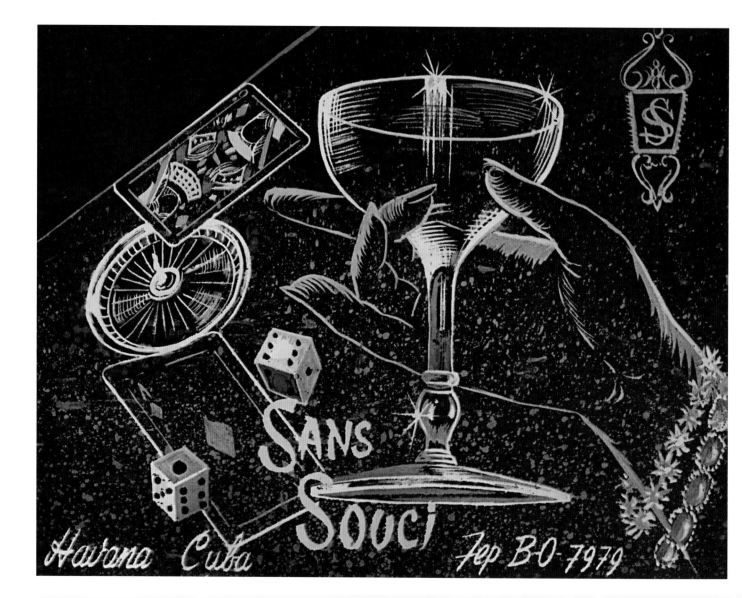

Sans
Souci

Havana Cuba Tep B-O-7979

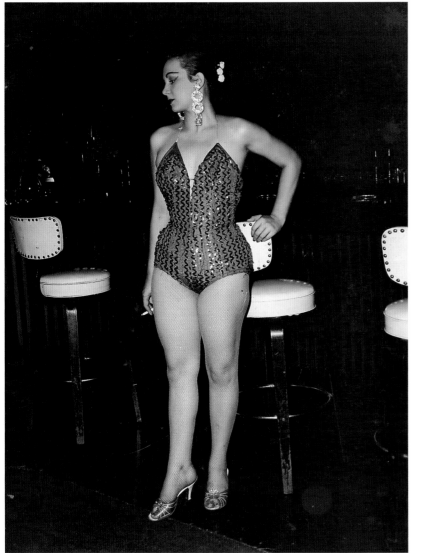
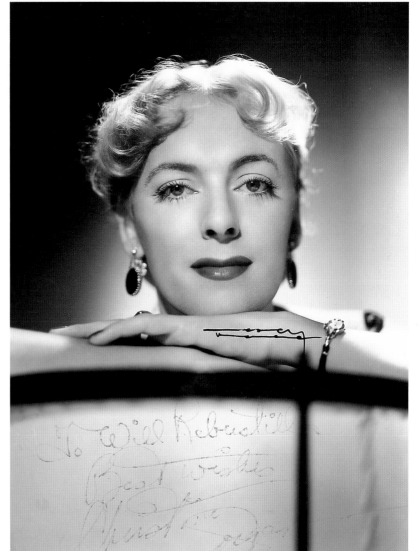

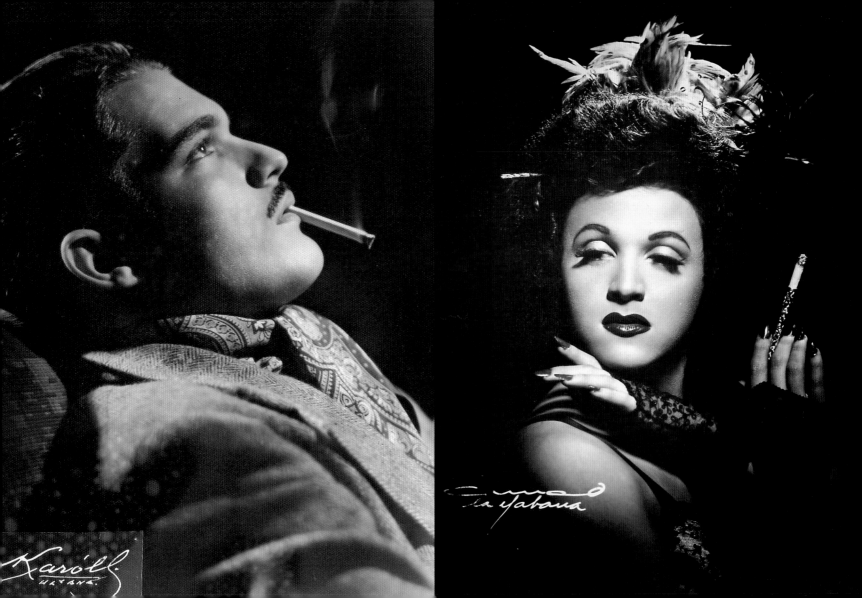

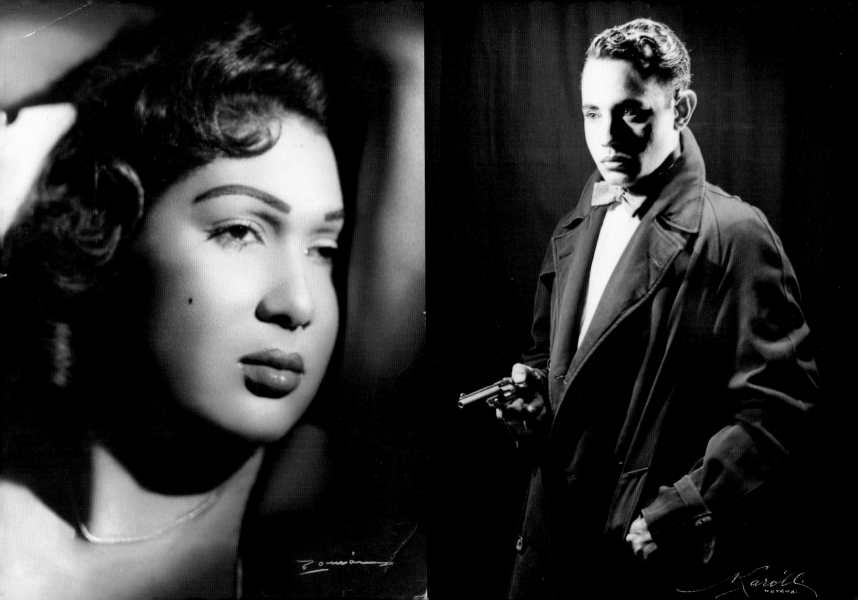

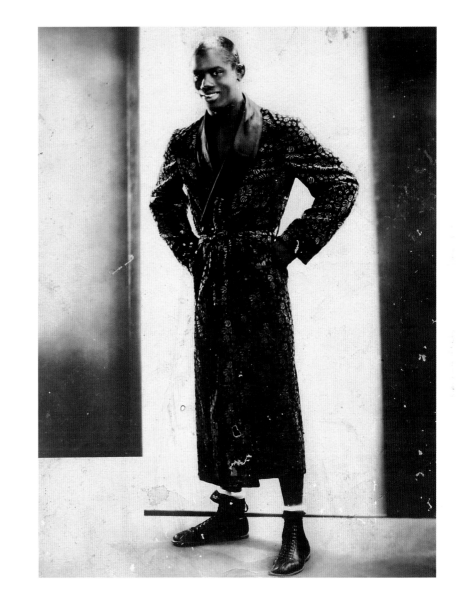

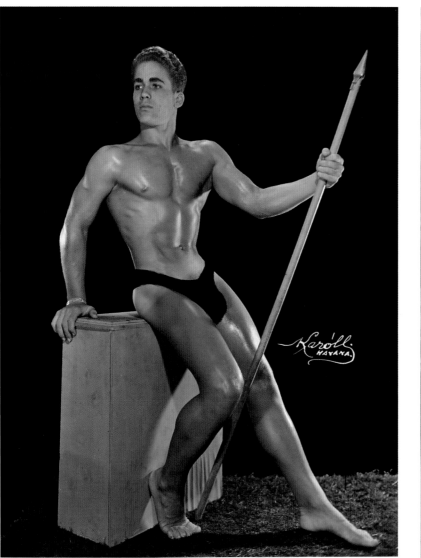
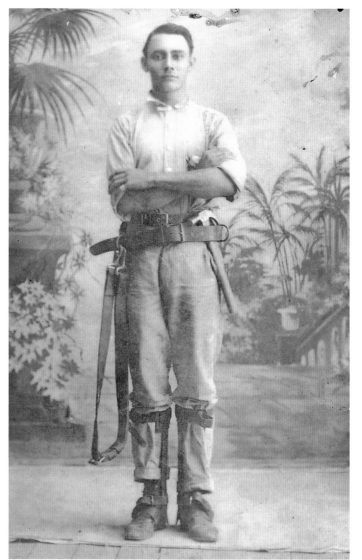

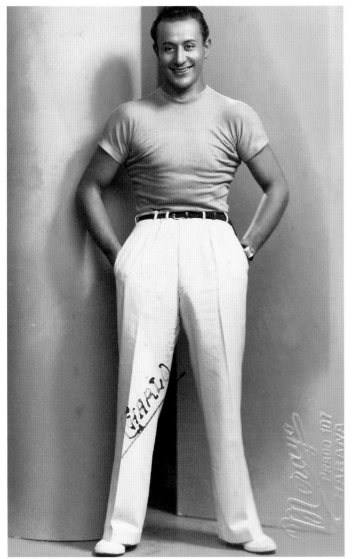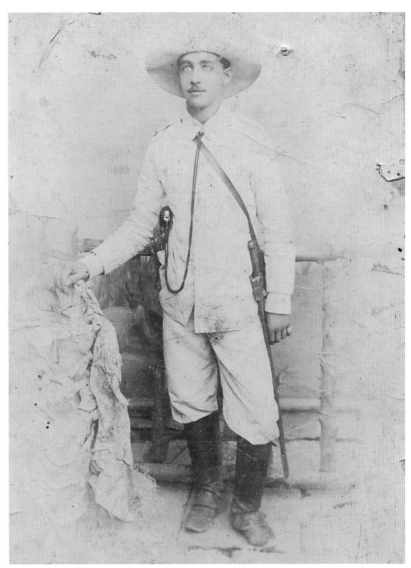

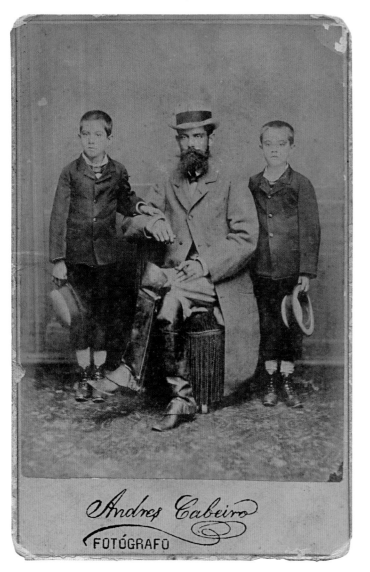

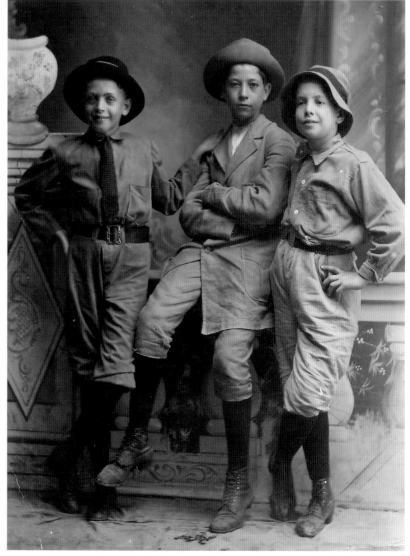

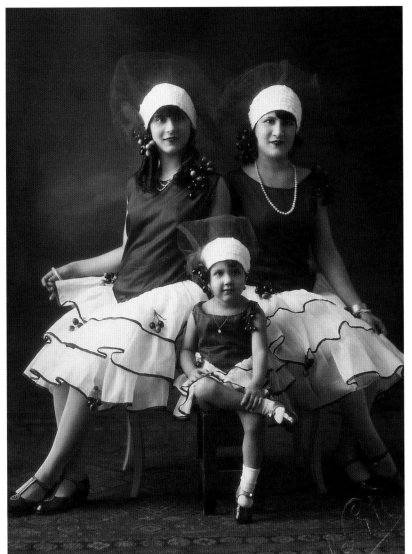
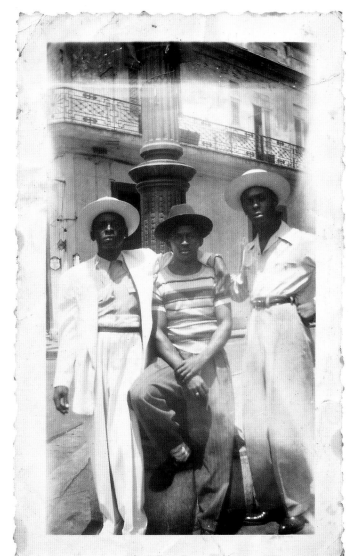

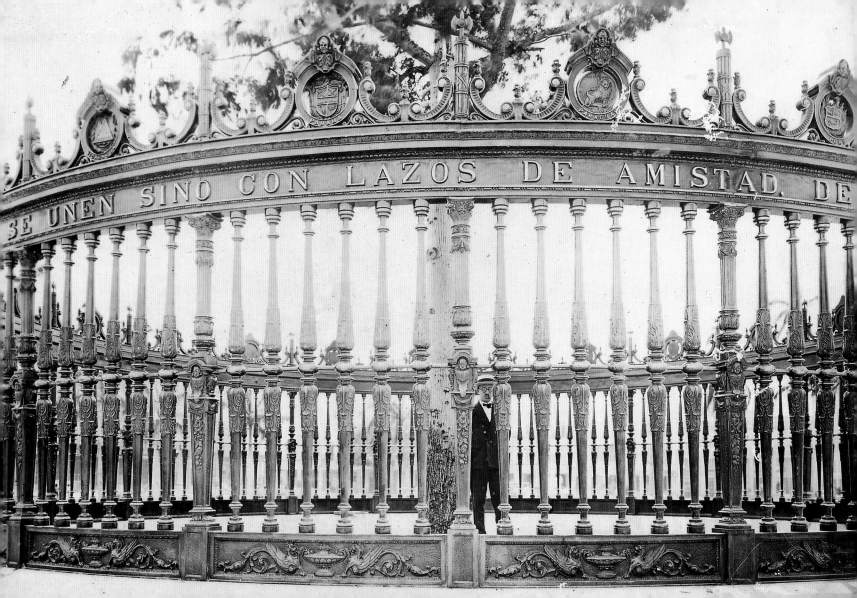

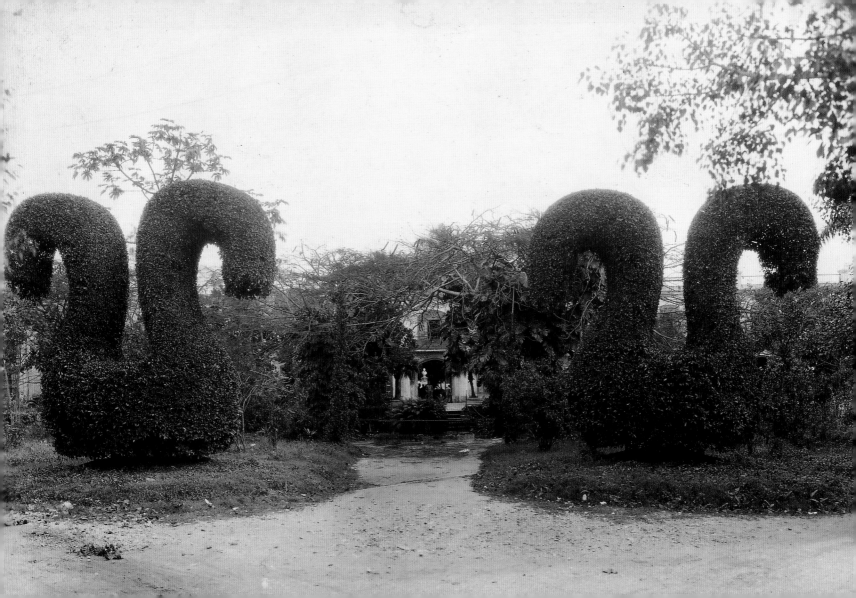

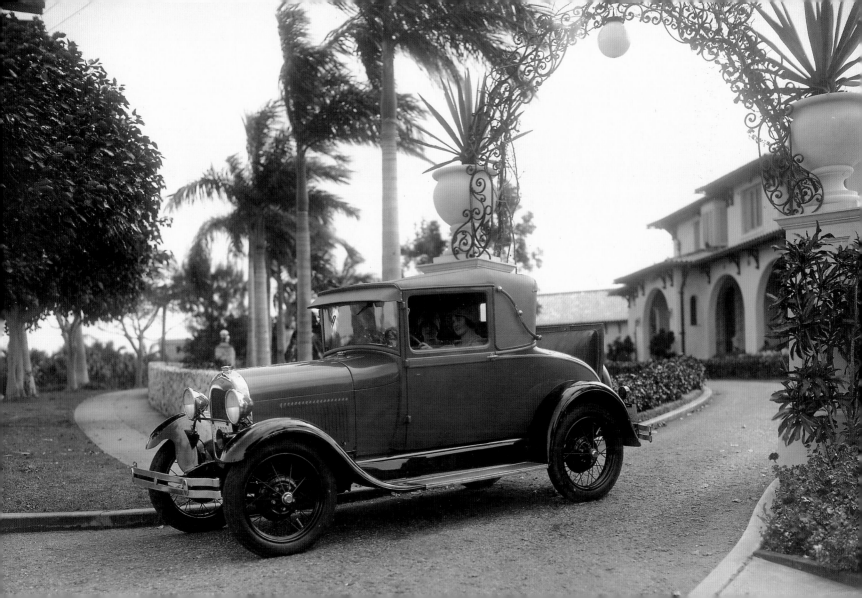

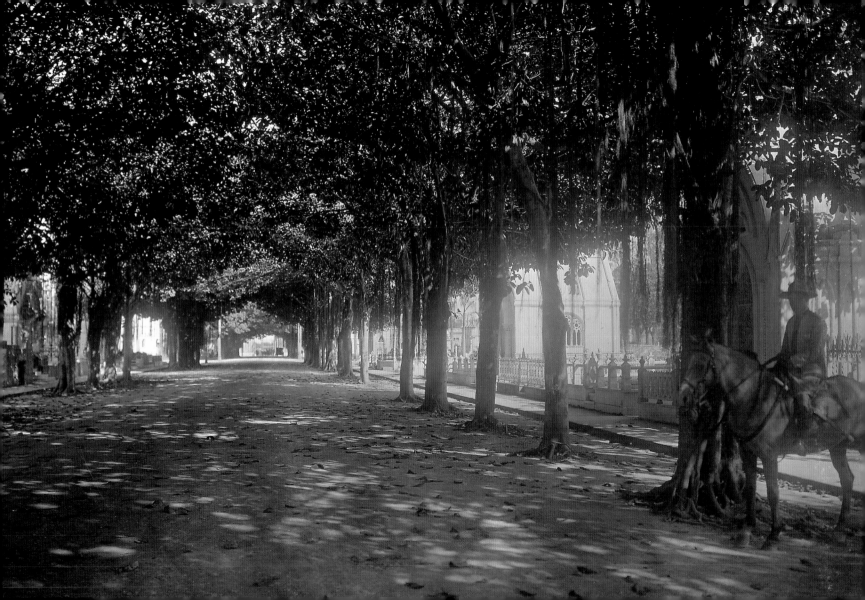

TREES HAVE A SECRET LIFE THAT IS ONLY REVEALED TO THOSE WILLING TO CLIMB THEM. TO CLIMB A TREE IS TO SLOWLY DISCOVER A UNIQUE WORLD, RHYTHMIC, MAGICAL, AND HARMONIOUS, WITH ITS WORMS, INSECTS, BIRDS, AND OTHER LIVING THINGS, ALL APPARENTLY INSIGNIFICANT CREATURES, TELLING US THEIR SECRETS.

From *Antes que anochezca (Before Night Falls)*

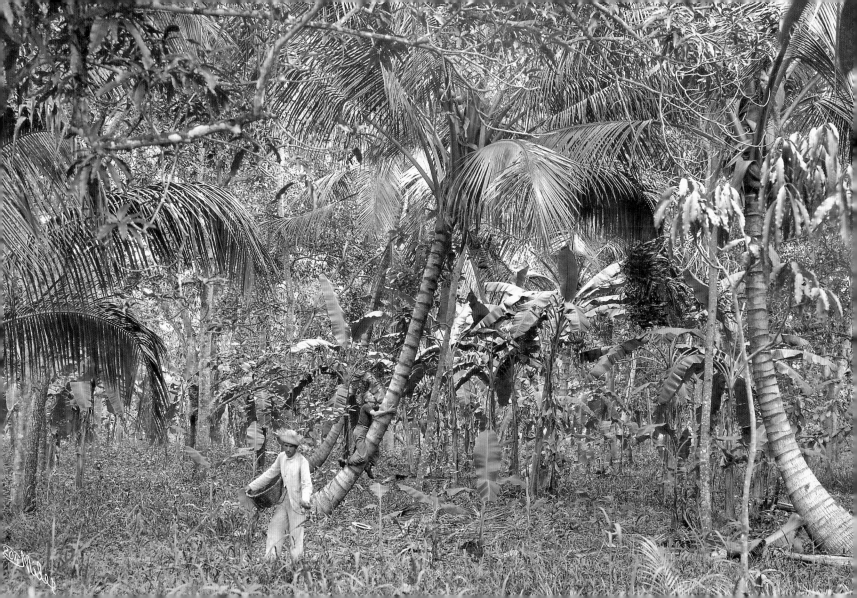

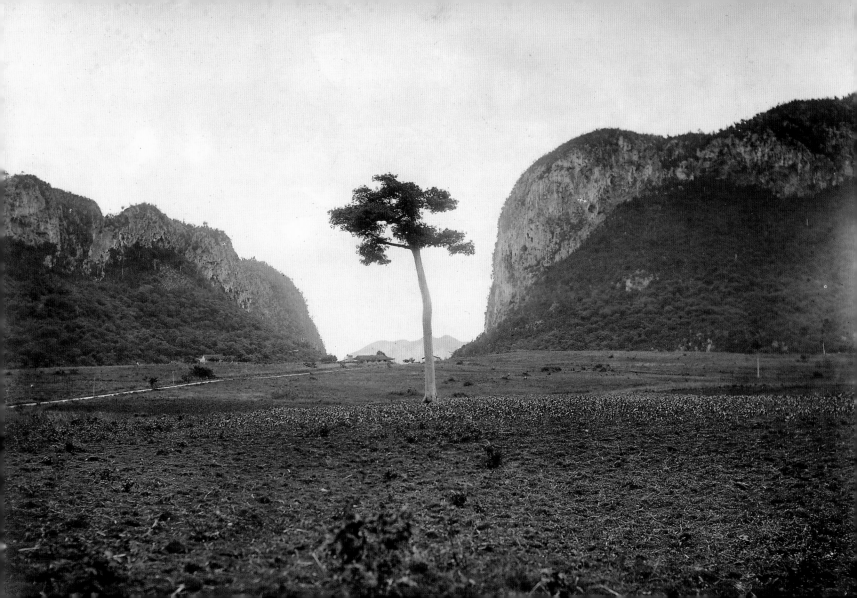

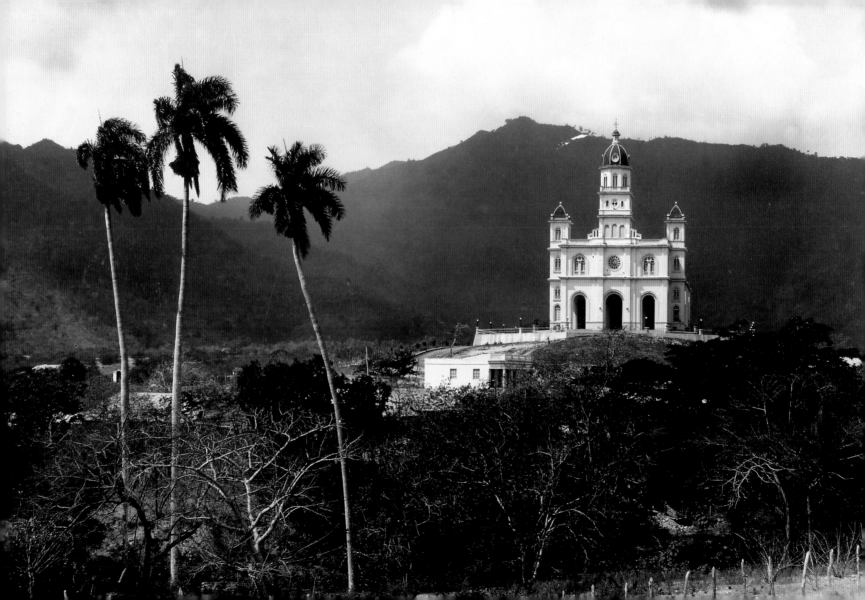

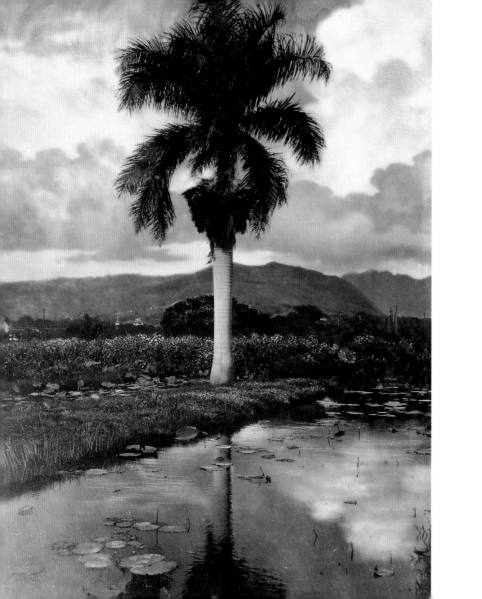

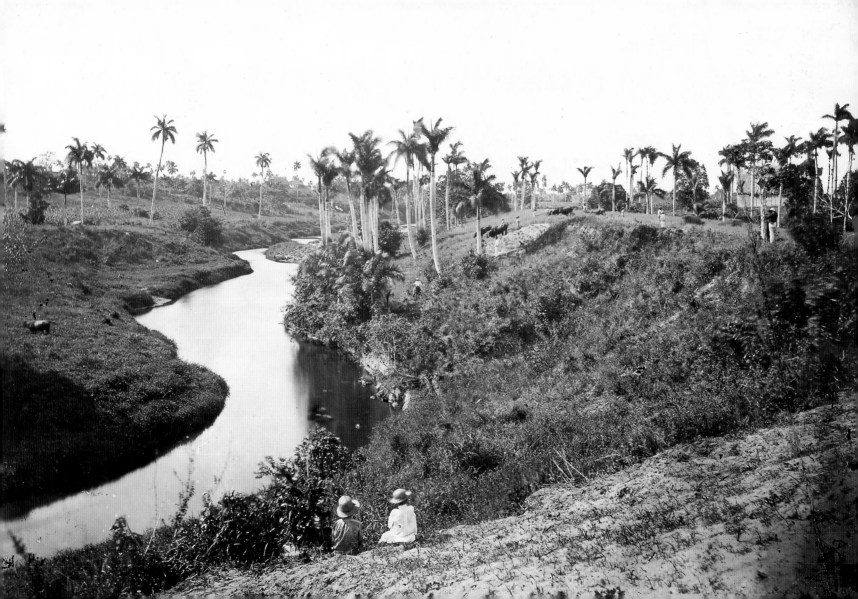

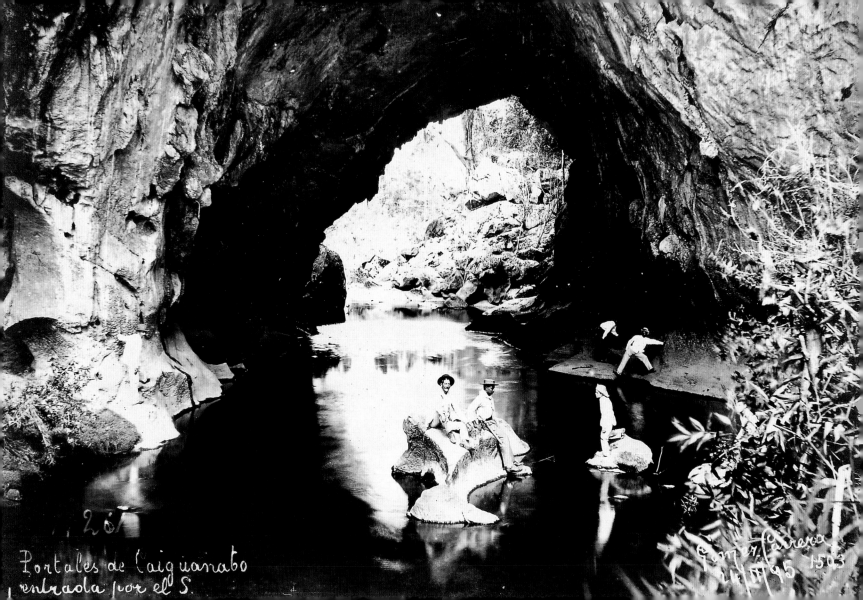

Portales de Caiguanabo
, entrada por el S.

Gómez Carrera
1895 1503

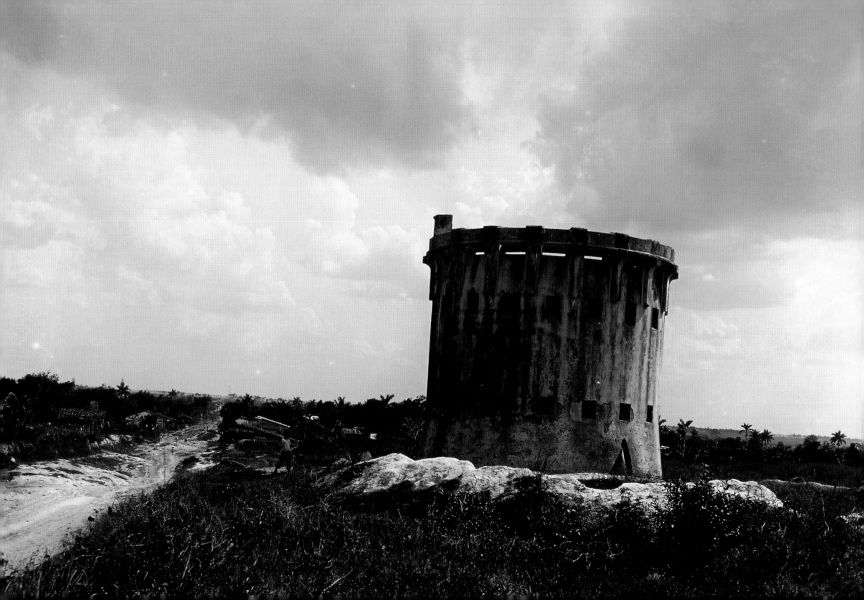

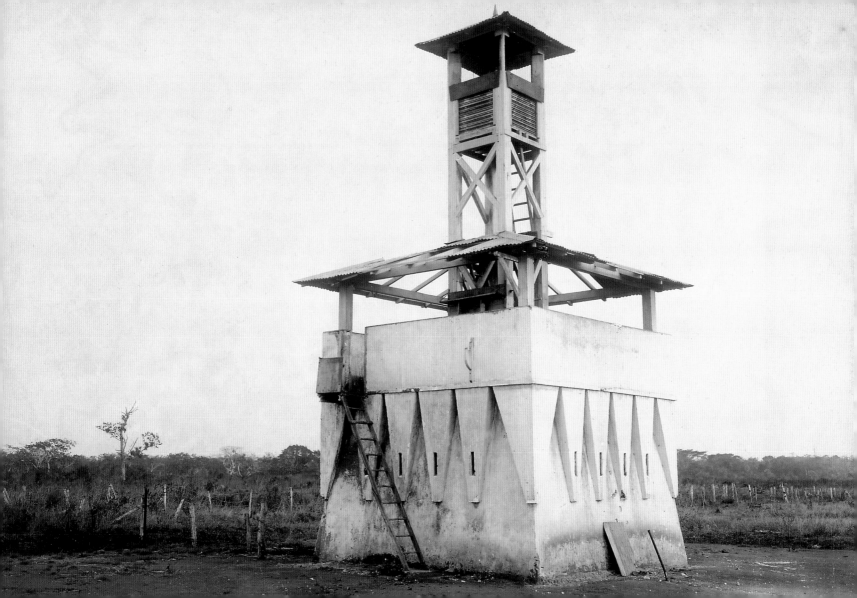

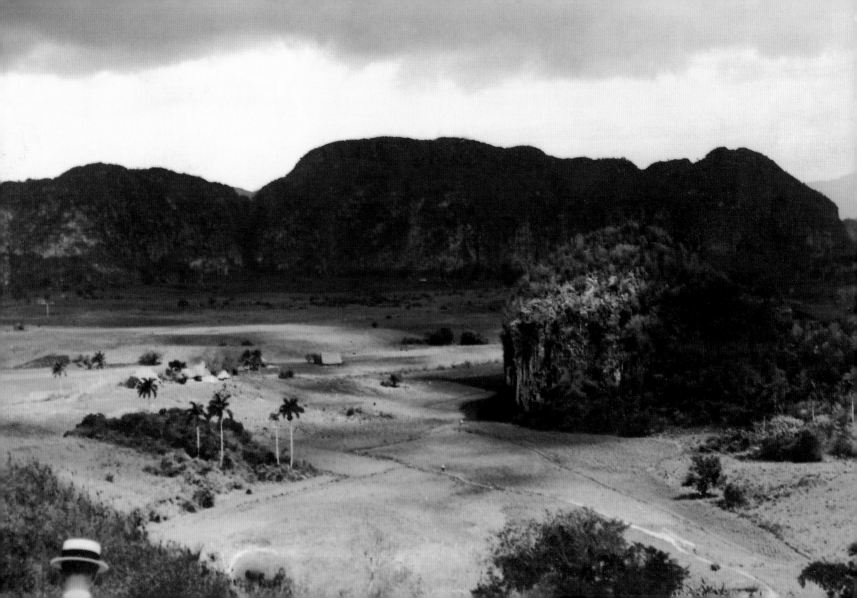

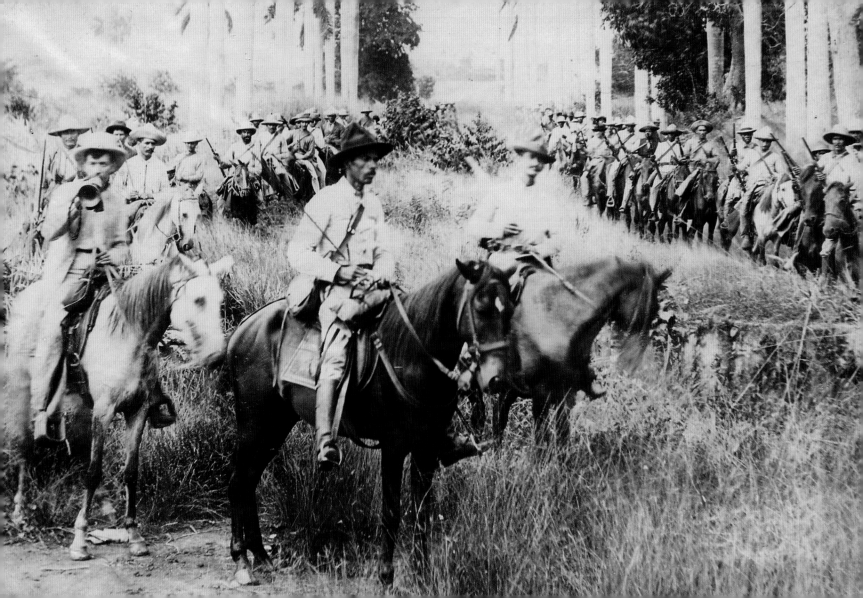

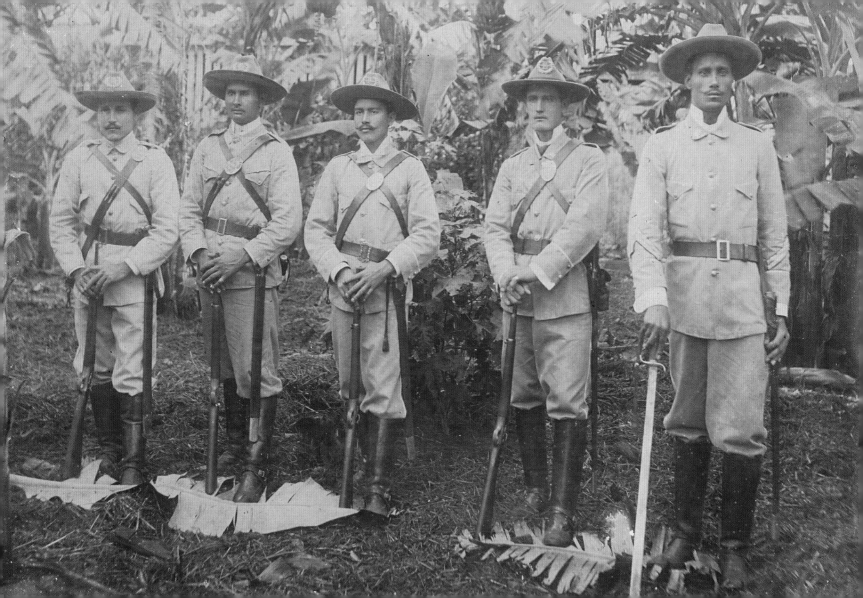

SUGARCANE HAS ALWAYS BEEN FOR US AN AGGRESSIVE PLANT,

FOREIGN AND INVASIVE, LINKED TO SLAVERY, EXPLOITATION, AND POWER;

THE PALM TREE, ON THE CONTRARY, ASSUMES ITS UNDEMANDING

AND INDIGENOUS FRESHNESS IN ITS FREE, TALL, AND SLENDER TRUNK,

SWAYING RHYTHMICALLY IN THE BREEZE.

From *Necesidad de libertad* (*Need of Freedom*)

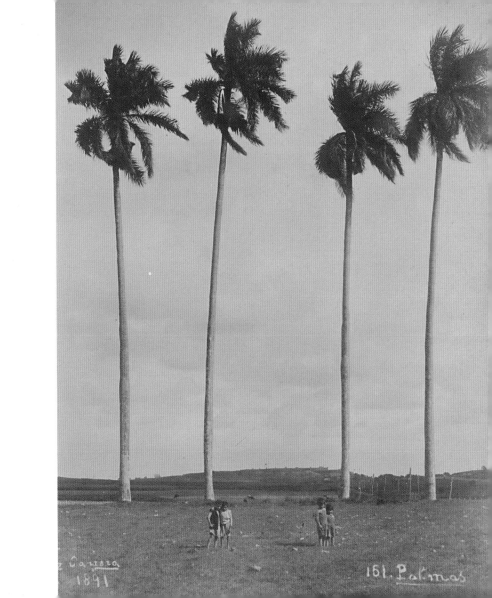

Carrero
1891

151. Palmas

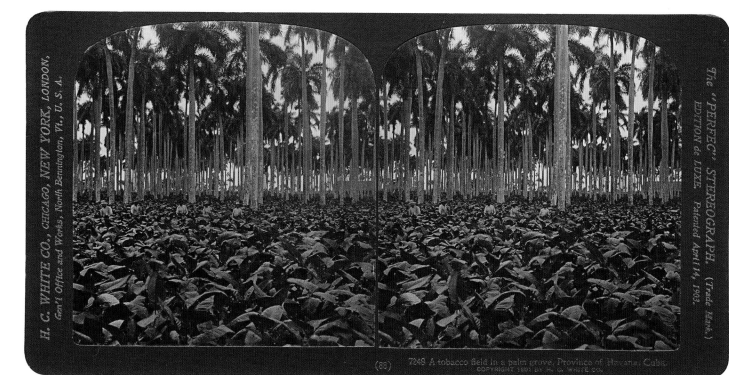

(86) 7248 A tobacco field in a palm grove, Province of Havana, Cuba.
COPYRIGHT 1901 BY H. C. WHITE CO.

7245 Cuban Boys, Province of Havana, Cuba.
COPYRIGHT 1901, BY H. C. WHITE CO.

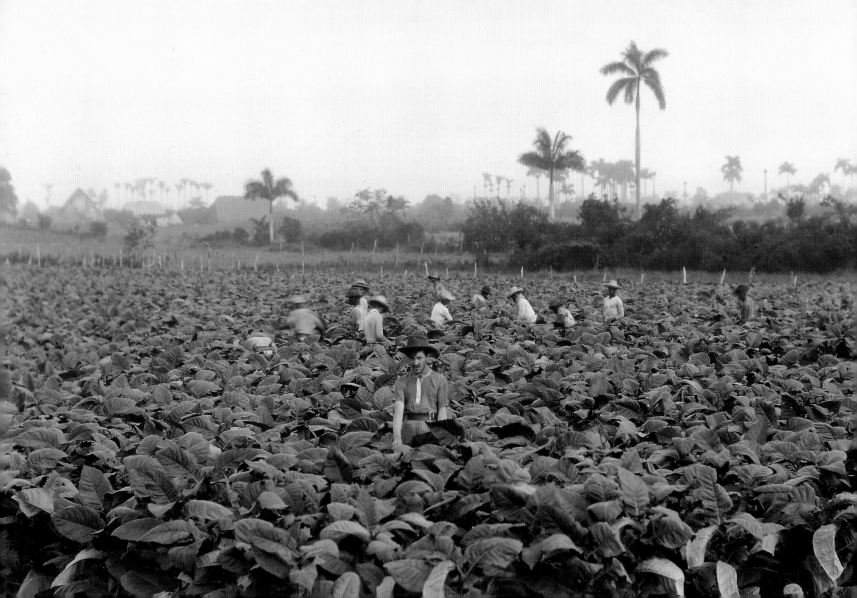

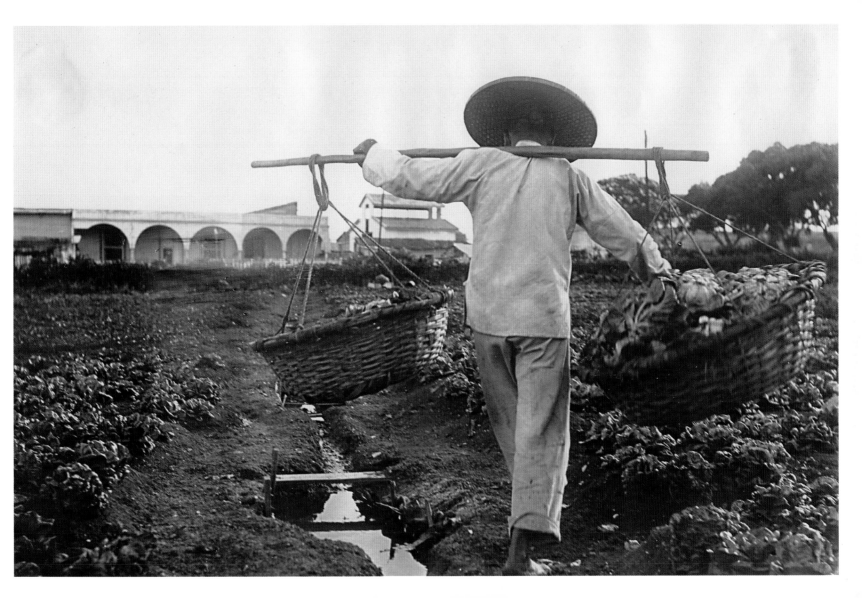

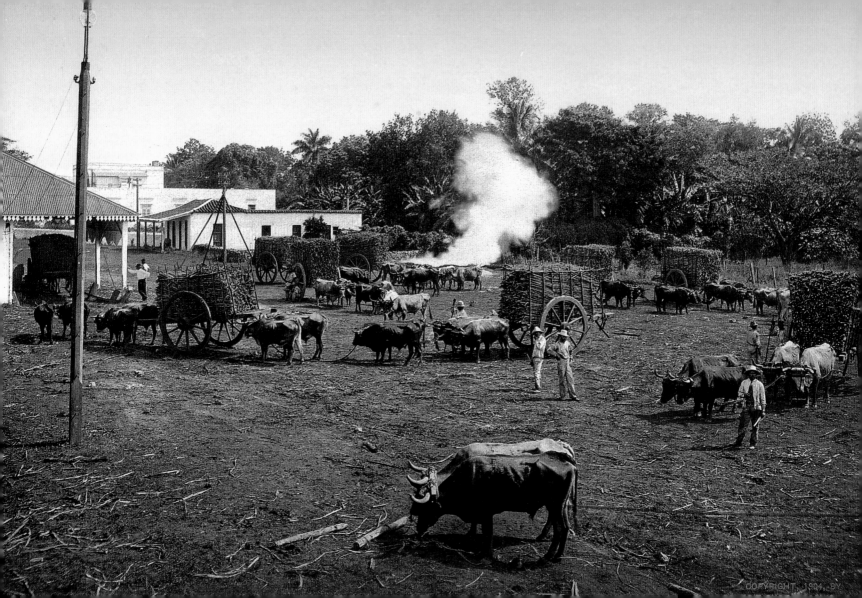

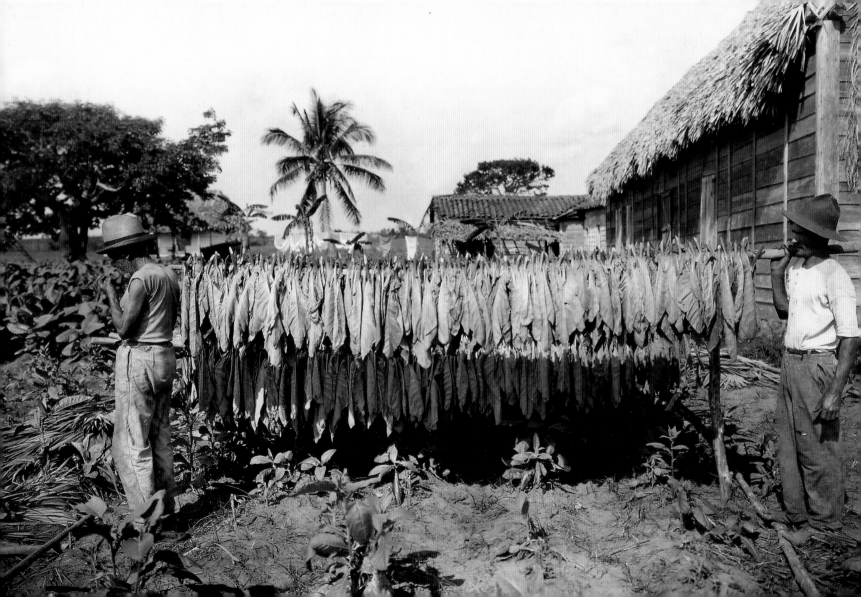

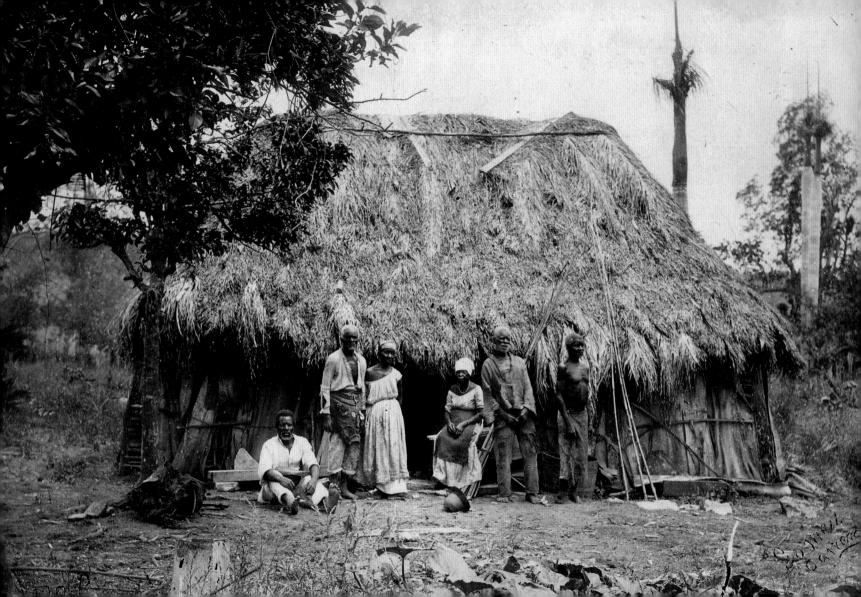

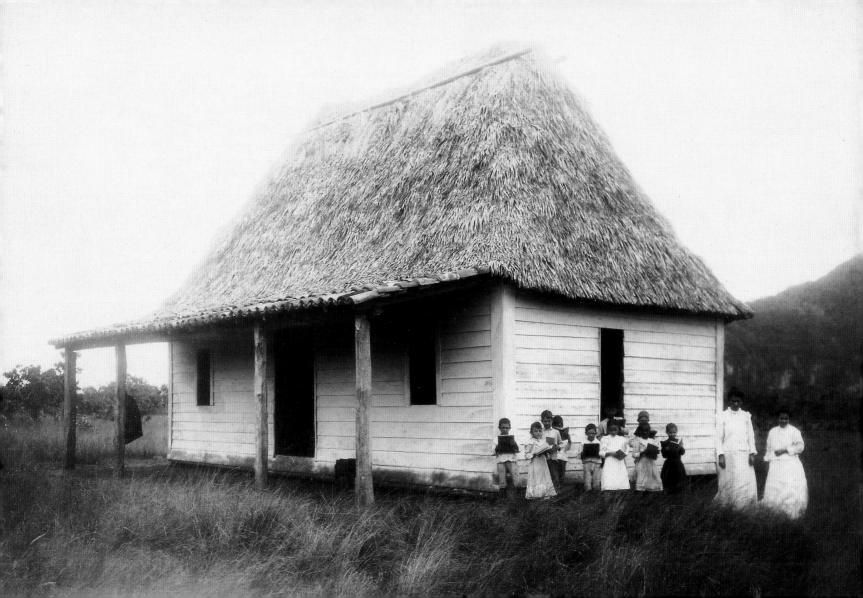

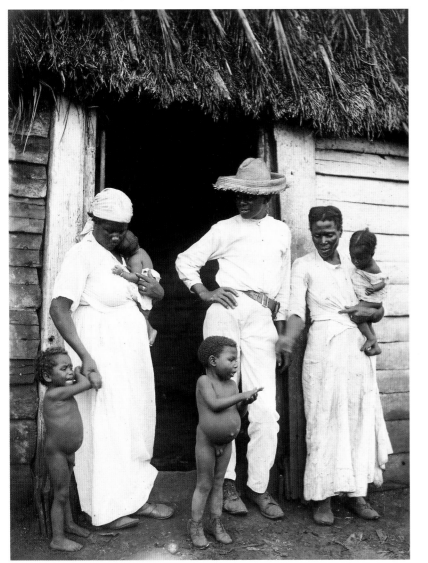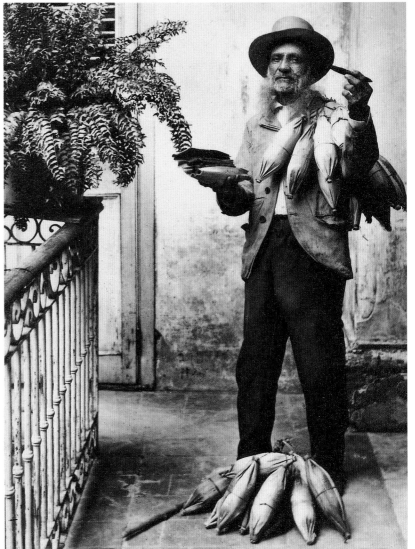

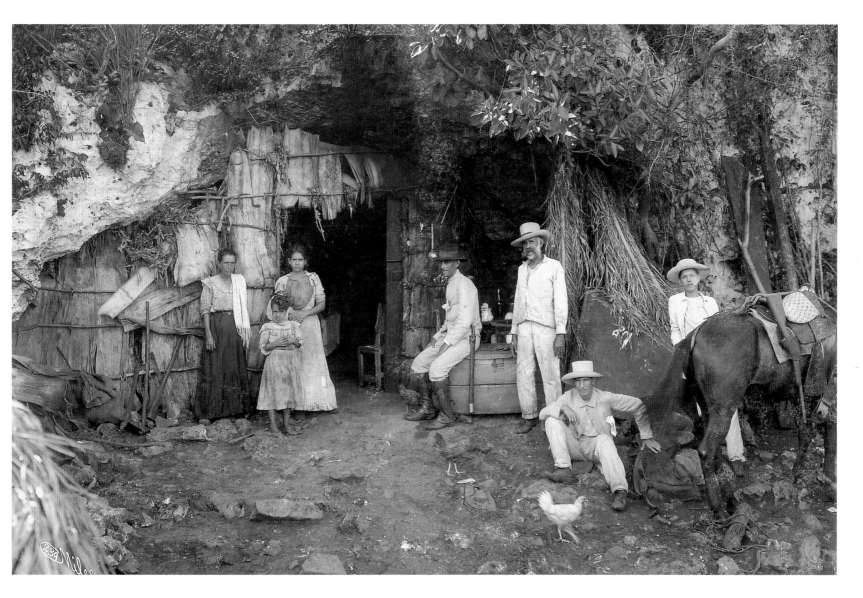

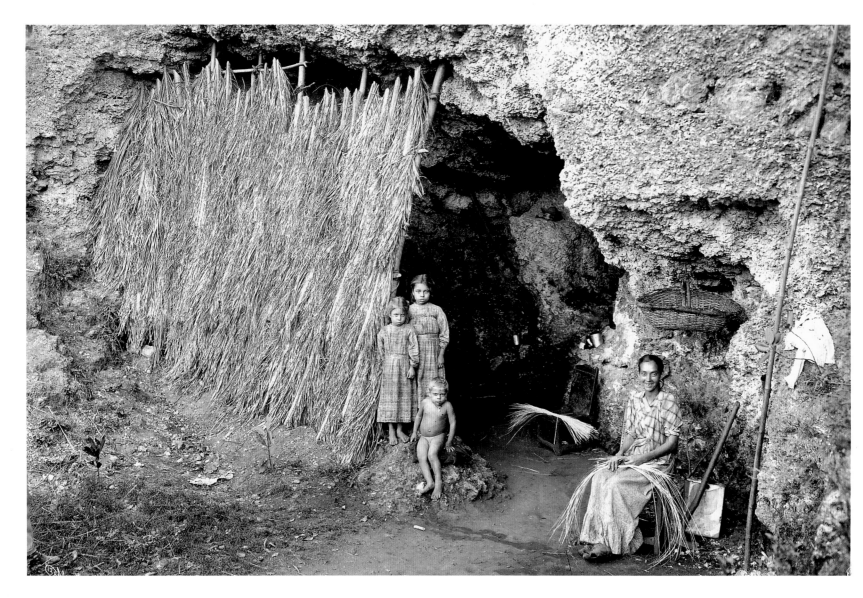

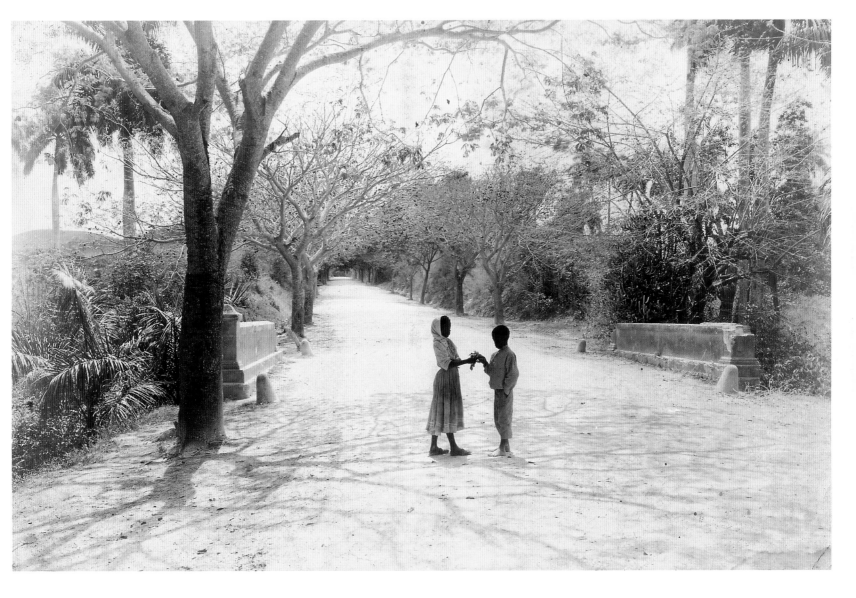

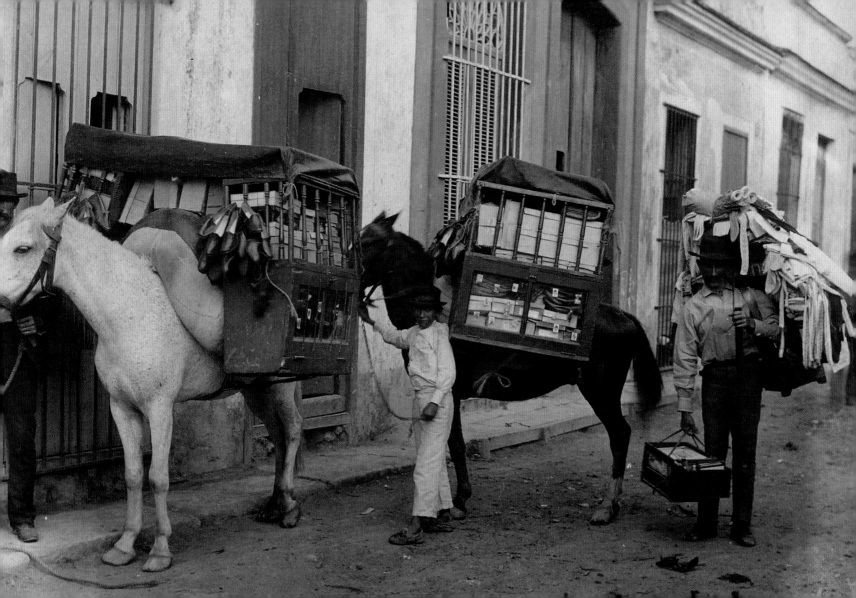

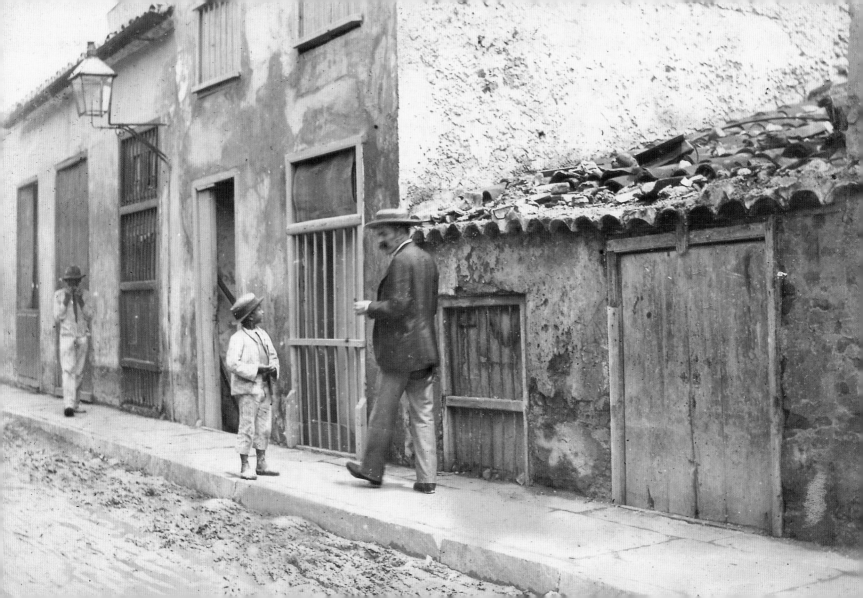

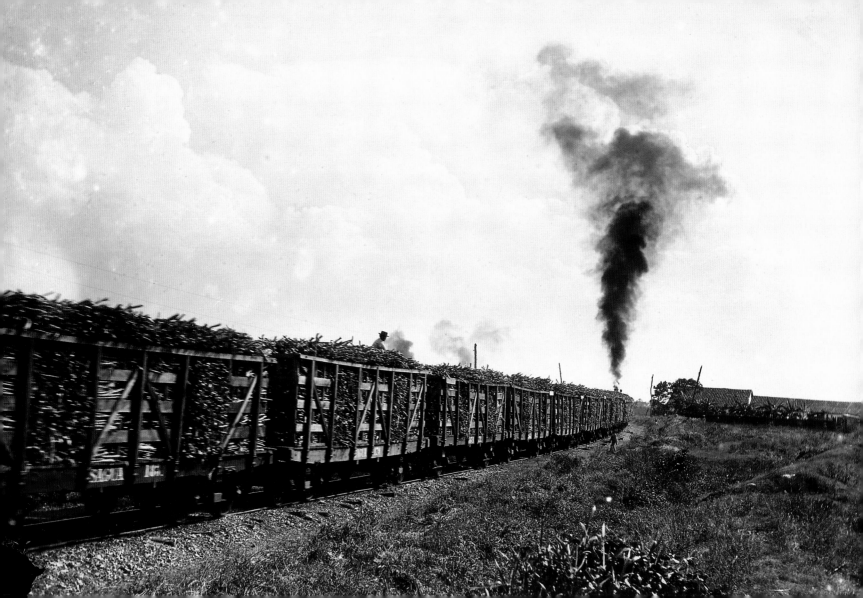

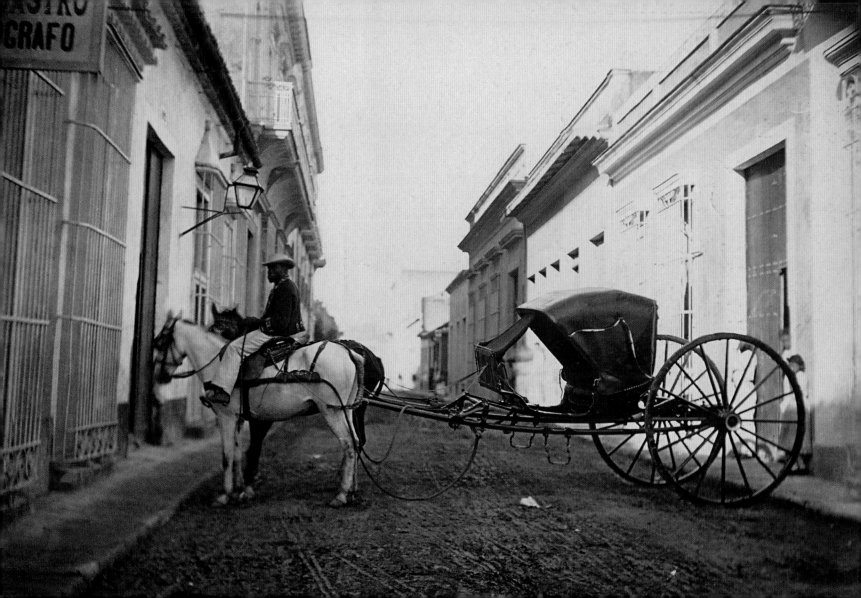

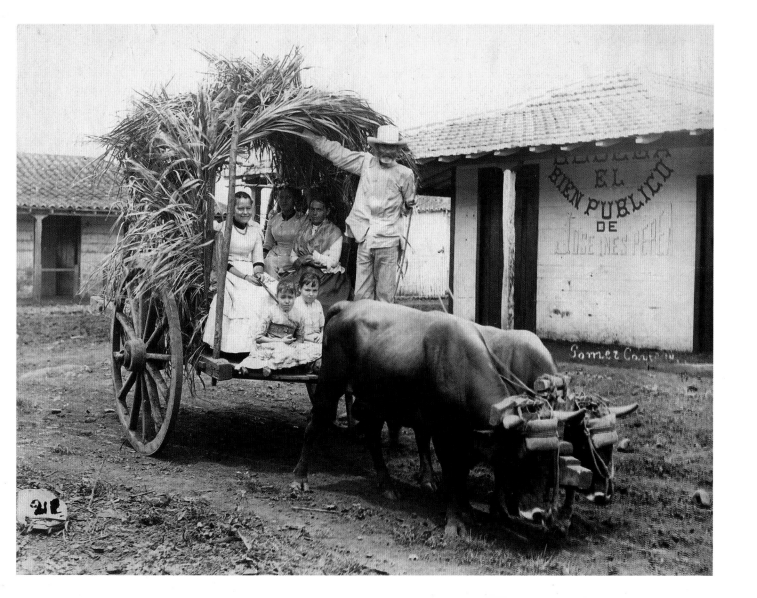

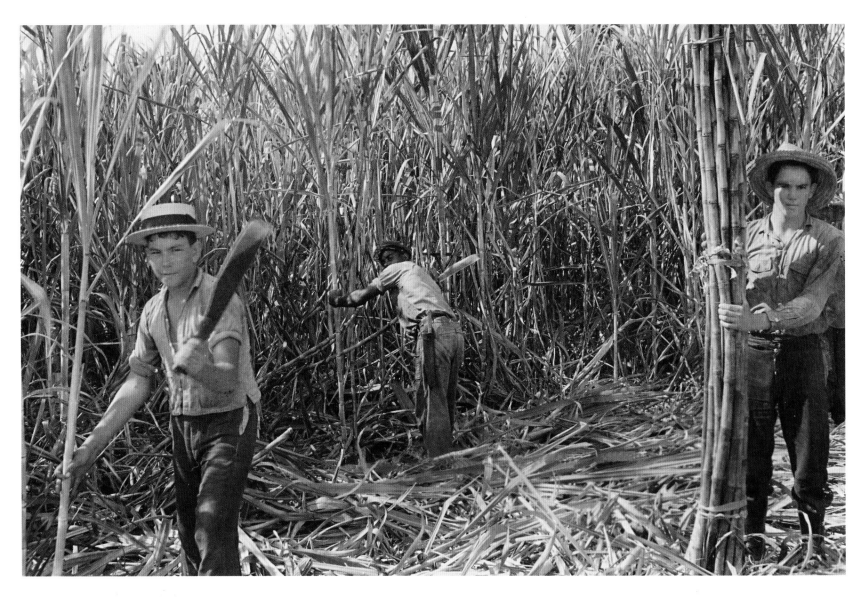

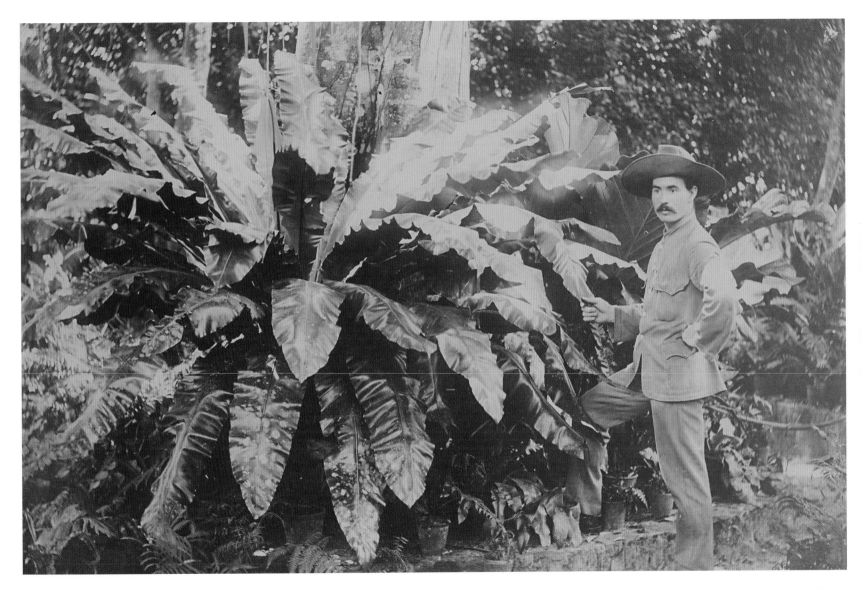

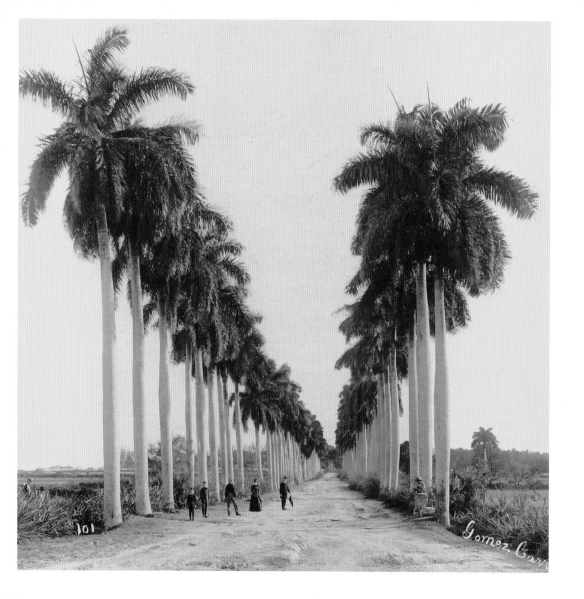

101

Gomez Garc

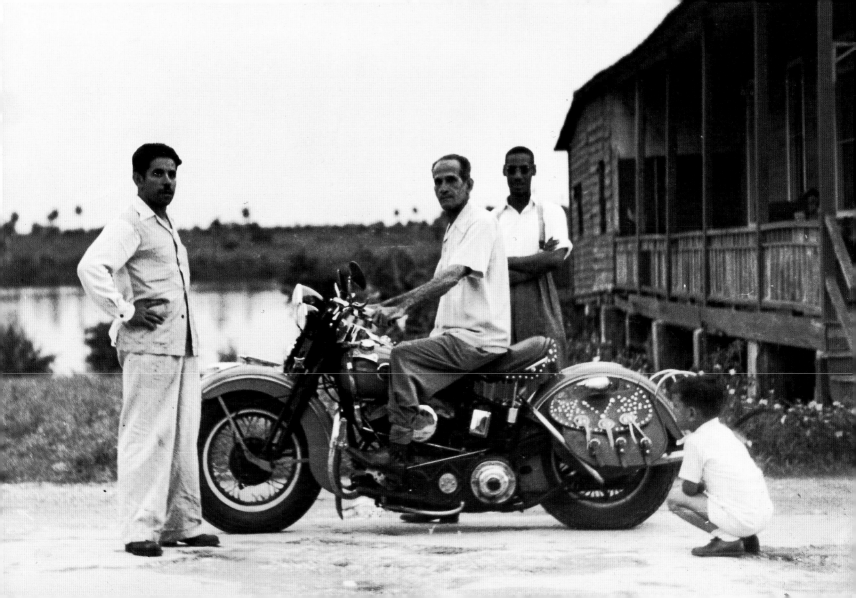

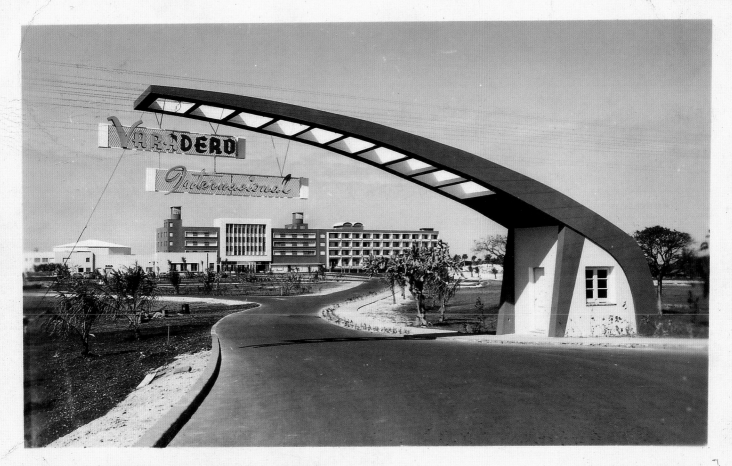

HOTEL VARADERO INTERNACIONAL, CUBA

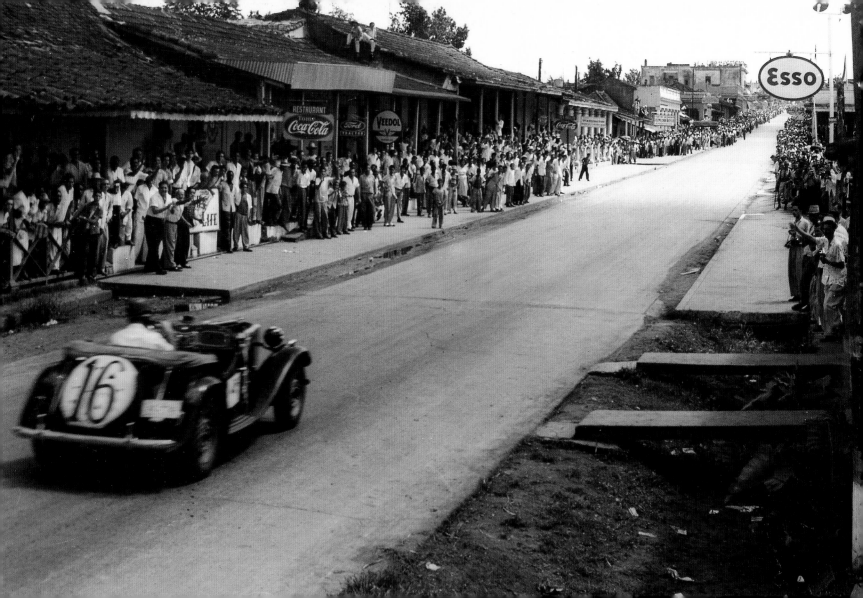

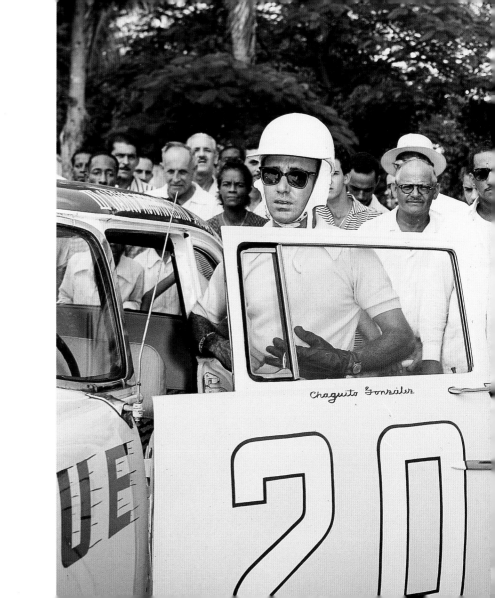

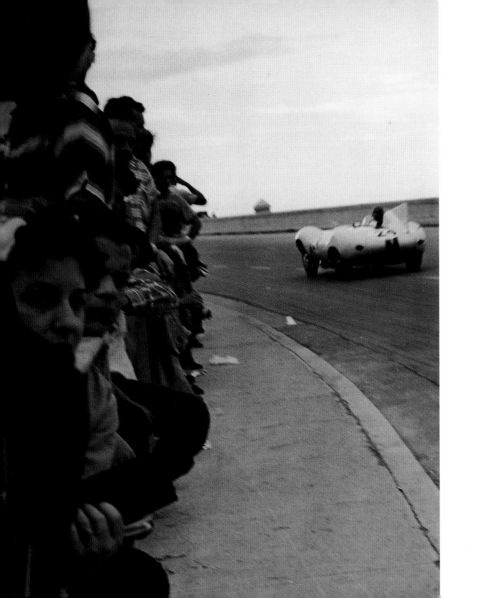

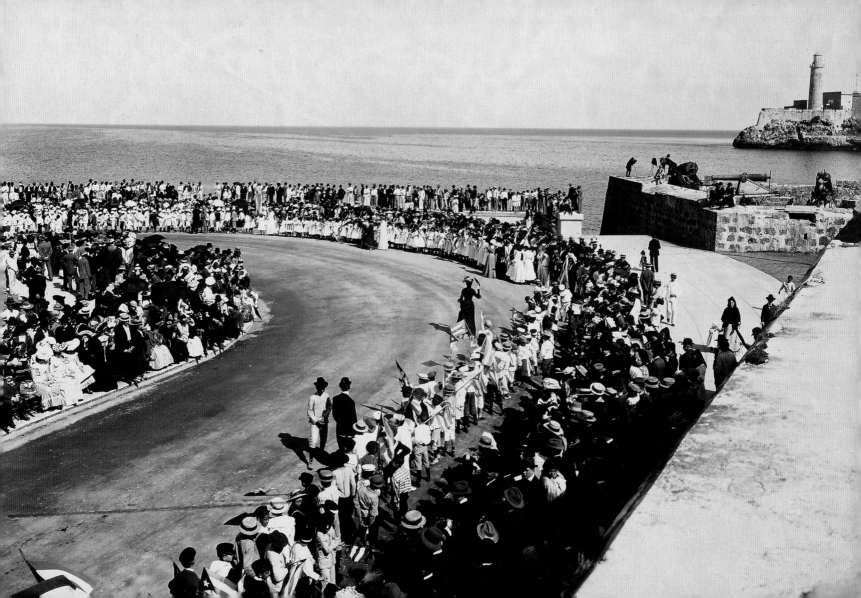

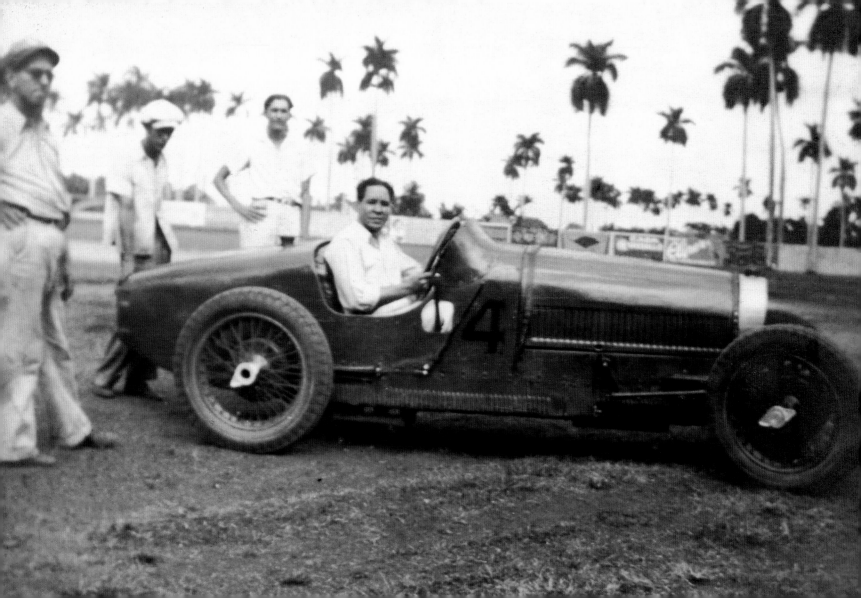

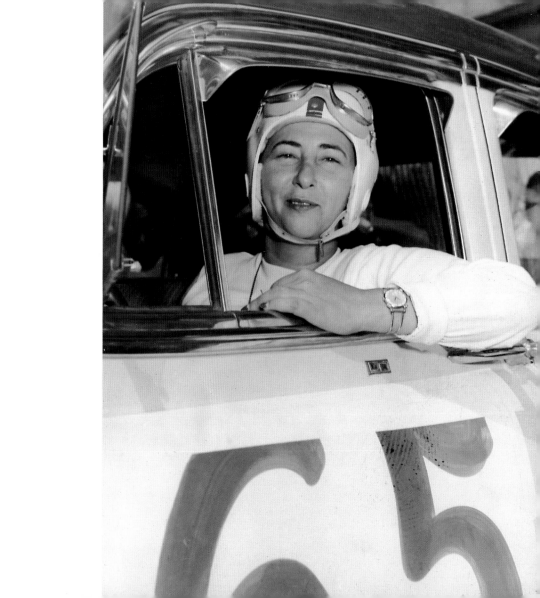

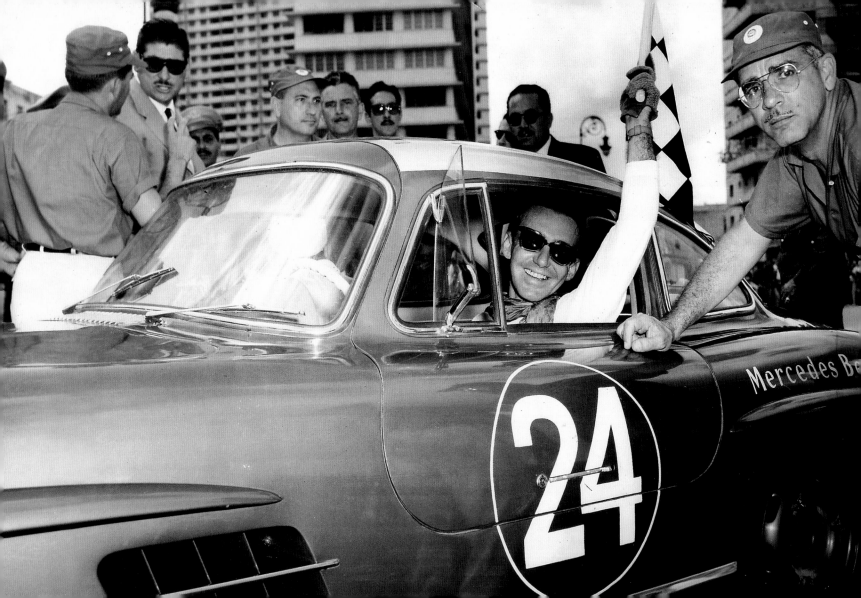

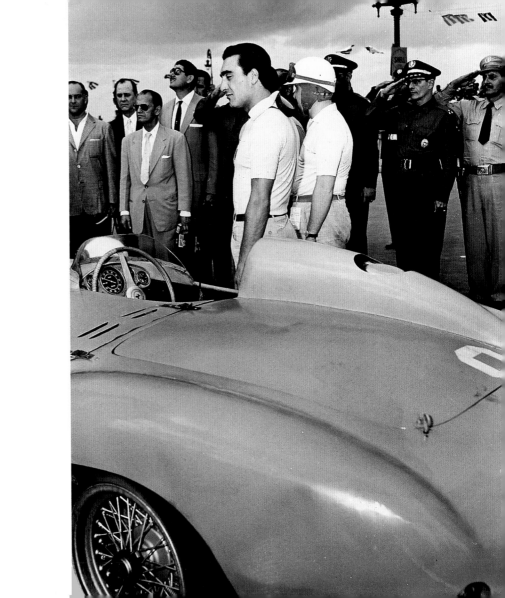

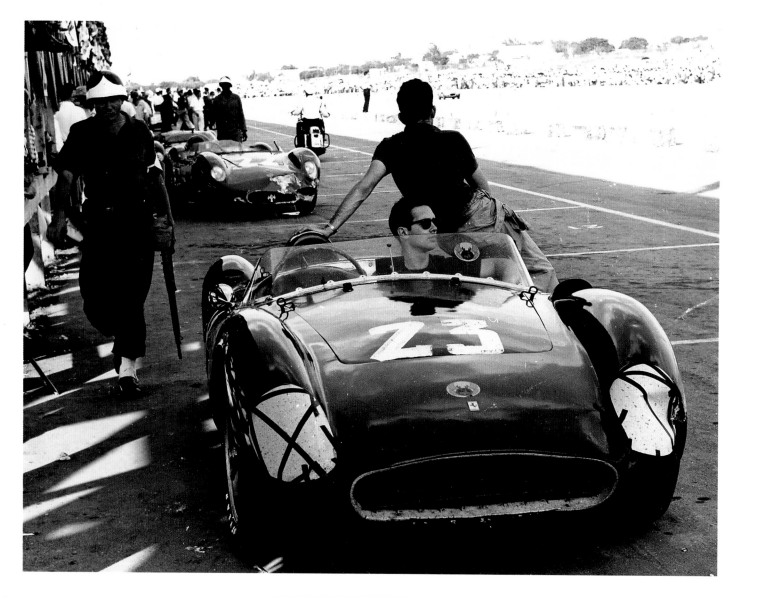

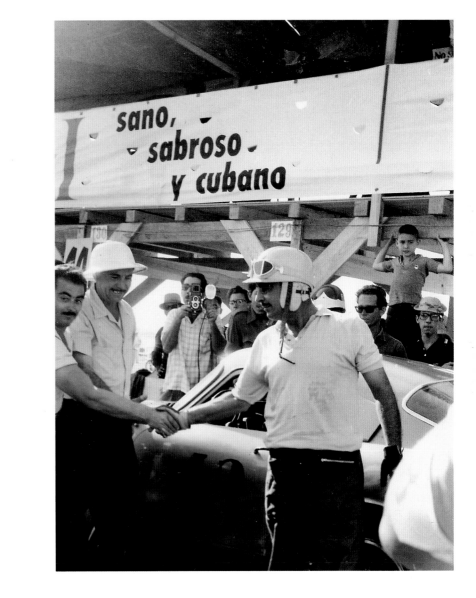

THIS IS MY MOTTO: LIVE TO THE HILT (AND THEREFORE ALWAYS IN DANGER) FOR AN INSTANT, OR TWO OR THREE IF POSSIBLE, AND THEN PERISH. TO SOAR, WHILE STILL STRONG, UPON A RAY OF SUNLIGHT AND THEN, STILL ENTRANCED, TO FALL.

From *El portero (The Doorman)*

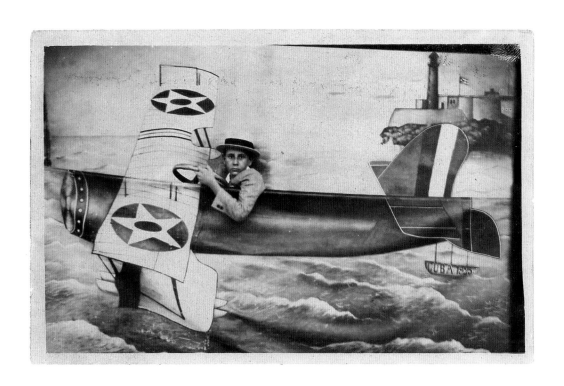

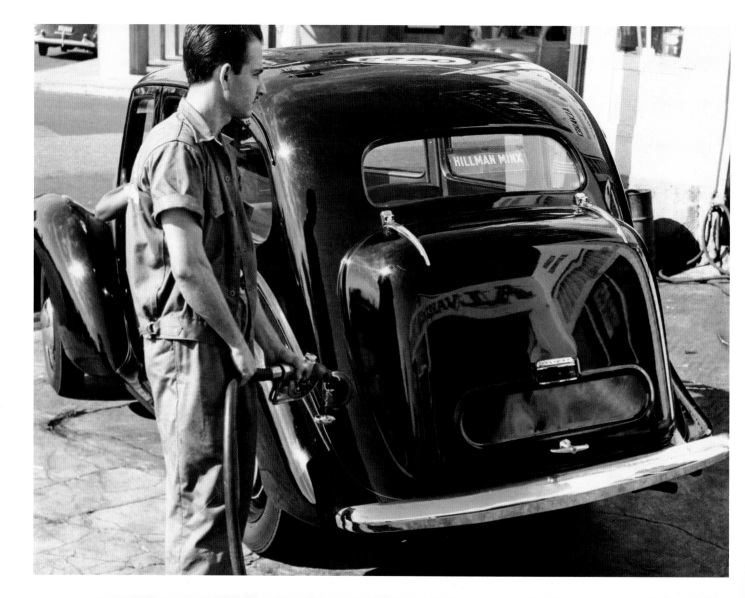

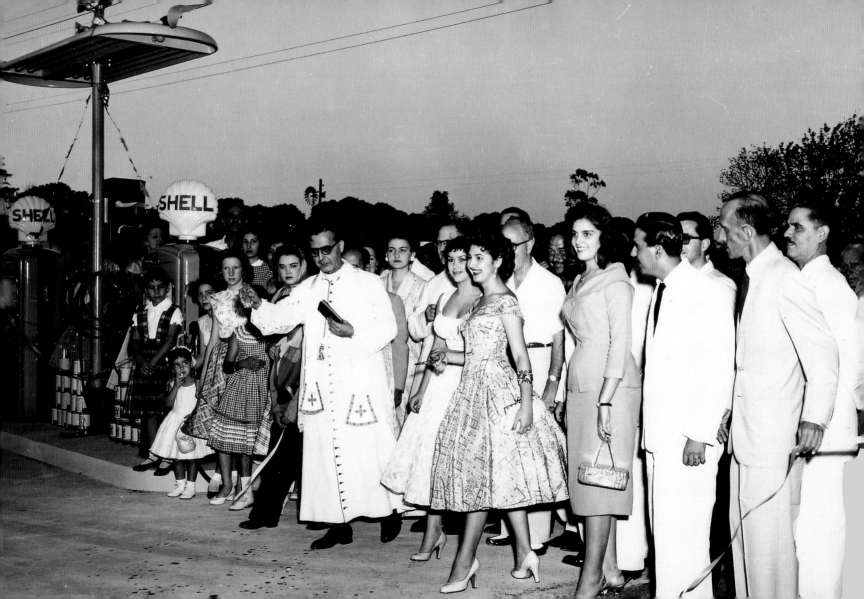

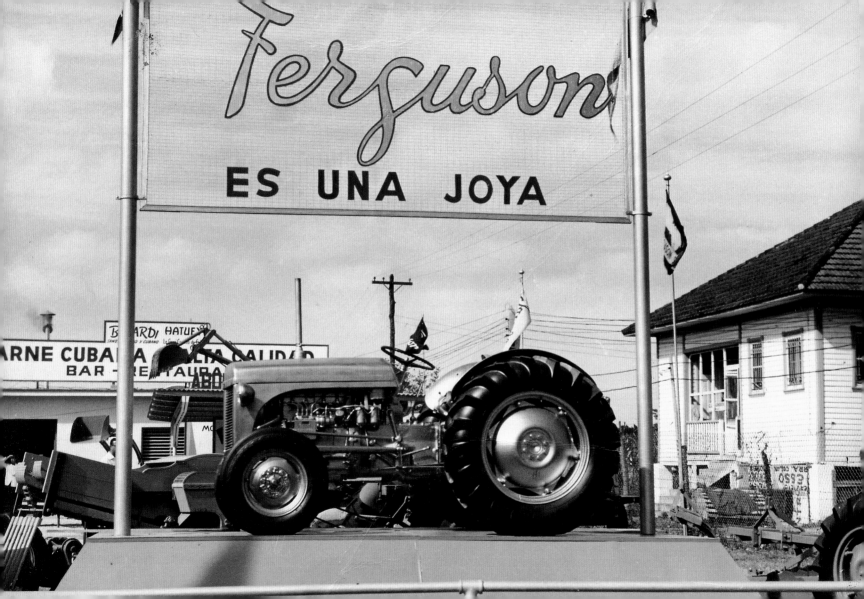

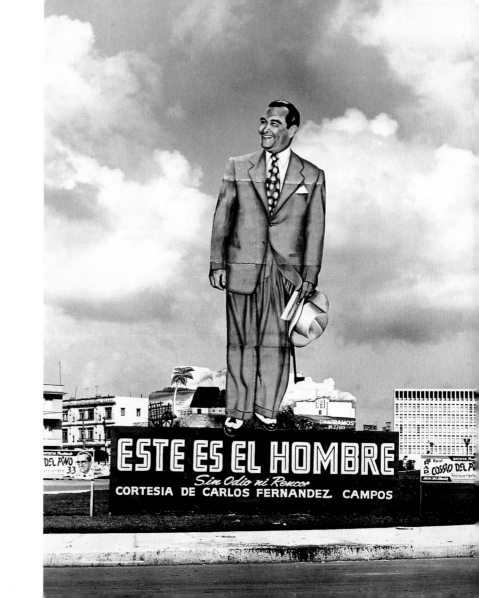

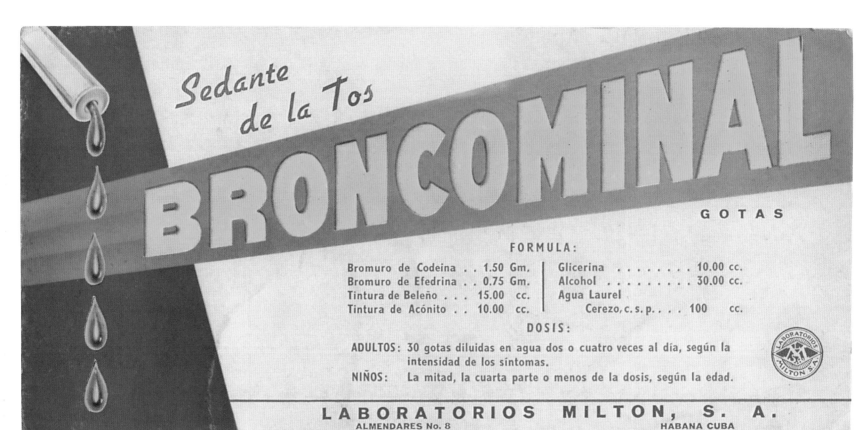

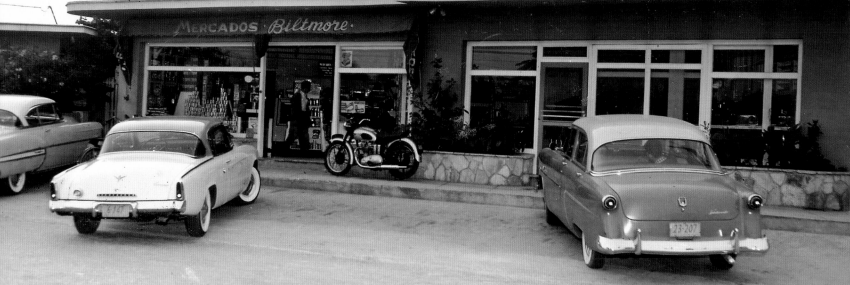

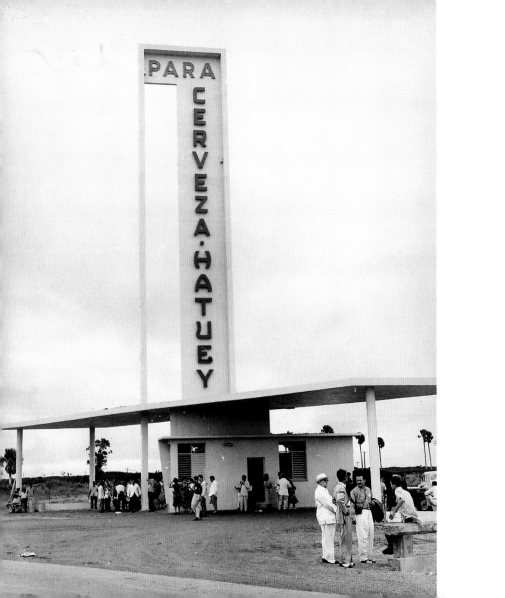

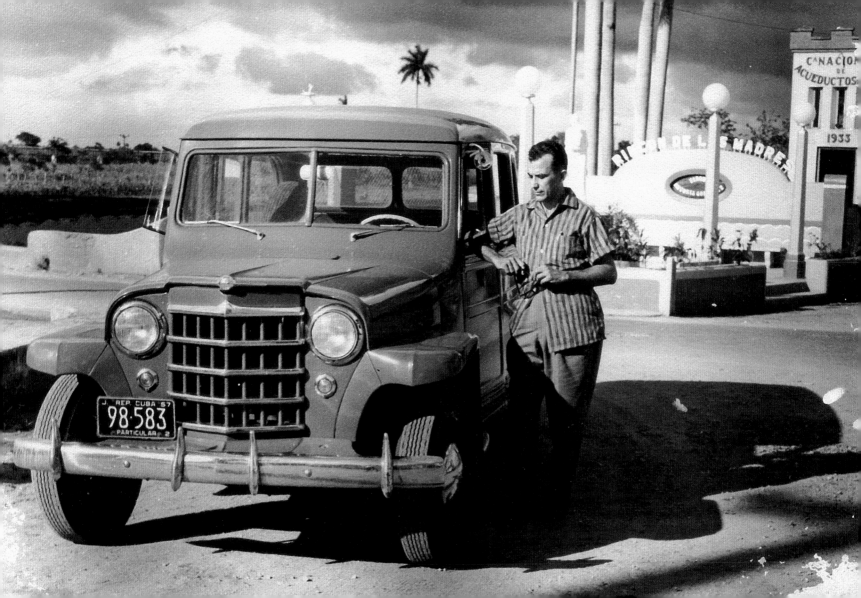

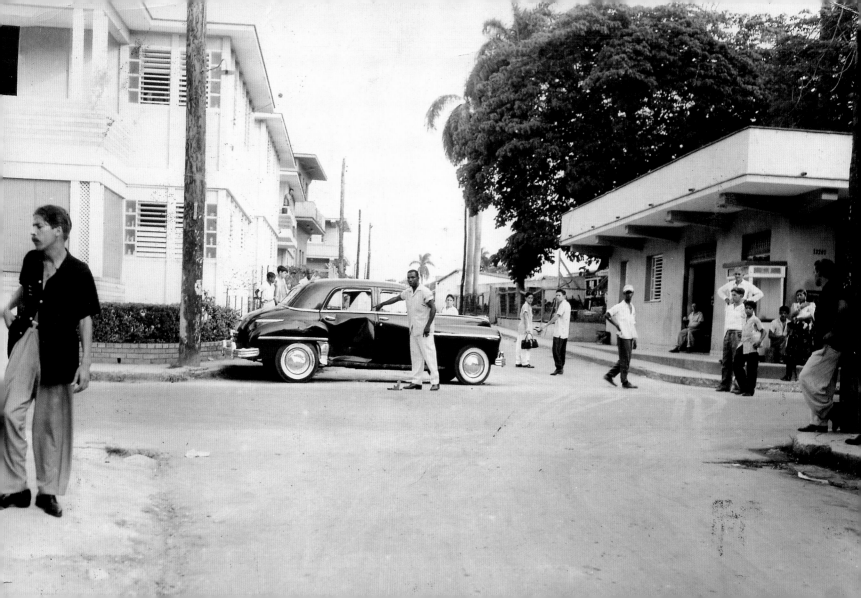

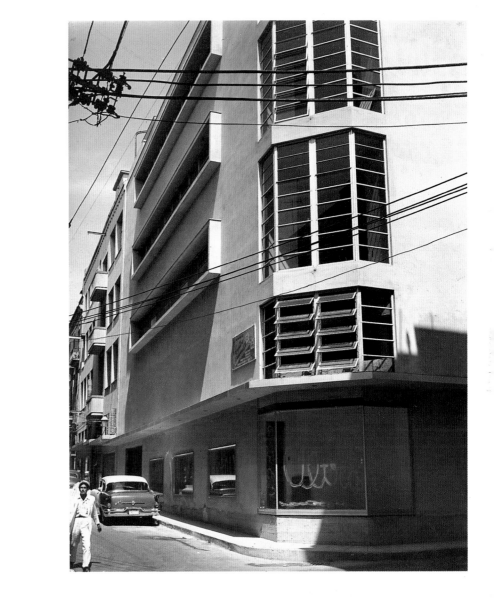

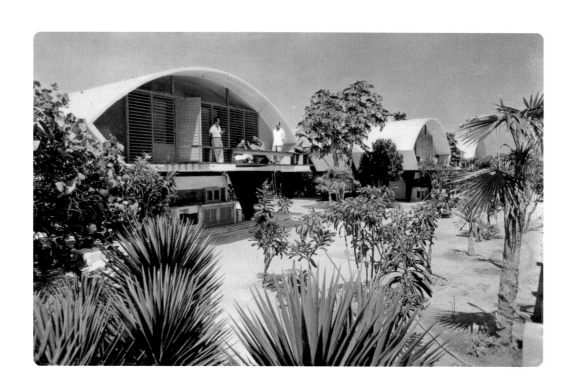

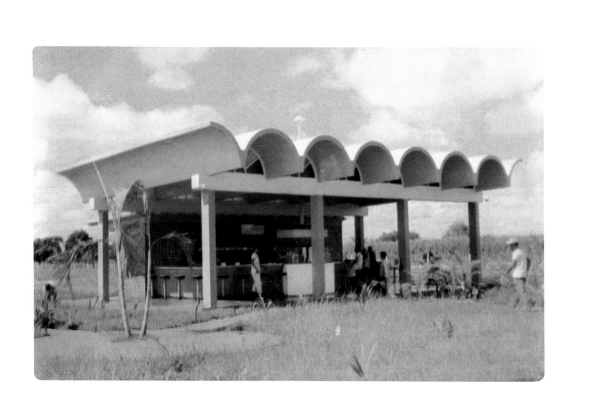

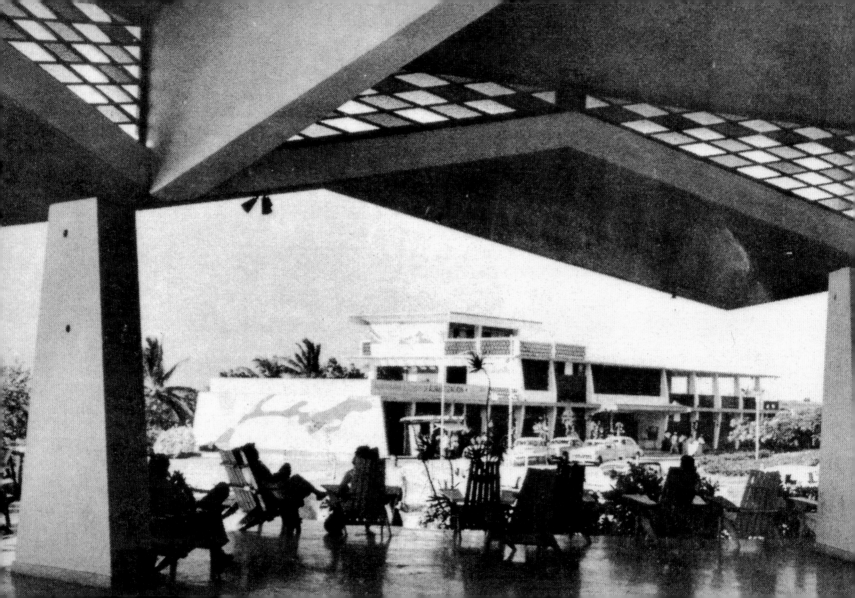

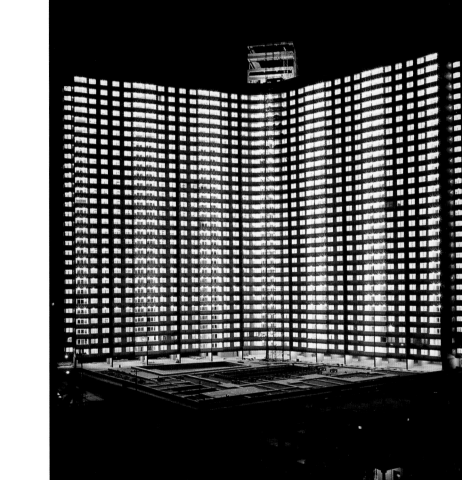

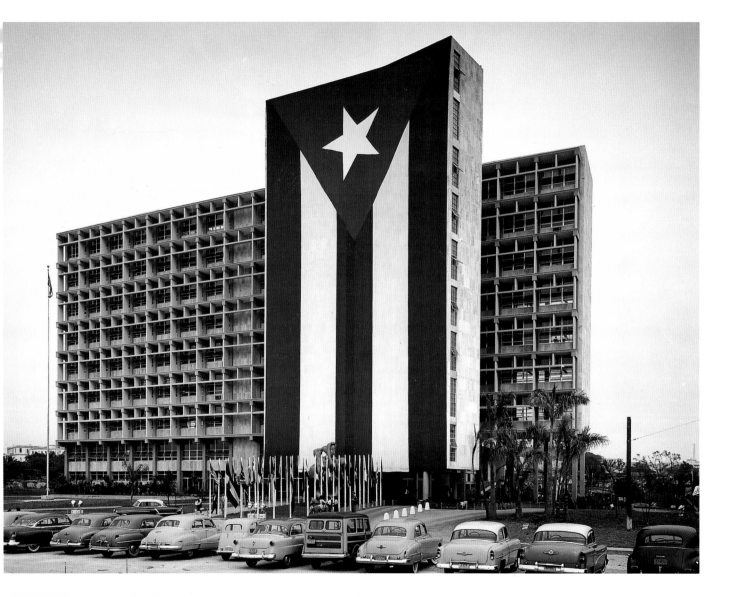

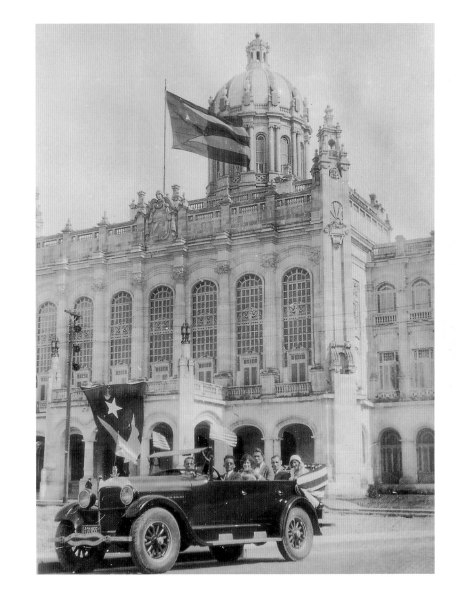

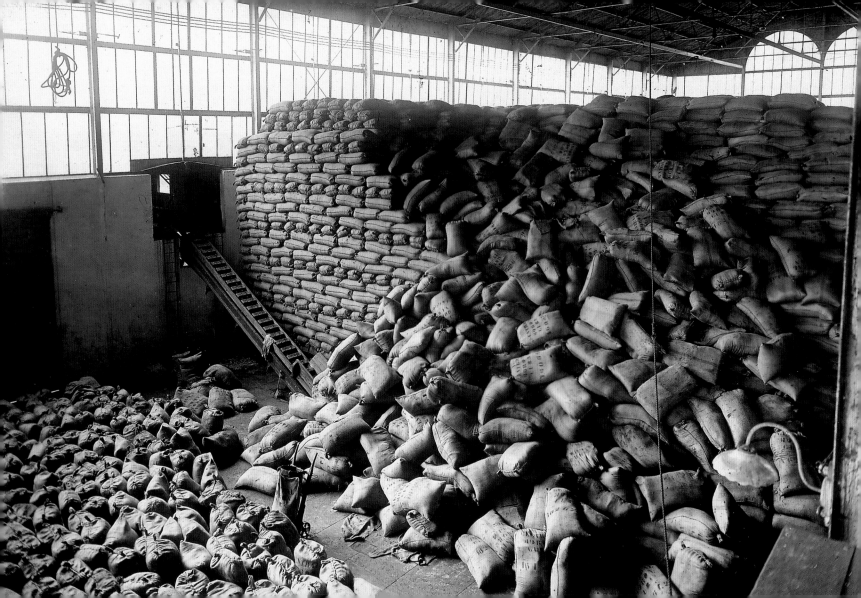

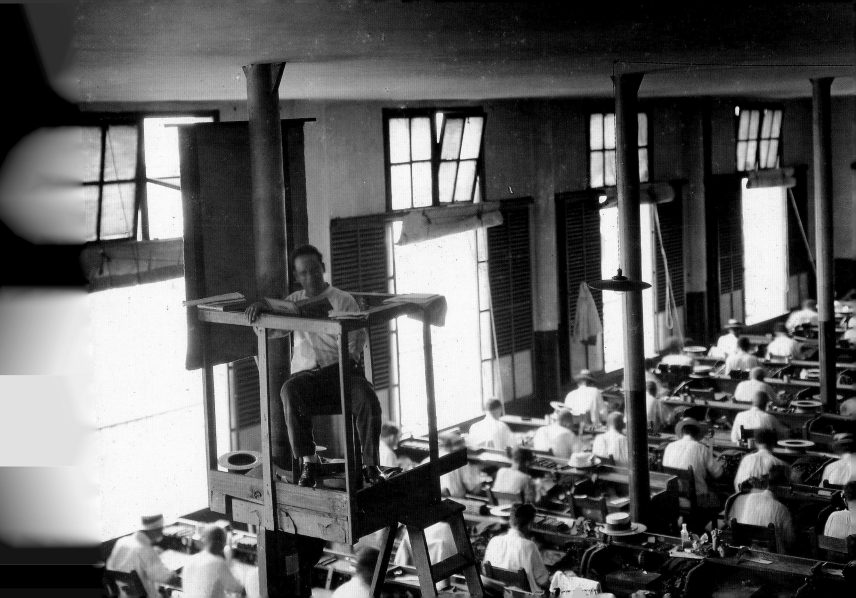

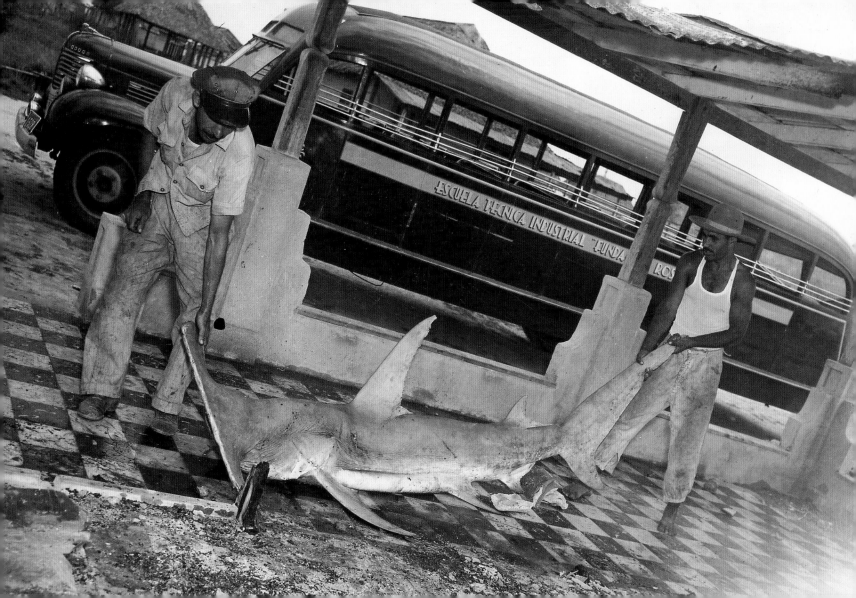

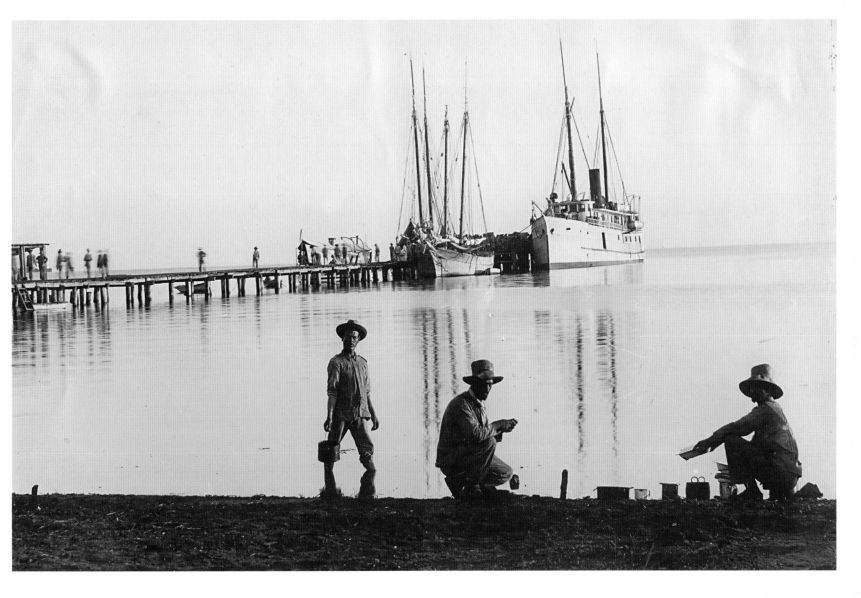

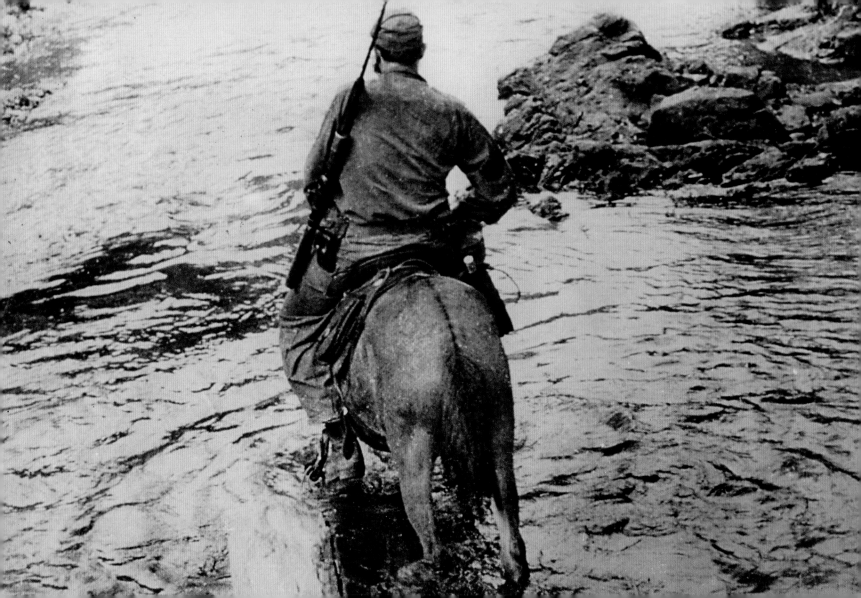

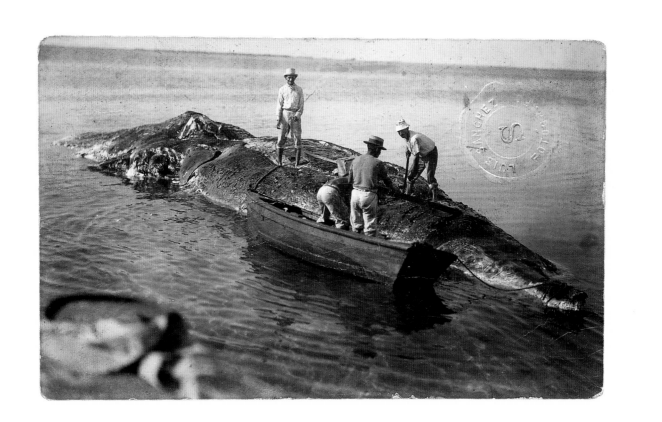

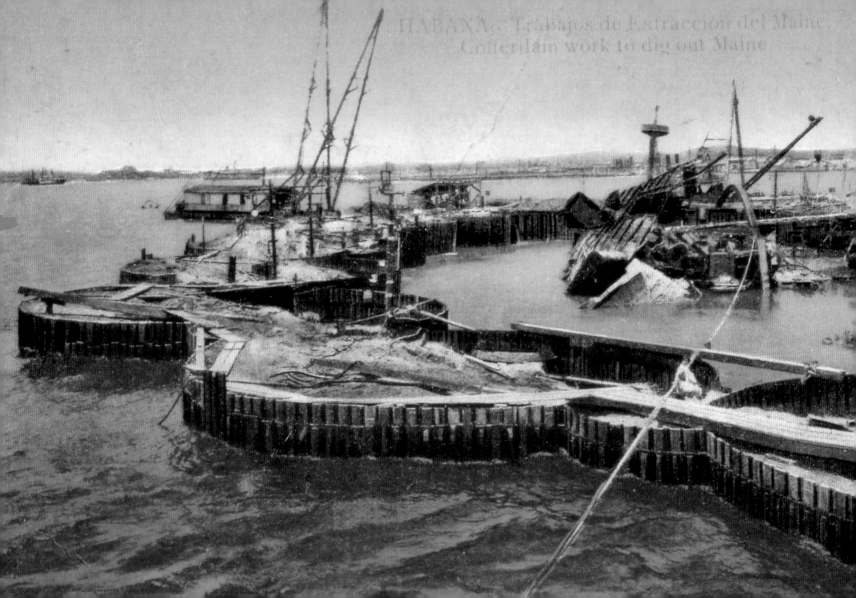

HABANA. Trabajos de Extracción del Maine.
Cofferdam work to dig out Maine

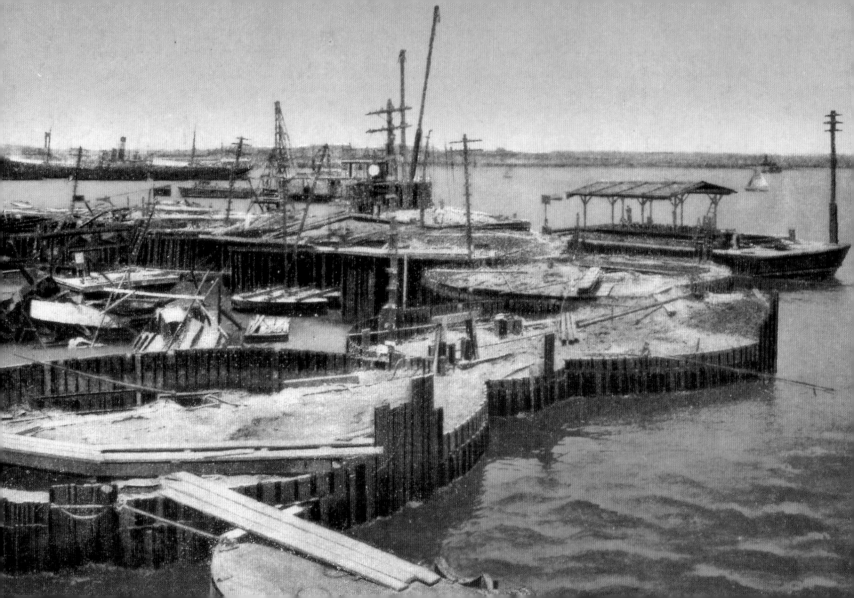

HOW COULD I EXPLAIN WHAT I FELT THE FIRST TIME THAT I SAW

THE SEA! IT WOULD BE IMPOSSIBLE TO DESCRIBE THAT MOMENT.

THERE IS ONLY ONE WORD THAT DOES IT ANY JUSTICE:

THE SEA.

From *Antes que anochezca (Before Night Falls)*

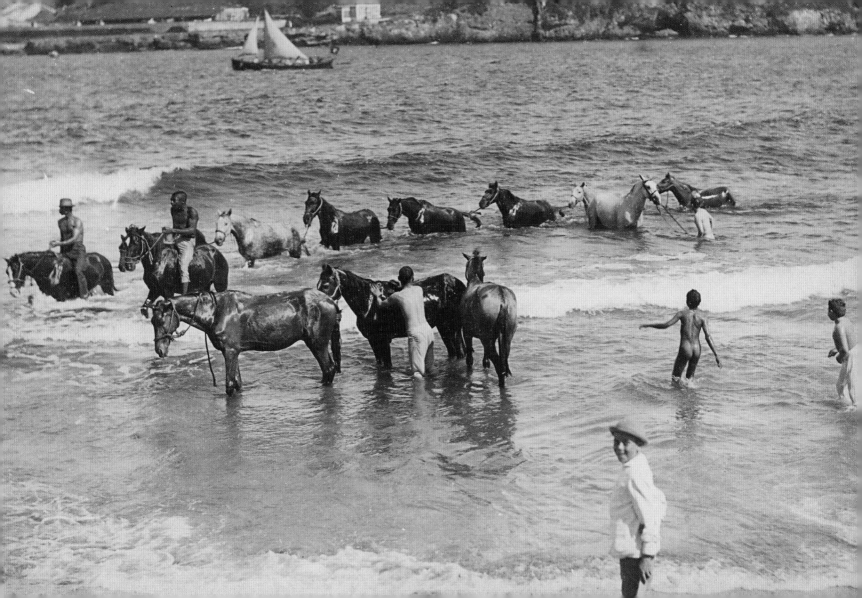

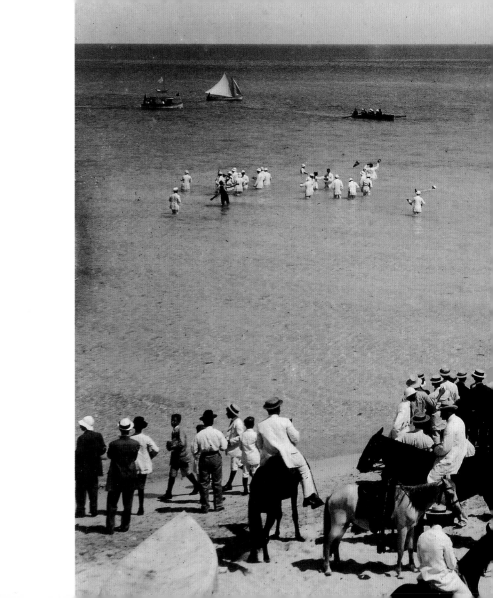

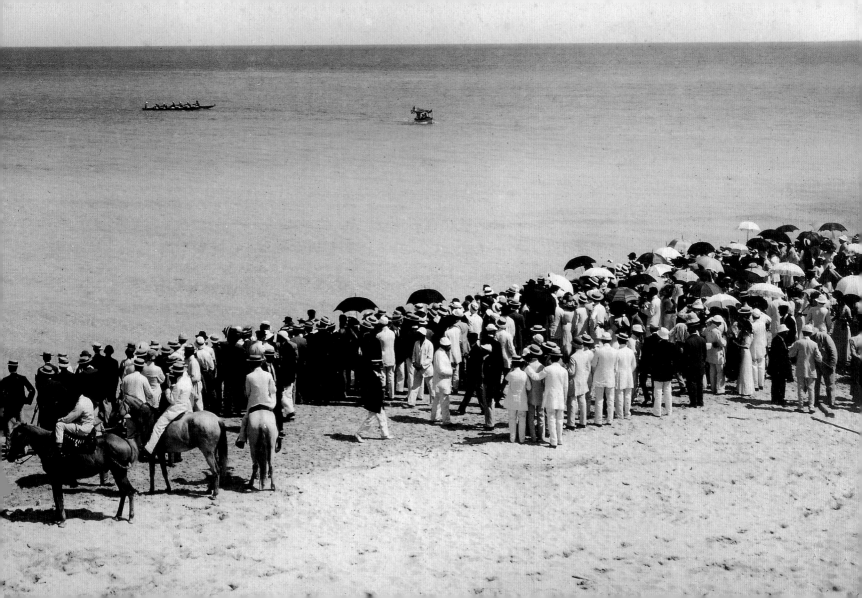

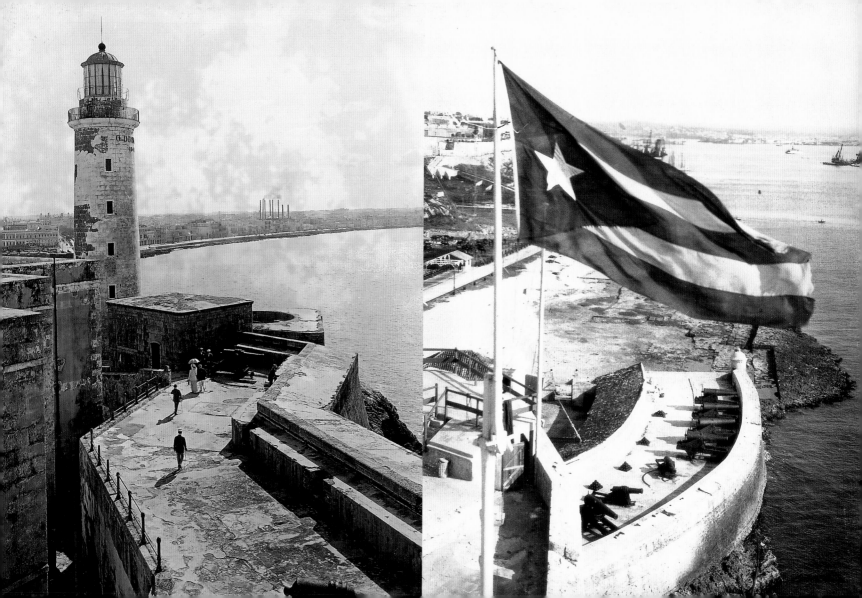

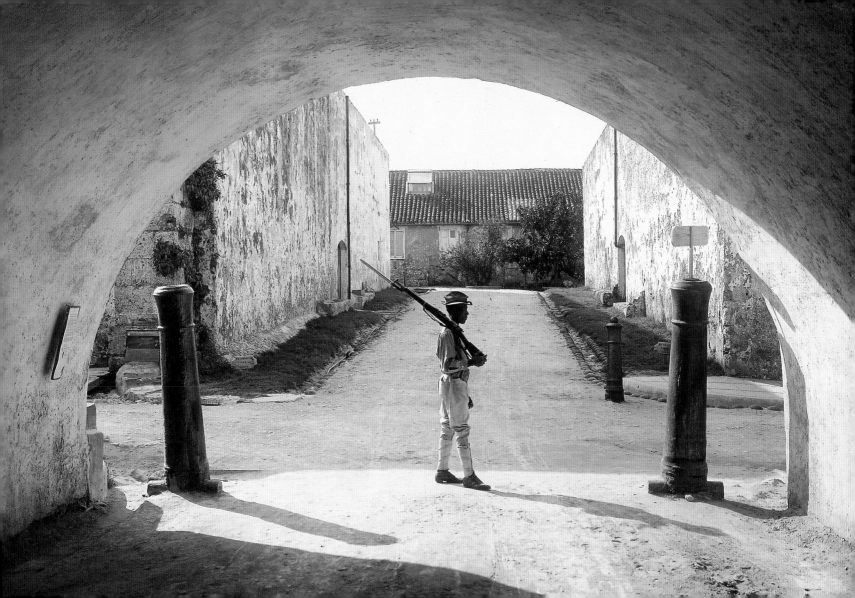

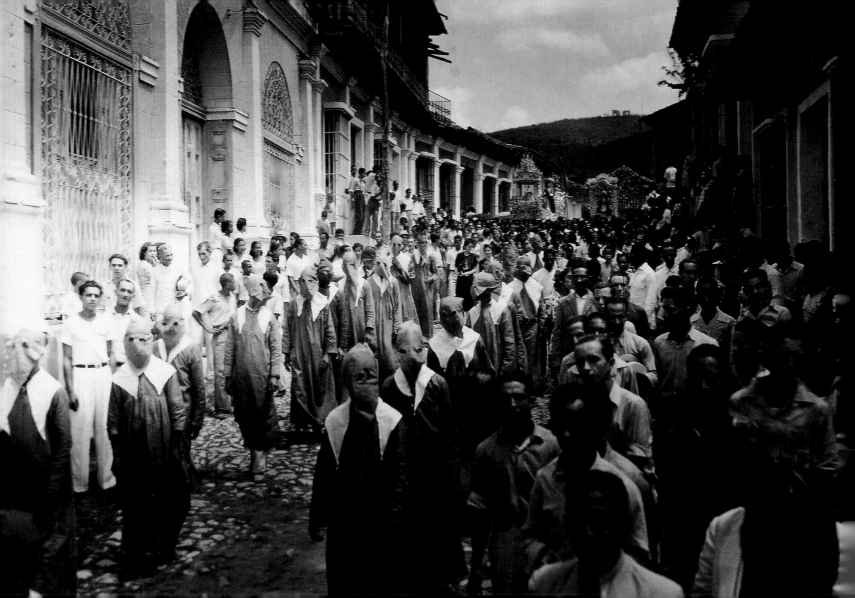

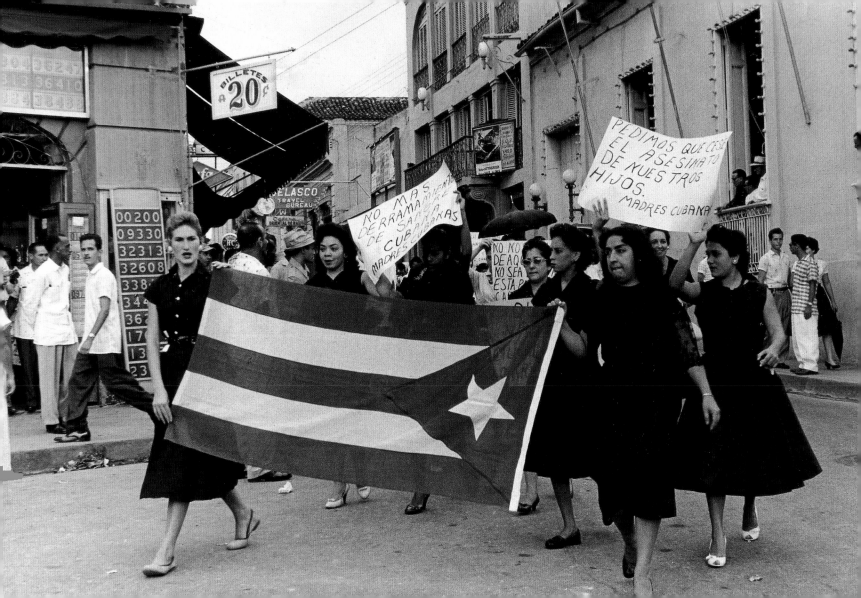

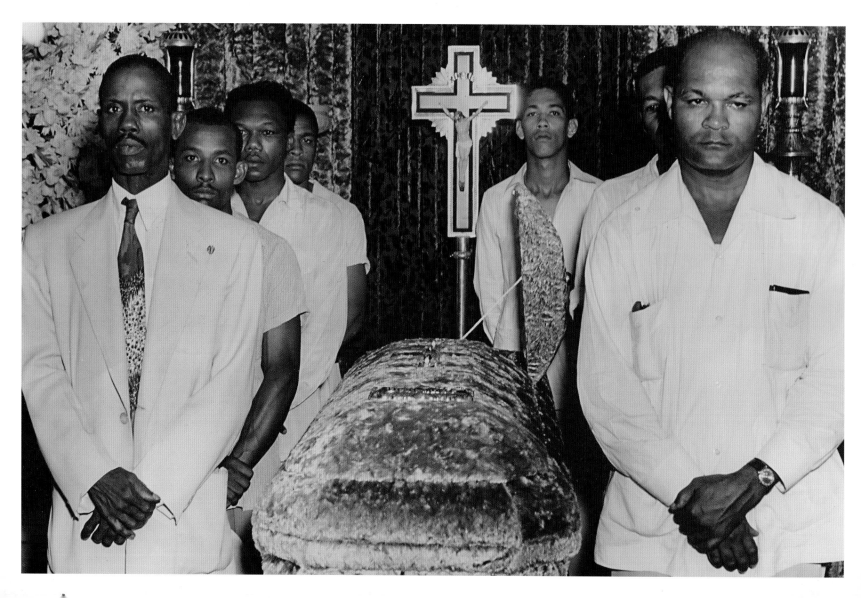

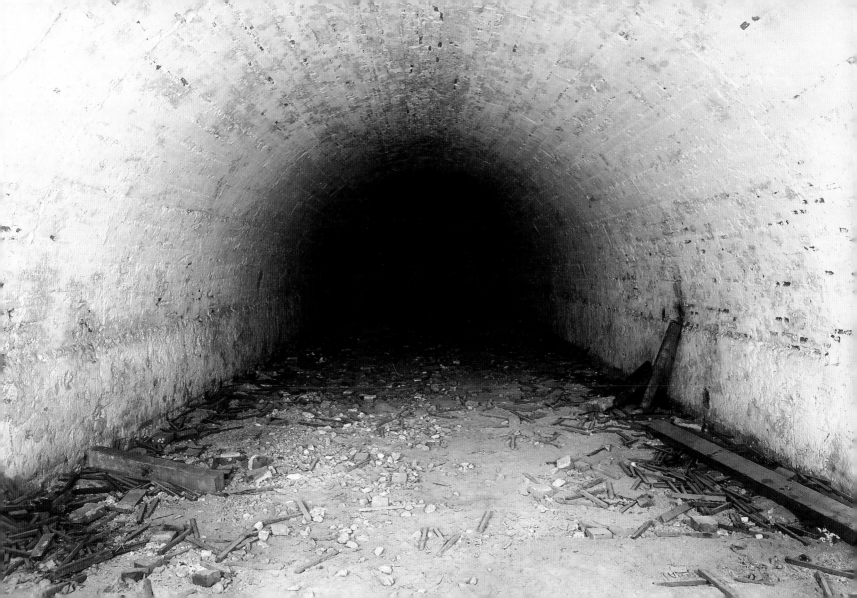

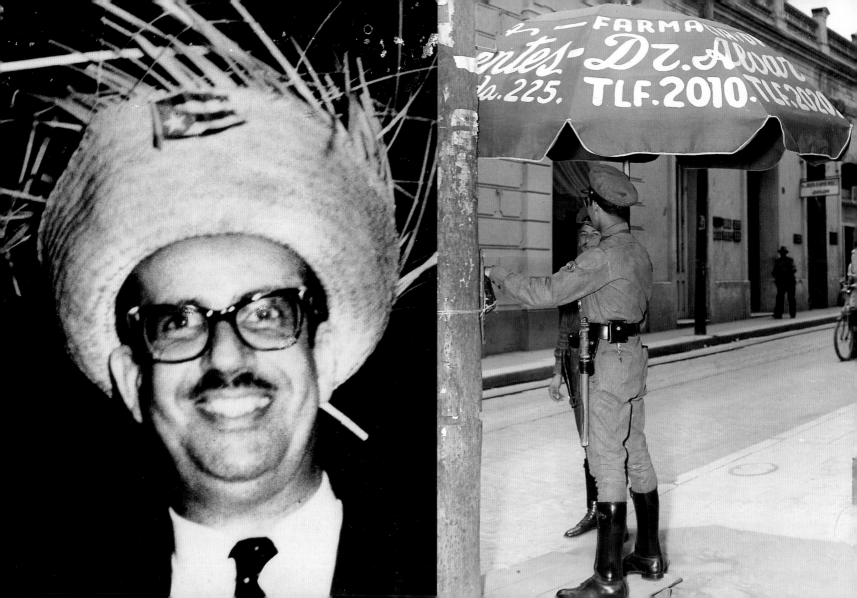

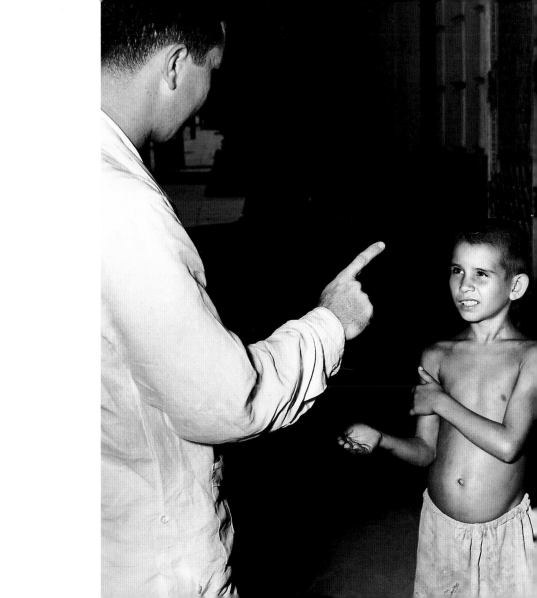

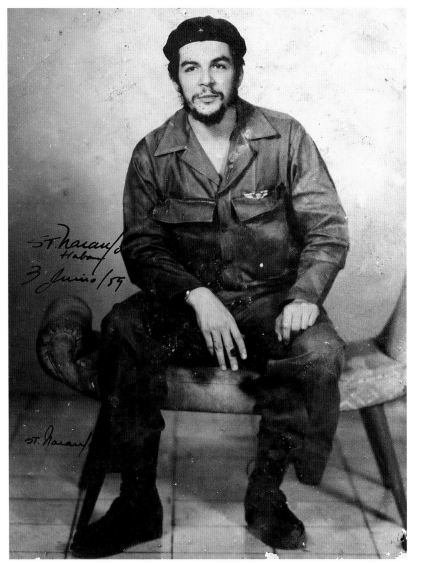
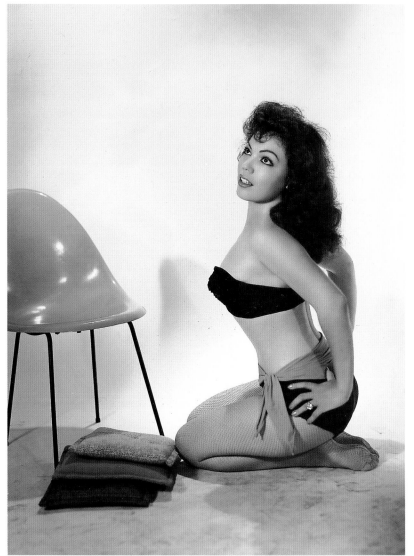

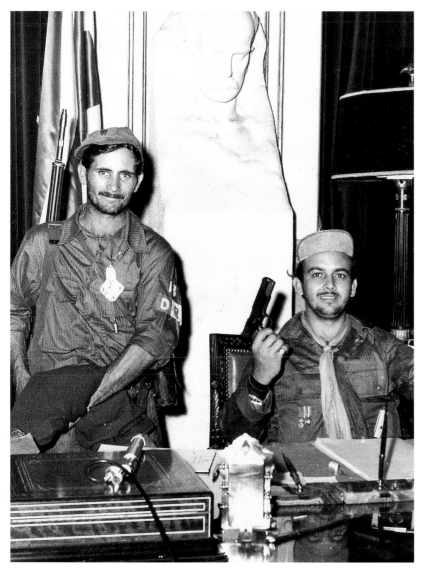
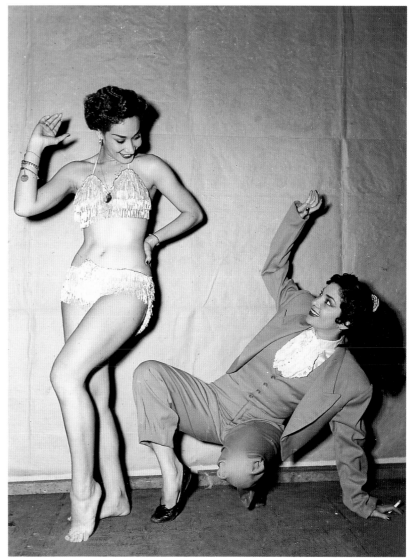

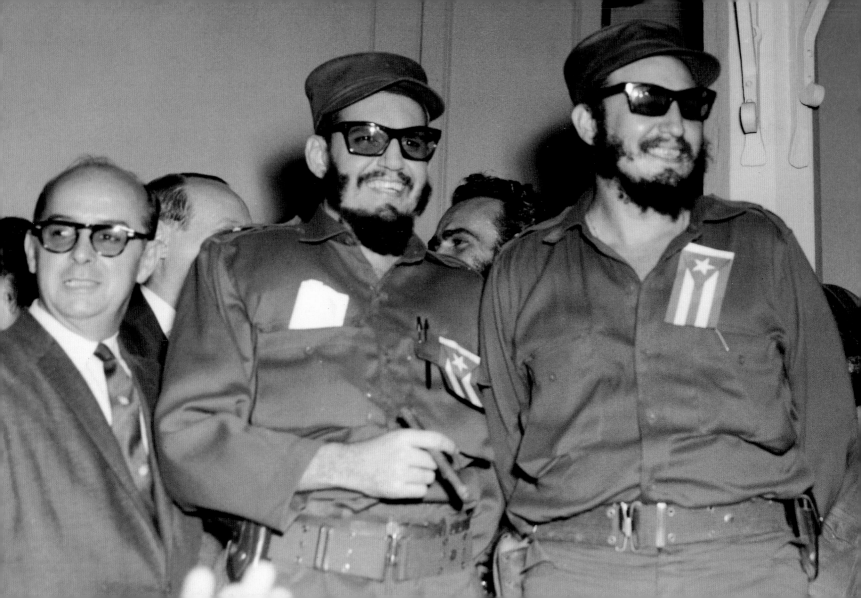

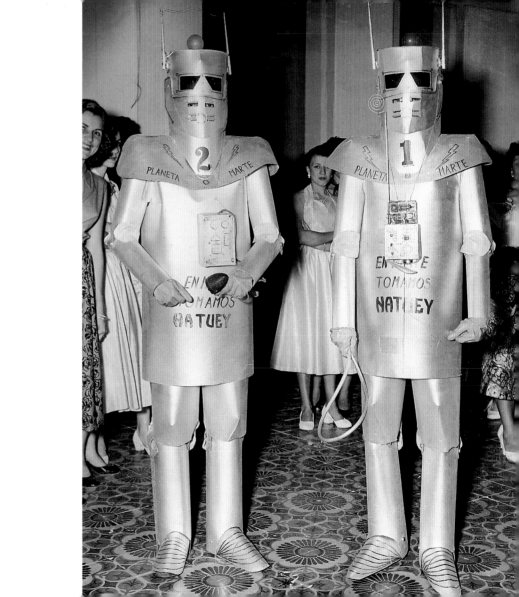

It was on May 2nd last that George and Emma Martin made their escape from the Spanish prison at Cardenas, Cuba.

George and Emma Martin were born in Tampa, Florida. They were taken to Cuba by their parents when one and three years of age respectively. George Martin is now thirty years of age and his sister twenty-eight. The 13th day of April '96 the entire Martin family was cast into prison at Cardenas, Cuba, the only crime of which they were found guilty was harboring and sheltering a number of insurgent soldiers, who had stopped over night at the Martin plantation. For two long years they suffered untold hardships and were nearly starved to death. The parents succumbed to the cruel treatment and died last spring. George Martin conceived a plan of escape by feigning death, he and his sister cast themselves among a lot of dead bodies which were thrown on the beach outside the prison walls. This was done under the cover of night. Next morning George attracted the attention of the dispatch boat Hercules, a boat was lowered and rowed ashore and he and Emma were taken aboard the Hercules and so carried back to their native birth place, Tampa, Fla.

If living testimony to the cruelty and barbarity of the Spanish in corroboration of the harrowing stories which reached American ears during the past few years, were needed, they are to be met with here. George says he has weighed 132 pounds and his sister 118 pounds; now they weigh respectively 51 and 57 pounds.

It was learned by the managers of the Fair Association that these people were with friends in Buffalo, where they were trying to recuperate. They have been induced to visit our fair and will be glad to tell the visitors all about their experiences in the Spanish prison at Cardenas. A special pavilion will be erected on the Fair grounds, where George and Emma Martin will be found during the entire fair week. Don't fail to see these living examples of Spanish misrule and barbarity in Cuba.

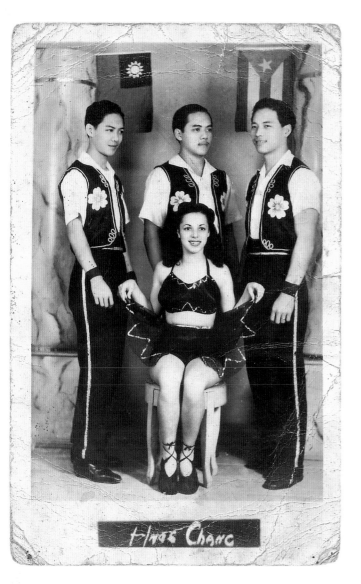

Hnos Chang

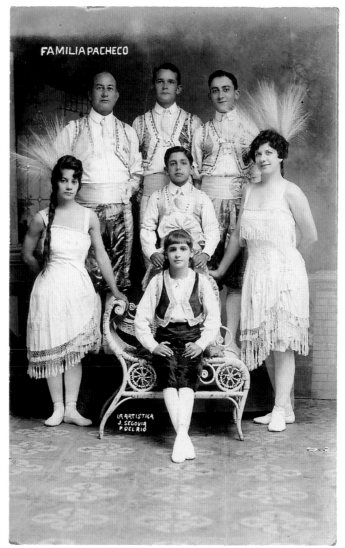

FAMILIA PACHECO

LA ARTISTICA
J. SEGOVIA
P. DEL RIO

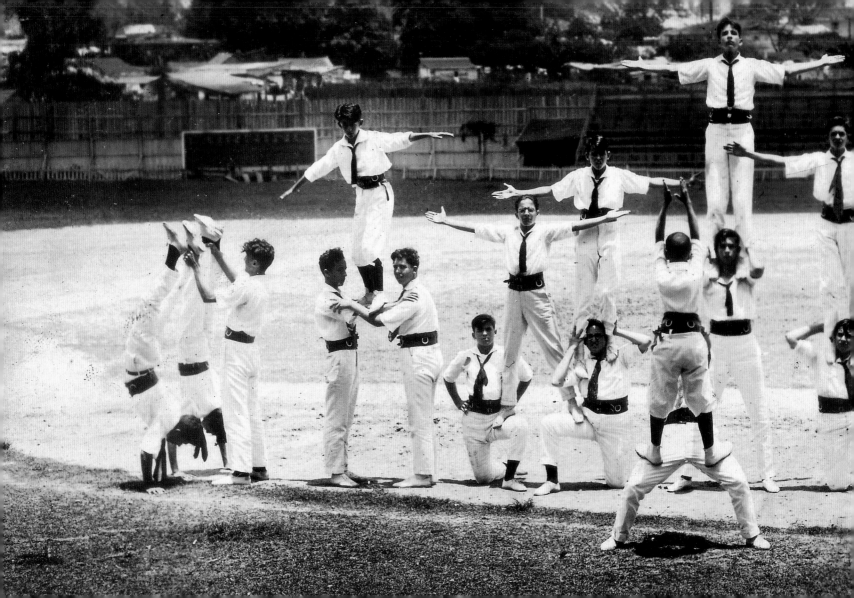

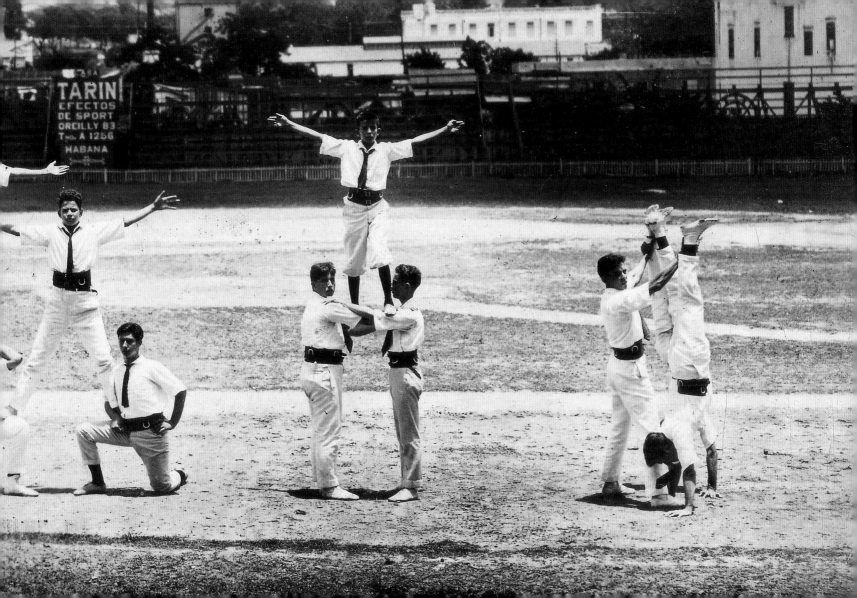

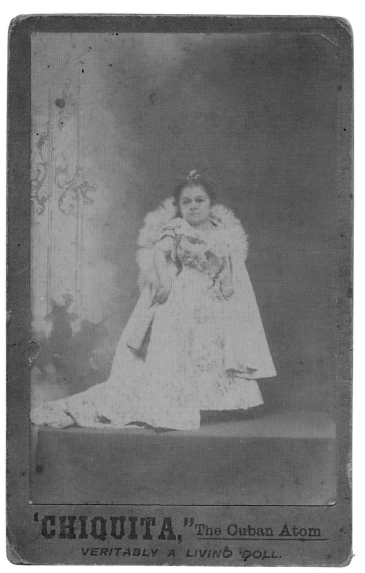

'CHIQUITA," The Cuban Atom
VERITABLY A LIVING DOLL.

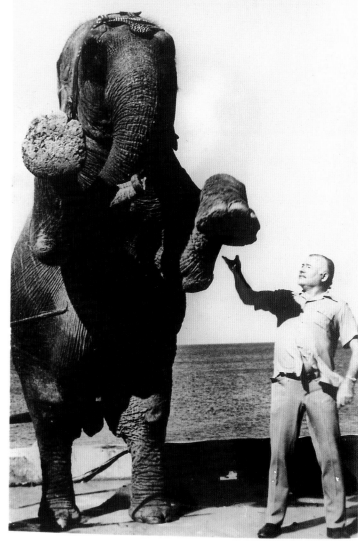

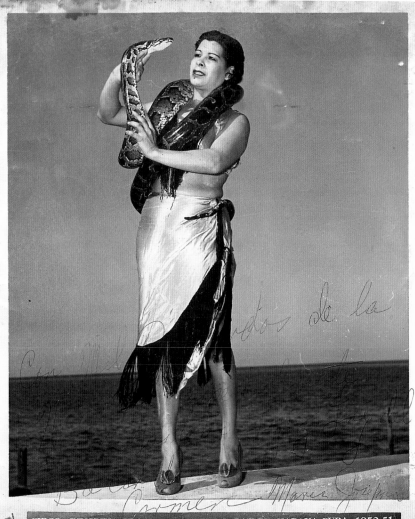

CIRCO: RINGLING BROS and BARNUM & BAILEY. HABANA CUBA.-1950-51

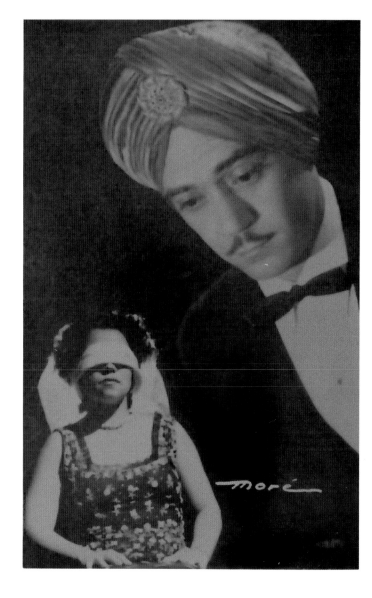

moré

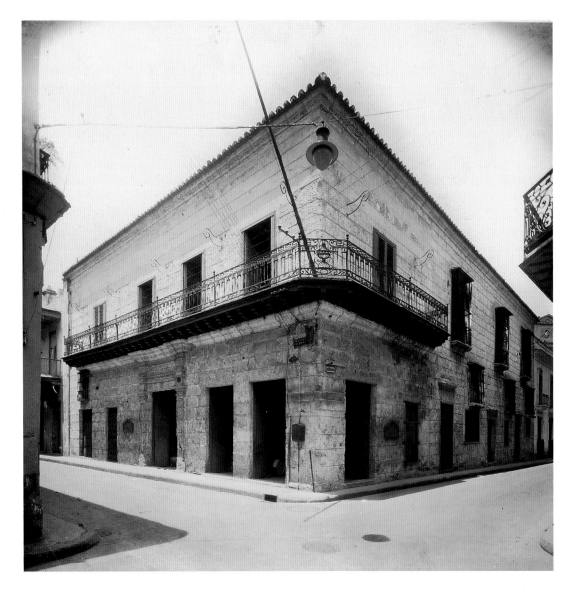

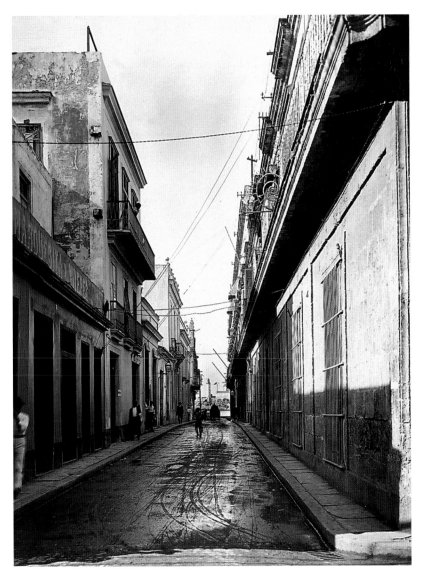
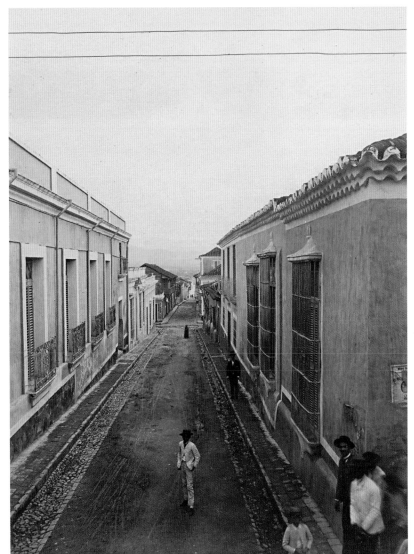

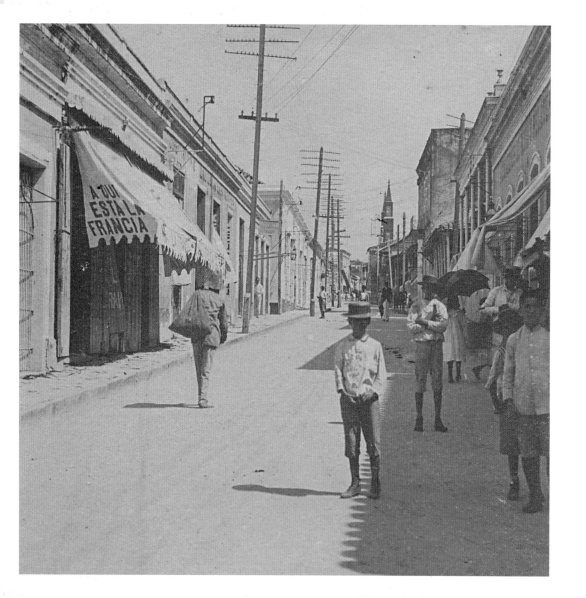

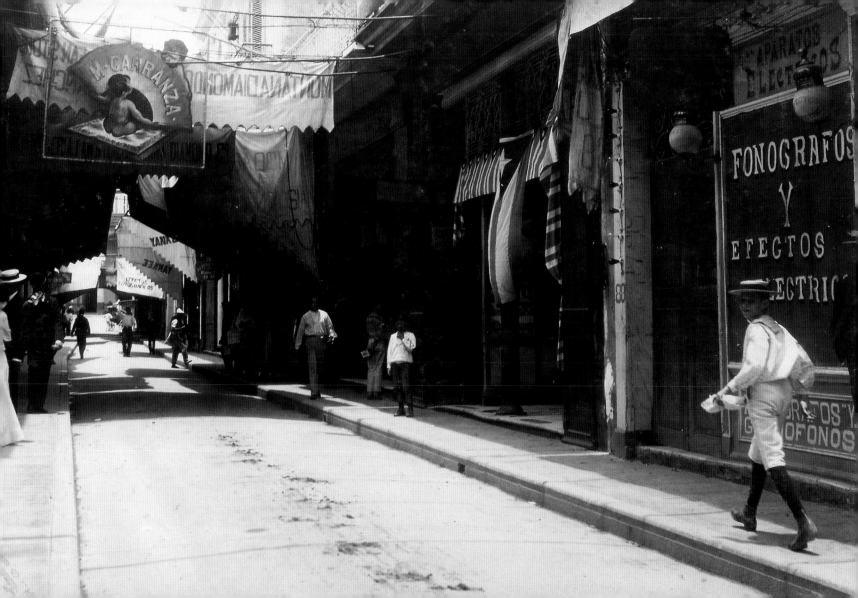

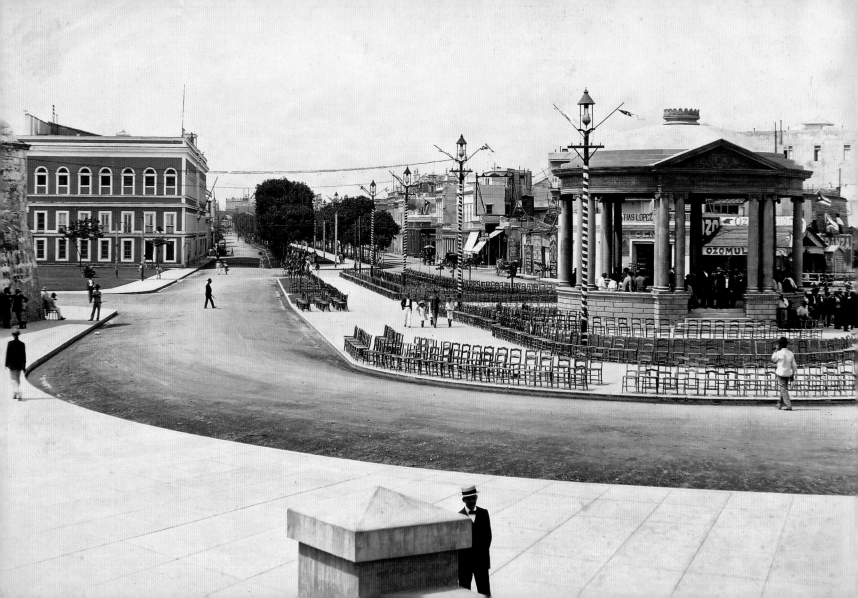

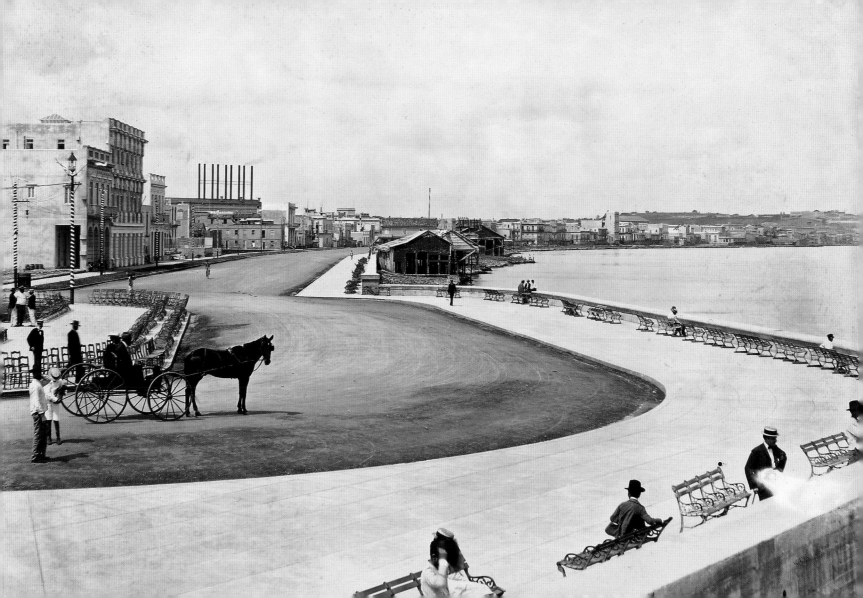

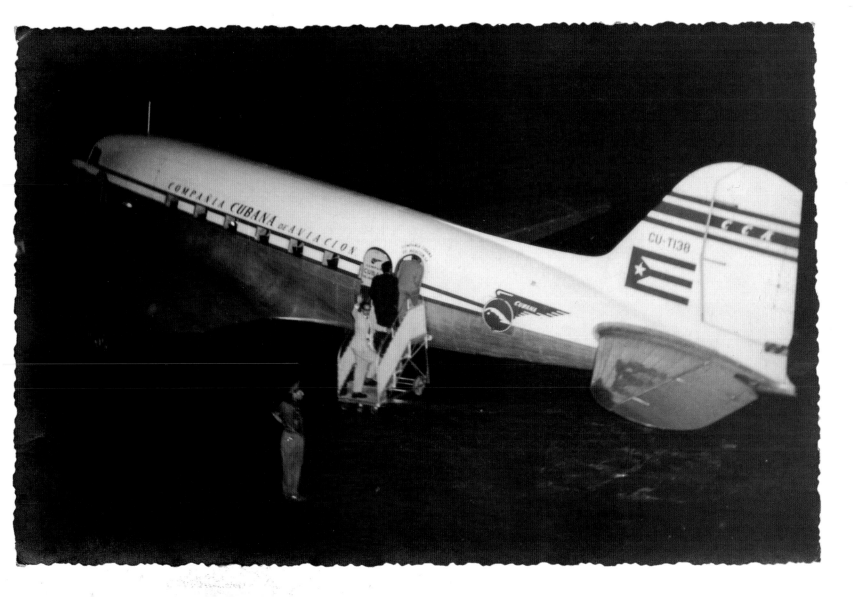

AN EXILE HAS NO PLACE ANYWHERE, BECAUSE THERE IS NO PLACE,

BECAUSE THE PLACE WHERE WE STARTED TO DREAM, WHERE WE

DISCOVERED THE NATURAL WORLD AROUND US, READ OUR FIRST BOOK,

LOVED FOR THE FIRST TIME, IS ALWAYS THE WORLD OF OUR DREAMS.

From *Antes que anochezca (Before Night Falls)*

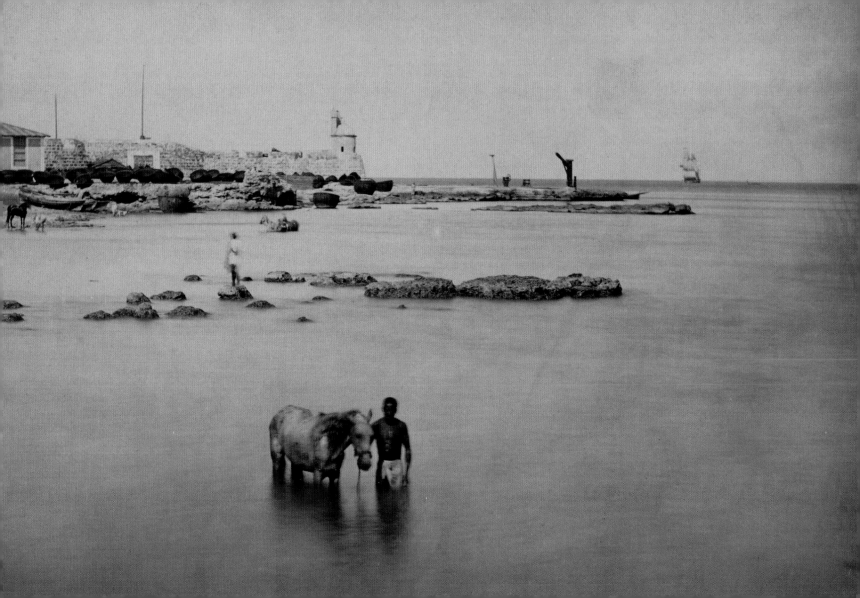

RAMIRO FERNÁNDEZ IN CONVERSATION WITH PETER CASTRO

There's a Cuban saying that refers to those rare, perfect fits in life: "*como añillo al dedo*" (like the wedding band on your finger). During the many years I worked with Ramiro Fernández at *People*, I never got the sense that his working at a pop culture magazine was, for him, a perfect fit. Sure, he was a keenly intelligent photo editor with an exceptional eye for composition. But I always felt his mind and heart were someplace else. Cuba, as I later discovered.

I only stumbled upon this realization by chance, and after nearly ten years of working with him. (One of the more dubious distinctions of living or working in Manhattan is that one usually knows almost nothing about the lives of next-door neighbors . . . or office colleagues.) One night in 2004, when I visited his office to discuss some story we were both working on (Britney Spears, or was it the Olsen twins?), I noticed that Ramiro's light box was crammed with old photographs. He told me that they were of Cuba and spanned from the mid-nineteenth century to the revolution and that he had one of the world's leading collections of such pictures. I was stunned. I always knew Ramiro to be a hep cat, connoisseur of French film noir, Bikram yoga, and Lacoste shirts, but I had no idea he had this other passion. Soon after that, *People*'s managing editor at the time, Martha Nelson, suggested he share these photos with the staff, and he did. His slide show was a huge hit. I was so taken with it, I offered him a precious oval photograph of my parents, which he graciously accepted.

In some ways, that presentation to the *People* staff fueled his desire to create this book. On a rainy afternoon in October 2006, I sat down with Ramiro and we chatted about his beloved photographs. Two friends talking about a precious place they both loved. *Como añillo al dedo.*

PETER CASTRO When did you start collecting these photos, and why?

RAMIRO FERNÁNDEZ I started collecting in 1981. My mother had been an amateur photographer in Cuba. She had a Rolleiflex and a Leica, and she had magazines around the house with the Edward Westons and the Wynn Bullocks, so I became exposed to photography very early on. My father, being a pharmaceutical manufacturer, had a lot of promotional materials around the house with these amazing graphics of pills and tranquilizers that also inspired me. But it was my grandmother Cuca Machado who really encouraged me to collect. My grandmother in her own life had a rich past. In Havana, she lived above the Parque Central, which you see in one of the pictures in the book—a shot from the 1940s, hand-colored, overlooking the city square. She lived in the Telégrafo Hotel, which is the Havana version of New York's Chelsea Hotel. People who were writers, painters, poets, and retirees lived there. It was a fairy-tale setting for a kid my age to go up to this hotel, with a gilded cage elevator, to this rooftop apartment overlooking the city square. My grandmother at the time, in the '50s, had a monkey . . .

PC As all grandmothers do . . .

RF [*Laughs*] . . .Yes, she had a caged monkey up there. She definitely had her own style, and when the '60s rolled around, she became an exile in Miami. She had a genuine love for the homeland she left behind, so she actually found old magazines with photographs of Havana and taped them to the wall. She filled her little Southwest Miami apartment with pictures of Havana and used to tutor me when I came to visit her about the history, the folklore, the traditions. She felt that so much of what Cuba was all about was disappearing so quickly, and urged me to collect anything I could find.

PC So in 1981 you started collecting these photographs . . .

RF Yes, I was working at the Museum of Modern Art's photography department in New York, and it was at this time that I became acquainted with collectors and dealers in nineteenth-century photography. Taking the ideas that my grandmother had instilled, I began to acquire photographs.

PC Every time I look through these images, I not only learn something new about Cuba, I have a new emotion about it. Why do you feel this collection is so special?

RF Because the collection spans the life of a nation. The age of photography began in 1839, and photography came to Cuba in 1840 with the first daguerreotype. What happens in Cuba is that the transition from colony to republic, on through the revolution, spans the age of photography. So it's an encapsulation, an impression of a country via the development of photography.

PC In terms of the eclectic nature of the collection of photos, I've never seen anything like it, and I'm assuming it doesn't exist anywhere else.

RF I don't know if it does, because I've never really compared it to other collections. I think it's special because it has a different range of imagery: photographs that are vernacular in nature, snapshots, tourist photography—the sort of flat, linear photography that only conveys the simplest of meanings—and family memorabilia. There are a lot of personal pictures here that were passed down from family to family. But beyond that, every image I acquired had to have a very strong narrative quality to it. The image also had to reveal something to me—something that adds more than, say, just a simple image of a palm tree. I needed context, I needed historical anecdote. I needed to see whether the photograph had something that set it apart.

PC And how did that shape your view of Cuba?

RF Well, it completely reshaped it. When you look at most of the pictures of Cuba these days, you always see these old American cars left over from the '50s. That's not what Cuba is to me. It's Cuba now, but that's not how Cuba *was*. What's happened is that this image of Cuba has been perpetuated by countless images of glued-together cars and decaying buildings, and it's such a contrived image, seen from a neo-colonialist viewpoint. So I said to myself, I have to show that Cuba had a lot of things besides these cars. I needed to create a collection that not only covered the photography of Cuba but also used me as a prism leading into the whole sphere of what it means to be born Cuban. What does it smell like to be Cuban? What does Cuba look like? Is it a hip or a hand gesture?

PC But why did you need to be a prism?

RF Because I wanted the collection to have my point of view, my eye as a photo editor, my taste, something completely different from how other collections are put together. When the revolution came in and all these photography exhibitions and books came out regarding the revolution, a lot of photographers got omitted. I wanted to rectify that. I wanted to collect work of photographers who were covering the entertainment industry, the sports stars, the showgirls—the forgotten amateur photographers. That's the kind of photography we tend not to recognize, but that's the sort of imagery that I cherish. Another thing that fascinates me to no end are performers—singers, magicians, and circus acts. The Ringling circus used to set up every year near my house in Havana. When I got out of school, my nanny used to take me to the circus every day—she had a little boyfriend—and I would go to the circus every afternoon. So my childhood impressions of Cuba were shaped by car races, circuses . . .

PC . . . and bearded ladies!

RF Yes, bearded ladies and Siamese twins! I'm always on the lookout for unusual photos, even ones that aren't necessarily of special provenance or in pristine archival condition. I love a photograph that looks like it's got a history of its own. Where that photograph has been or what it has gone through attracts me as a collector. I have, for example, a very rare image of Che holding his baby daughter that someone folded up into a little square, so that when you unfold it, it's a picture that's creased with all these grids. I love the creases. That object has a history of itself, unto itself.

PC You mentioned the factors you think about before acquiring these photographs. Talk to me a little about the history of Cuban photography—they were at the forefront of this art form, weren't they?

RF Well, they surely started practicing it as soon as it was invented. One of the earliest formats of photography, the daguerreotype, was invented in 1839 in France. By the year 1840, there was already a notice in a Havana newspaper announcing the daguerreotype's arrival in Cuba.

PC So Cubans became fascinated with photography?

RF Yes, everybody became fascinated. There was an immediate demand for portrait photography from the bourgeois class that could afford sittings in studios. *Cartes-de-visite* became immensely popular in the 1860s. At the same time, the rise in tourism made for a demand in souvenir imagery. Then photography began to expand into photojournalism with such photographers as José Gómez de la Carrera and José Soroa at the turn of the last century, who documented the news events of the day. As photojournalism and commercial photography progressed, you began to see what Cubans themselves were fascinated by. Race-car driving, for instance, or fencing—did you know Cuba excelled in fencing? The first Olympic gold medal awarded to a Cuban went to Ramón Fonst for the sport of fencing. Then there's baseball, boxing, and the revolution, of course.

PC Well, there's always that. Now, tell me about your mother's connection with Fidel.

RF My mother was introduced to Fidel by a friend in 1952, when he was still married to Mirta Díaz-Balart. They had a summer house near us. So they met before he went into exile and started the revolution.

PC He was a lawyer, wasn't he?

RF Yes, he was a lawyer. But the other side of the story is that my mother's closest friend, Nati Revuelta, became his lover. She was a prominent Havana socialite and his intellectual equal—they shared a love of literature. I don't know how close my mother was with Fidel, although she did end up working as a volunteer to a cabinet member at INRA, the National Institute for Agrarian Reform, the first socialist program established after the revolution came into power. But nevertheless they saw each other, although I don't know all of the details. It was something she would never discuss with me.

PC Those sensitivities are still prevalent, and a lot of people in this country who will buy this book will probably bristle at the photographs of Fidel, Che, and the revolution. Explain why that was necessary—and I think it's important to state that you're no great lover of Fidel or Che.

RF Well, I don't have any heroes but they make for awfully good photography. The thing to keep in perspective here is that we can't *not* include them, because it's important to show that photography underwent its *own* revolution in 1959. It was a pivotal year that changed everything. You can see this perfectly in the studio photography of the era. There were three major studio photographers working in Havana in the '50s, all with their individual glamour styles—Karóll, Armand, and Narcy. They provided movie stars and celebrities that came through Cuba with portraits and publicity material. But in 1959, you suddenly begin to see the revolutionary women and men stepping into the studios where a

few years before Josephine Baker and Celia Cruz had posed. So basically you have an interesting transition from pre-revolution to revolution using the same glamour studios, which you never see anywhere else. It was so explosive and it was everywhere, so I wanted to make sure the pictures portrayed the revolution without glorifying it, but just stating it as it was . . .

PC As a historical document.

RF As a historical document. The other thing is that the collection is part of my personal history, and I do have memories of Fidel. I remember meeting him and you know when you meet somebody as a kid, there are certain memories that become inflated in your head . . .

PC What year is this?

RF Early 1960.

PC So he's now in power?

RF Yes, he's now in power, and I was with my neighborhood friends after school on the curbside. There was a large house nearby where all these party officials were meeting, and Fidel came out, said hello to us, and shook all our hands. He bent down, and I distinctly remember two things about him—the smell, which was a heady mixture of his cigars, those Cohiba cigars, and soaked canvas. You know how it smells when you leave a pup tent out in the rain? That soaky canvas smell? It was because of the uniforms. . . .

PC [*Laughs*] Right, exactly . . .

RF . . . and his earlobes. If you ever notice his earlobes, they are enormous, and that's what stayed as a kid, those two things. The other association I have of him is perhaps more intriguing. My father had a Buick 55 Special, you know, those big, big cars. And in the '50s, the car interiors were still

made of felt, and there was a dark brown spot over the driver's seat. I rode so many times in that car, and I always remembered that brown spot, and it's one of those things that haunt you as a kid. I was a very haunted child!

PC [*Laughs*]

RF And I kept wondering what it was. Years later, after we came to the United States, out of the blue I asked my mother, "What was that brown spot over the driver's seat in Dad's Buick?" And she said, "I'll tell you a story. Nati, me, and Fidel went out one night. And Fidel wanted to drive your Dad's car, but he was so tall that when he got in, he bumped his head on the door and cut his head. And so the rubbing back and forth of the felt against his bloody head left that brown spot."

PC And they never washed it, I guess . . .

RF They could never get it out. You know, blood stains forever.

PC Well, especially when you're a world leader. I think the blood lasts even longer! That's a fascinating story. Now, tell me about your relationship with Arenas.

RF Well, first I should give a little background. Reinaldo Arenas was a Cuban writer who was persona non grata during the '70s in Cuba. He was persecuted and jailed in Cuba for his anti-communist writing. Reinaldo came to the U.S. during the Mariel boat lift, and at that time he had been in Cuba's jails already and he had been persecuted by the government, so it was to their advantage to get rid of Reinaldo—either that or kill him. Reinaldo ended up being in New York in the early '80s, and through my good friend René Cifuentes, we met and we became part of a group of Cuban artists and writers. Reinaldo knew that I was collecting Cuban photography, so he used to come over to my house to look at the photographs. He was really quite taken with them, and he was one

of the people who encouraged me to keep expanding my acquisitions. So I said to him, "Reinaldo, you've got to write something for me about the history of photography in Cuba. You've got to write about what the imagery of nineteenth-century Cuba means to you." Well, he said he would do it, and I believe he began writing, but he never showed me anything. But we kept talking about the collection, and we maintained our friendship until the day he died.

PC This was what year?

RF He died in 1990. A group of us were together with him the night before he committed suicide.

PC And of course, this is the man whose life was depicted by Javier Bardem in the movie *Before Night Falls*.

RF Right. He was a brilliant writer, and it means so much to me to be able to have some of his writings in the book. I think he would have loved to have seen it all in this form . . .

PC Was creating this collection at times emotional for you?

RF Well, it was emotional for me in the beginning, but I've done it for so many years, gone through it over and over, so it's getting . . . drier. It's important to me to make sure that the generations that come after me have an impression of Cuba that's more than just rumba, rum, and revolution . . .

PC . . . and, frankly, a ruined landscape. Cuba itself now seems frozen in time. This collection captures the magic of that island, and it saddened me to see these photos, in a way, because that island is now in ruins. A lot of young Cubans will take a very different image away after they see this book—I don't know if that was your intention, but that's certainly going to happen.

RF Well, there are some images steeped in social realism—there were a lot of tragic moments in the history of the island. But it also shows you that primarily, Cuba was a jewel in the Caribbean Sea. First of all, it was in the middle of the crossroads between Europe and South America. It enjoyed a very strategic spot as a shipping route, thus creating what came out of it—the richness of architecture, music, social customs, fashion. When I was a kid, I went to a parochial school and then to a military school. I always heard the chitter-chatter from the guys in the older grades about sports and the babes in the nightclubs. So I had to bring to the collection something of what I heard and what I saw—the legendary nightlife, those showgirls, the noir qualities of some of those photographs.

PC Well, the thing is, young and old alike will learn things that they never knew about Cuba. Some of these pictures go back to the mid-nineteenth century, and if I'm not mistaken, there's a slave family in one of these pictures . . .

RF That's right. I have these mid-nineteenth-century photographs where you see the colonial society with the plantations and the slave institution established there. In these images, you can clearly see that these were first-generation Afro-Cubans. You can see from the dress, the way they are sitting, the cooking utensils, the thatched structures that they lived in—they were straight out of West Africa. They were not "Cubanized" at all yet.

PC Yes, they are unbelievable pictures. The other thing of interest for geologists and topographists out there is that you get a really good vision of what the land itself was like during that era. So many of the pictures that we see now are of the Hotel Nacional and all those wonderful highways, but this was a really agrarian place, with lush vegetation. What's amazing about it is that it enjoyed its own natural history. The island is like a natural limestone boat floating through the sea—it enjoys an unusual amount of birds that are only native to Cuba, so the fauna is

interesting. There are all these natural-history elements and early land-scapes that I'm glad you collected.

RF I was particularly interested in the early landscapes, because it was very hard to photograph in the outdoors, especially in the early part of the last century, because of the light. The light in Cuba is very high. The sun sits very high, so I'm always looking for photographs where you see a little bit of shadow. It gives the photographs a little depth, a little mood.

PC I never realized that until you pointed it out! As you know, my favorite photograph of yours is the christening of the Shell gas station with the gorgeous women. I guess the reason I am so drawn to this image is the fact that I'm Cuban, and this is such a Cuban shot. The women are so typically Cuban, but also being Catholic and having been an altar boy, I'm intrigued that there's this really cool-looking priest with incredibly cool-looking sunglasses, and the fact that they are doing this at a Shell station is about the funniest thing I've ever seen. Now what is going on, and why are Cubans behaving like this?

RF Well, in Cuba it was the custom to christen everything.

PC [*Laughs*] Well, yes, clearly . . .

RF If you were opening a business, a cafeteria, or if you were opening an appliance store, or if you bought a new car, you had to have it christened. So for a gas station to be christened is not that far-fetched a notion. What's fascinating to me about that picture is how everyone's dressed in "high afternoon" attire. Everything's starched, everybody looks great.

PC But what are these people doing there? Where did they get these people?

RF Probably some are customers or would-be customers of the gas station as it opens. And do you notice the little girl mimicking the women? She's dressed in the same mode as the older women? Everybody's dressed to the nines . . .

PC Everybody's dressed up . . . I love it! The thing about your collection is that it's like this artistic artichoke. Every time you peel something, there's yet another layer there that fascinates and completely enlightens. Will you ever stop collecting?

RF I don't think so. I don't think I'll ever be finished with it, because I'm forever curious. I'll keep collecting as long as Cuba, on its limestone bedding, keeps moving across the sea.

American Photo Studios.
A schooner at full sail in Havana harbor, ca. 1925. 8″ x 10″ gelatin silver print.

Photographer unknown. Commemorative postcard sponsored by Polar beer of Cuban aviation pioneer Antonio Menéndez Peláez with mechanic Manuel Naranjo, marking the first transatlantic Cuban flight from Havana to Sevilla, Spain, in 1936 on a Lockheed 8A Sirius. 3½″ x 5½″ gelatin silver postcard.

Cia Fotográfica. Travelers disembarking from a Pan American World Airways DC-3, José Marti Airport, Rancho Boyeros, Havana, 1946. 4″ x 6″ gelatin silver print.

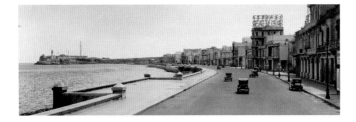

American Photo Studios.
El Malecón, the drive along the city's edge parallel to the Gulf of Mexico, looking east toward El Morro Castle, Havana, ca. 1925. 8″ x 10″ gelatin silver print.

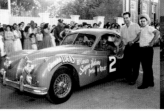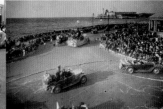

Photographer unknown. Cuban driver Encendido Lucas driving his Jaguar XK120 on the Sagua to the Havana Classic Race III, 1956. 8″ x 10″ gelatin silver print.

American Photo Studios. Floats, paper serpentine, and cars make their way from El Malecón onto Paseo del Prado Avenue during Carnavales (Easter), Havana, ca. 1926. 8″ x 10″ gelatin silver print.

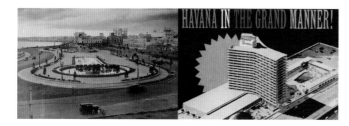 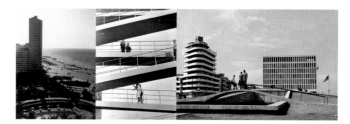

Photographer unknown.
Looking east from Maceo Park, Havana, photographed shortly after its completion in 1916. The park was named after Antonio Maceo, a beloved Cuban patriot and fighter of the War of Independence (1895–98). 8″ x 10″ gelatin silver print.

Published by Havana Riviera.
Back cover art of a souvenir gaming guide for the Havana Riviera Hotel, Cabana Club and Casino built by American mob boss Meyer Lansky. Situated on El Malecón Drive and Paseo, the hotel opened in December 1958. Vedado, Havana. 5½″ x 4″ offset litho cardstock.

C. M. Armesto. Looking out over the pool of the Hotel Nacional with the looming Someillán building in the background, Havana, ca. 1958. 8″ x 10″ gelatin silver print.

Prensa Latina Servicio Fotográfico. Ramps at the Administration building at the University of Oriente, Santiago de Cuba, ca. 1960. 5″ x 7″ gelatin silver print.

Cuban Tourist Commission.
Three people pose on a bridge with the American Embassy in the background (right), designed by Harrison and Abramovitz (1953), and the modernist Olan Tower (left), designed by Antonio Santana (1952), Havana, 1956. 8″ x 10″ silver gelatin print.

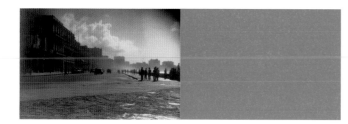

Photographer unknown.
El Malecón after a rainshower, Havana, ca. 1947. 4″ x 5″ gelatin silver print.

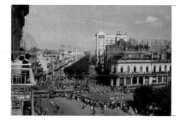 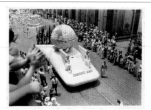

Photographer unknown. Looking from the Inglaterra Hotel balcony onto a parade coming down the tree-lined Paseo del Prado to the Parque Central, Havana, January 1942. 6″ x 9¼″ hand-tinted gelatin silver print.

Romay. An art-deco-inspired float for the Air Transport Labor syndicate, followed by banners demanding retirement benefits, Havana, 1957. 5″ x 7″ gelatin silver print.

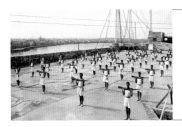 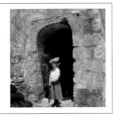 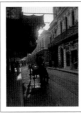 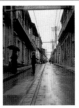

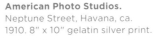

American Photo Studios. Police Academy cadets practicing rifle drills on the Morro Castle ramparts. The Havana cityscape can be seen in the background, ca. 1924. 8″ x 10″ gelatin silver print.

Photographer unknown. A girl stands by a stockpile of cannon balls at El Morro Castle. This image, most likely a tourist snapshot, was taken by a Brownie camera, Havana, ca. 1905. 3¹/₂″ x 3¹/₂″ gelatin silver print.

American Photo Studios. Neptune Street, Havana, ca. 1910. 8″ x 10″ gelatin silver print.

American Photo Studios. Street with rainsoaked streetcar tracks, Santiago de Cuba, Oriente Province, 1925. 8″ x 10″ gelatin silver print.

Photographer unknown. Looking north on the unpaved El Prado, Havana, ca. 1895. 8″ x 10″ silver print.

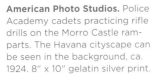

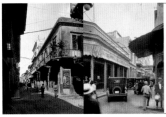 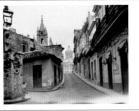

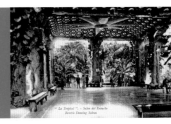

American Photo Studios. Corner of Lamparilla and San Ignacio streets, Havana, ca. 1918. 8″ x 10″ gelatin silver print.

Publishers Photo Service. Corner of Aguiar and Obispo streets, Havana, 1924. 8″ x 10″ gelatin silver print.

Photographer unknown. Loma del Ángel (Angel Hill), one of the modest hills in Havana, with the Church of Santo Ángel (left) and the Presidential Palace (center background), Havana, ca. 1925. 8″ x 10″ gelatin silver print.

C. Jordi Publishers/France. El Ensueño Dancing Room, situated in a park for popular entertainment owned and operated by La Tropical, Cuba's largest brewery. Havana, 1925. 3¹/₂″ x 5¹/₂″ offset litho postcard.

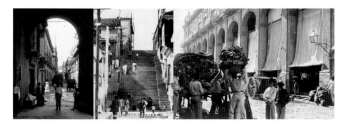

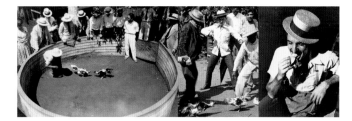

American Photo Studios. An archway leading onto street traffic in Matanzas, 1921. 8″ x 10″ gelatin silver print.

Photographer unknown. Padre Pico Street, Santiago de Cuba, Oriente Province, ca. 1920. 3¹/₂″ x 6″ gelatin silver print.

López. Unloading tobacco at the Tacón Market, Havana, ca. 1905. 5¹/₂″ x 6″ gelatin silver print.

Photographer unknown. A rare instance in which a woman is seen attending a cockfight. Havana, ca. 1930. 6³/₄″ x 4³/₄″ gelatin silver print.

Photographer unknown. Cockfight. Stamped on verso, "from The French Doll Novelty Store Next to Sloppy Joe's Bar, Habana," ca. 1929. 3¹/₂″ x 5¹/₂″ gelatin silver print postcard.

David. A man on the street enjoying a small tropical banana, Havana, November 1, 1951. 4″ x 5″ gelatin silver print.

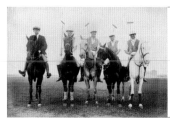

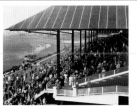

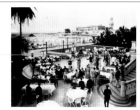

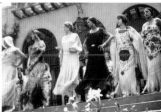

José López López. Havana Polo Team, Marianao, ca. 1915. 5″ x 7″ gelatin silver print.

American Photo Studios. The Oriental Park Racetrack, a favorite leisuretime mecca for Cubans and tourists alike, Marianao, 1924. 8″ x 10″ gelatin silver print.

American Photo Studios. Dancing at the Havana Yacht Club (established in 1886) overlooking La Concha beach, Marianao, 1925. 8″ x 10″ gelatin silver print.

American Photo Studios. Sevillian-themed fashion show with embroidered mantillas, dresses and shawls during Carnavales week, Havana, 1924. 6″ x 9³/₄″ gelatin silver print.

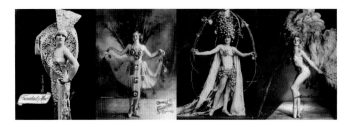

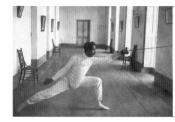

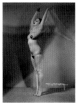

Joaquîn Blez. Spanish operetta star María Caballé in an ad for Trinidad & Hermanos tobacco company, Havana, ca. 1920. 8″ x 10″ gelatin silver print.

Segovia. Entertainer Grecia Dorado in a Trinidad & Hermanos ad, Havana, ca. 1920. 8″ x 10″ gelatin silver print.

Photographer unknown. Model wearing an elaborate grapevine headdress and grape-clustered outfit, Havana, ca. 1920. 8″ x 10″ gelatin silver print.

Vicente Muñiz. Showgirl posing with ostrich fans, Havana, March 13, 1951. 8″ x 10″ gelatin silver print.

Photographer unknown. Ramón Fonst Segundo, the Cuban-American fencer whose victories at the 1900 Olympics in Paris made him the first Olympic medalist from Latin America, Havana, ca. 1910. 6½″ x 8½″ gelatin silver print.

Narcy Studios. A model with veils and sequined under-garments poses for an ad campaign, ca. 1956, Havana. 8″ x 10″ gelatin silver print.

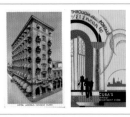

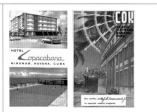

Publisher unknown. Hotel Lincoln, inaugurated in 1927, Havana, ca. 1930. 3½″ x 5½″ offset litho postcard.

El Encanto. Deco cover of an El Encanto department store brochure, 1930. 4″ x 7″ offset litho cardstock.

Colourpictures Publishers, Inc. Hotel Copacabana, Miramar, Havana, 1958. 3½″ x 5½″ offset litho on linen postcard.

Secretaría de Educación–Cuba. Radio news program broadcast acknowledgment from the Palacio de Deportes detailing its DSL frequency, Havana, ca. 1940. 3½″ x 5½″ offset litho postcard.

Photographer unknown. "La Vía Blanca" at dusk, where neon modern lights line the main road leading east out of Havana. June 1, 1958. 5¼″ x 6¾″ gelatin silver print.

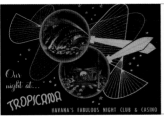 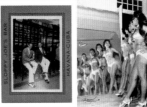 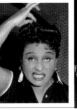

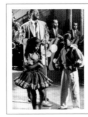 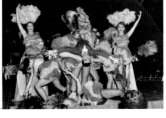

Published by Tropicana Night Club & Casino. Cover artwork for take-home souvenir photos. Marianao, ca. 1957. 8 ½″ x 6″ litho on cardstock.

Photographer unknown. Souvenir of two dapper friends having a drink at Sloppy Joe's, one of Havana's most famous bars, ca. 1948. 7″ x 9″ gelatin silver print.

Foto-Marcos. Lineup of showgirls from the famed Tropicana Nightclub. From left: Erene Sesary, Esperanza Ofarri, María Del Carmen Duquesne Cruz, Eulalia Dominguez Sandino, and Silvie Pedroso. Marianao, Havana, ca. 1954. 8″ x 10″ gelatin silver print.

Photographer unknown. Legendary Cuban performer Beny Moré (El Bárbaro) performs while Perla Rodríguez dances in the foreground, Havana, ca. 1962. 5″ x 7″ gelatin silver print.

Photographer unknown. Celebrated singer and actor Rita Montaner, "La Única" (the one and only). Known for her lyrical

voice and expressive nature, Montaner worked with Josephine Baker in Paris in the late '20s, Havana, ca. 1954. 3½″ x 5½″ gelatin silver postcard.

Vicente Muñiz. A nightclub performance of spirited dancers, Havana, June 8, 1952. 8″ x 10″ gelatin silver print.

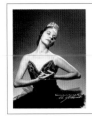 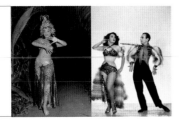 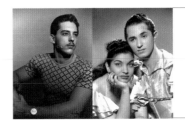

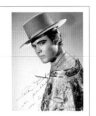

Studio Armand. Prima ballerina Alicia Alonso as captured by Armand, one of Cuba's leading entertainment industry photographers, Havana, ca. 1956. 5½″ x 4½″ gelatin silver print.

Photographer unknown. "Pamela," a vedette at the Sans Souci Nightclub and Casino, Havana, ca. 1955. 8″ x 10″ gelatin silver print.

Narcy Studios. "Rosita" and rumba partner. Narcy was a leading Havana celebrity photographer during the '50s, Havana, 1957. 8″ x 10″ gelatin silver print.

Karóll. Portrait of Cuban actor Juan Soar, Havana, ca. 1958. 8″ x 10″ gelatin silver print. Karóll was renowned for photographing actors and musicians.

Studio Armand. Studio extras, Havana, ca. 1958. 8″ x 10″ gelatin silver print.

Narcy Studios. Pedrito Rico, the Spanish-born singer and actor who was a pop-idol sensation in his day. The print is autographed and addressed to _Bohemia Magazine_ expressing his gratitude to his Cuban fans, Havana, October 1958. 5″ x 7″ gelatin silver print.

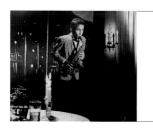
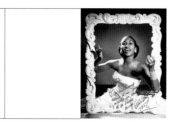

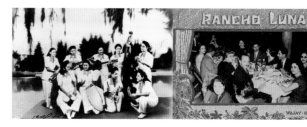

Photographer unknown. The celebrated musician Paquito D' Rivera at age 11 performing during the popular TV program *El Casino de la Alegría*, Havana, 1959. 8" x 7" gelatin silver print.

Studio Armand. Celia Cruz, the legendary "Queen of Salsa," autographed and dated 1952. This portrait of the young Celia Cruz was taken while she was still living in Cuba and head-lining for the famed Sonora Matancera troupe. 8" x 10" gelatin silver print.

Leal Foto. Studio shot against a scenic backdrop of the Orches-tra Anacoana, an orchestral ensemble composed of sisters, Havana, ca. 1948. 4½" x 6½" gelatin silver print.

Foto "Martin." Souvenir photo of a dinner party at the Rancho Luna Restaurant, Wajay, February 2, 1959. 6½" x 10" gelatin silver print encased in cardboard frame.

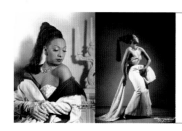
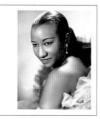
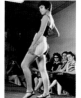

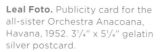
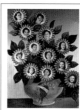
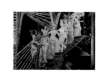
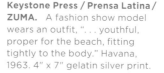

Studio Armand. Two photos of Josephine Baker, American jazz-age legend and performer. This photo sitting was scheduled during her triumphant nightclub performance run in Havana, January 1951. 8" x 10" gelatin silver print.

Narcy Studios. Promotional stamped photo card of Celia Cruz, Havana, ca. 1954. 3½" x 5½" gelatin silver print.

Leal Foto. Publicity card for the all-sister Orchestra Anacoana, Havana, 1952. 3¼" x 5¼" gelatin silver postcard.

Keystone Press / Prensa Latina / ZUMA. A fashion show model wears an outfit, ". . . youthful, proper for the beach, fitting tightly to the body." Havana, 1963. 4" x 7" gelatin silver print.

L.J. Cadenas Publishers. Post-card for the Tropicana nightclub. The promotional writing on the card states: "You will see the most dazzling beauties at this splendorous and world's famous night club and casino." Marianao, ca. 1956. 3½" x 5½" color litho postcard.

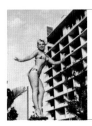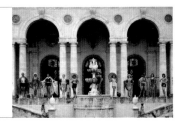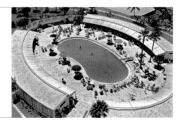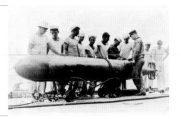

Carlos Uribe Cortés. Mexican film star Yolanda "Tongolele" Montes poses against the Capri Hotel, built in 1958 by New York mobster Santo Trafficante, Havana, 1959. 3¼" x 5" gelatin silver print.

American Photo Studios. Summer fashion show of resort beachwear held at the home of Marcos Pollack, a replica of a Renaissance villa in the country club district near Havana, 1935. 8" x 10" gelatin silver print.

Bohemia Archives. Cuban painter Wifredo Lam (center) along with (left to right) *L'Express* editor Alain Jouffroy, photographer Leo Klatser, and Cuban writers Roberto Fernández Retamar and José Lorenzo. Riviera Hotel, Havana, 1963. 5" x 7" gelatin silver print.

Colourpicture Publications. Aerial view of the Cabana Sun Club and Swimming Pool at the Hotel Nacional, Havana, ca. 1954. 3½" x 5½" color litho postcard.

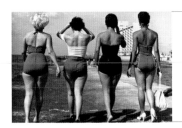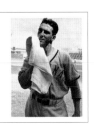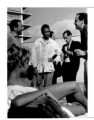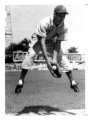

Photographer unknown. Modeling shot of bathing beauties with the latest beachwear and bags, Miramar, Havana, 1959. 4" x 6" gelatin silver print.

Ramón Fernández / RFM Fotos. Cuban baseball star Miguel Fornieles, seen here in a Marianao Tigers uniform, who played for the Boston Red Sox in 1960 and then went on to the All-Stars in 1961, Havana, 1952. 8" x 10" gelatin silver print.

Ramón Fernández / RFM Fotos. Cuban baseball star Willie Miranda, who broke into the major leagues in 1952 at age 24. Seen here in uniform for the Almendares Cuban League team, he also played for the Washington Senators, the New York Yankees, and the Baltimore Orioles, Havana, 1959. 8" x 10" gelatin silver print.

Photographer / Publisher unknown. U.S. Navymen stand over a type MK-10 torpedo, Guantánamo, ca. 1915. 3½" x 5½" gelatin silver print postcard.

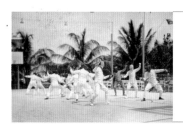 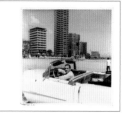

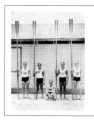 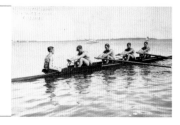

American Photo Studios. Cuban fencing champions training for the 1932 Los Angeles Summer Olympic Games, Havana, 1931. 8″ x 10″ gelatin silver print.

Photographer unknown. A Havana driver in his 1954 Cadillac El Dorado convertible on El Malecón, Havana, 1955. 8″ x 8″ gelatin silver print.

Photographer unknown. Cienfuegos Rowing Team, Cienfuegos, Camagüey Province, ca. 1926. 8″ x 10″ gelatin silver print.

Martínez Otero Estudio Foto-gráfico. Cienfuegos Yacht Club sculling team, Cienfuegos, Camagüey Province, ca. 1930. 5″ x 7″ gelatin silver print.

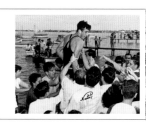 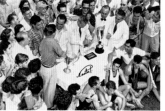

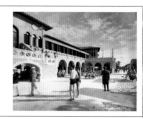 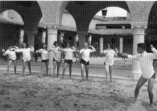

Newton Estapé. Fans cheering the Cienfuegos Yacht Club rowing champions, Cienfuegos, Camagüey Province, 1952. 8″ x 10″ gelatin silver print.

Newton Estapé. Cienfuegos Yacht Club members at the trophy table, Cienfuegos, Camagüey Province, 1952. 8″ x 10″ gelatin silver print.

Publishers Photo Service. Beach pavilion at La Concha beach, Marianao, 1935. 8″ x 10″ gelatin silver print.

Havana Post News. A fencing lesson on La Concha beach, Marianao, ca. 1935. 8″ x 10″ gelatin silver print.

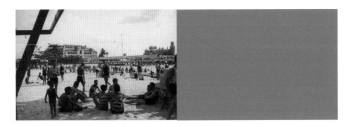

American Photo Studios.
Beachside at Marianao looking
toward the Havana Yacht Club
and the Casino Español (right
background), ca. 1930.
8″ x 10″ gelatin silver print.

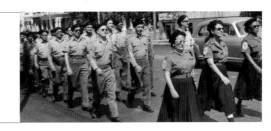

Photographer unknown.
Accessorized *milicianas* and
milicianos (militia women and
men) on the move. During the
first days of the revolution,
these civilian volunteers took
to the streets in government-
commissioned uniforms to show
solidarity for the new regime
headed by Fidel Castro, Havana,
1959. 5″ x 8″ gelatin silver print.

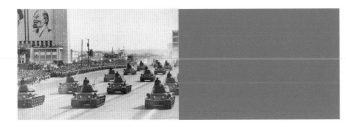

C. Núñez. Military Parade with a
unit of Eastern Bloc–built tanks
rolling by oversized images of
Camilo Cienfuegos and Lenin,
Plaza de la Revolución, Havana,
1962. 8½″ x 14″ gelatin silver print.

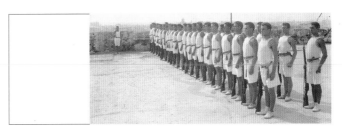

American Photo Studios. Police
Academy cadets practicing their
rifle drills on the Morro Castle
ramparts, Havana, ca. 1924,
8″ x 10″ gelatin silver print.

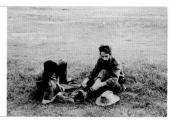

Photographer unknown. Snapshot of Raúl Castro Ruz, brother of Fidel Castro, shortly after arriving in Havana after the Revolution in 1959. 4½" x 3¼" gelatin silver print.

Photographer unknown. Fidel Castro having a close talk with his secretary, Dr. Juan Orta, shortly after taking power in January 1959, Havana. 8" x 10" gelatin silver print.

Photographer unknown. Man sitting at the edge of a mass grave. The "memento mori" photograph, a reminder of one's own mortality, was a popular theme in nineteenth-century photography and art, 1880. 5" x 4" albumen print.

Photographer unknown. Camilo Cienfuegos, a leading figure of the Cuban Revolution, is seen (at right) in early 1959. On October 28, 1959, less than a year after taking power, Cienfuegos' Cessna-310 mysteriously disappeared over the ocean during a night flight from Camagüey to Havana. 8" x 10" gelatin silver print.

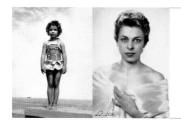 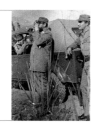

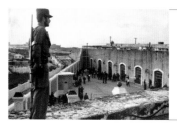

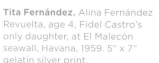

Tita Fernández. Alina Fernández Revuelta, age 4, Fidel Castro's only daughter, at El Malecón seawall, Havana, 1959. 5" x 7" gelatin silver print.

Rembrandt. Natalia Revuelta Clews. A Cuban socialite prior to the Revolution of 1959 and mother of Fidel's daughter,

Alina Fernández Revuelta. Natalia is an advocate of Cuban art and culture, Havana, May 1956. 8" x 10" gelatin silver print.

Photographer unknown. Fidel Castro holding a camera as his driver and escort look on. Unidentified location, 1962. 11" x 14" gelatin silver print.

Corbis / United Press International. A soldier from Castro's army overlooks political prisoners at La Cabaña's prison yard immediately after the toppling of Batista's regime, Havana, January 1959. 8" x 6½" gelatin silver print.

Photographer unknown. Cubans being executed by a Spanish firing squad. The photo was released as propaganda for those opposed to Spanish rule, and ended up in a U.S. soldier's photo album of his tour in Cuba during the Spanish-American War. 1895. 3½" x 4½" albumen print.

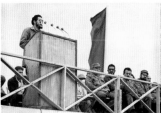
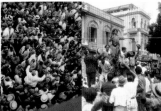
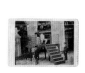

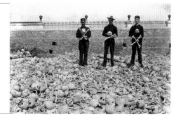

Photographer unknown. Ernesto "Che" Guevara partially obscured by microphones during a speech at Plaza de la Revolución, ca. 1964. 5" x 7" gelatin silver print.

Havana Post News. President Gerardo Machado (foreground, in white jacket) addressing a crowd of supporters outside the

Presidential Palace, Havana, 1932. 8" x 10" gelatin silver print.

International News Service. Joyous throngs surround the man who shot down Col. Antonio Jiménez, head of the "Porra," the secret police of dictator Gerardo Machado, Havana, 1933. 8" x 10" gelatin silver print.

Photographer unknown. A garrote-style execution, most likely staged for the camera, Havana, 1896. 4" x 5³/₄" gelatin silver print.

Photographer unknown. Union Soldiers posing at the Colón Cemetery potter's field, a mass burial field for Cubans who could not afford a proper burial. The field became a popular tourist destination beginning in the 1850s, Havana, 1902. 5" x 7" gelatin silver print.

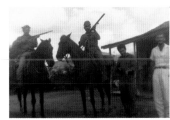

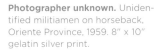
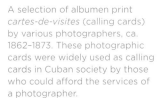

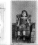

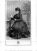

Photographer unknown. Unidentified militiamen on horseback, Oriente Province, 1959. 8" x 10" gelatin silver print.

Palacio del Arte. A young boy poses with his tiny toy horse, Havana, January 9, 1864. 4¹/₂" x 2¹/₂" albumen *carte-de-visite*.

A selection of albumen print *cartes-de-visites* (calling cards) by various photographers, ca. 1862–1873. These photographic cards were widely used as calling cards in Cuban society by those who could afford the services of a photographer.

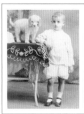
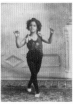
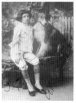
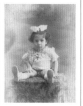

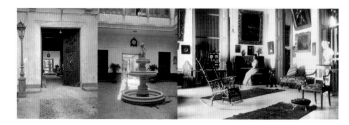

Ruíz de Castro & Sons. Marcelino Broscia Giroud, age 5, with his poodle, Camagüey, December 6, 1914. 3¼″ x 5¼″ gelatin silver print postcard.

Ramón Carreras. A dancing child, Havana, ca. 1912. 4½″ x 6½″ gelatin silver cabinet card.

Colominas y CA. Pepito Arriola, Spanish child prodigy pianist and master violinist, at age 10, photographed in Havana during a tour, April 15, 1910. 3½″ x 5½″ gelatin silver print postcard.

Ramón Carreras. Inscribed on verso: "My son, Ignacíto, 20 months, March 20, 1910." 4½″ x 6½″ cabinet card.

American Photo Studios. Door leading into the Palacio Balboa, a private residence built in 1871 by a Spanish functionary, later torn down and replaced with a government building of the same name, ca. 1920. 8″ x 10″ gelatin silver print.

American Photo Studios. Inner courtyard of the Palacio Balboa, Havana, ca. 1920. 8″ x 10″ gelatin silver print.

Photographer unknown. A woman poses in the drawing room of an upper-class Cuban family home, Havana, ca. 1900. 8″ x 10″ gelatin silver print.

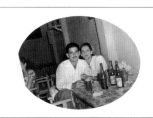
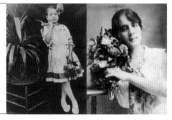

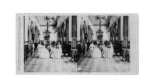

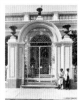

Benítez. Newlyweds police lieutenant René Castro and Olimpia Castro, age 20, at the "El Bohío" bar and cantina, Victoria de Las Tunas, Oriente Province, 1949. Oval 9½″ gelatin silver print.

J. M. Quintero. Jesús Rita Alanes, Santiago de Cuba, Oriente Province, March 13, 1913. 4″ x 6″ gelatin silver print.

Colominas y Co. Portrait of Hortensia Lisazo Machado at age 18, the collector's grandmother, who inspired the formation of this collection, Havana, 1918. 3½″ x 5″ gelatin silver print postcard.

Published by E. Anthony, New York. The gallery at the Palace of the Conde de Santovenia, Havana, ca. 1862. 3″ x 7¼″ albumen print stereograph.

Publishers Photo Service. Fanciful iron gates at the Francisco López García residence, built in 1888, El Vedado, Havana, ca. 1920. 8″ x 10″ gelatin silver print.

U.S. Corps of Engineers. Groundskeeper and girl at the Castillo del Príncipe fortress. Built by the German engineer Agustín Crame beginning in 1767, the name of "El Príncipe" (The Prince) was given to it to honor the son of King Carlos III, Havana, 1900. 8″ x 10″ gelatin silver print.

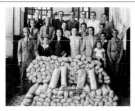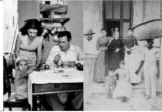

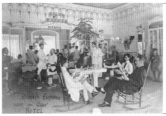

Hernández Foto. Boy Scouts and Lions Club members during a blanket drive for the poor pose for the *Diario de la Marina* newspaper, Villaclara, Las Villas Province, 1944. 5" x 7" gelatin silver print.

Louis Hamburg. Catalino Delgado Morales, wife Violeta, and son Geraldo sharing a noonday meal, Havana, 1947. 8" x 10" gelatin silver print.

Photographer unknown. A baker (left) making a delivery to a door full of family and neighborhood members, Havana, ca. 1885. 8" x 10" albumen print.

Benito Fonseca. "Salon Viena" barbershop, a gentlemen's retreat situated within the Gran Hotel Havana, 1912. 5¼" x 5½" gelatin silver print postcard.

Photographer unknown. "La Bodega," a dry goods store where foodstuffs, hardware, and local gossip all came together. Güines, Province of Havana, 1907. 8" x 10" gelatin silver print.

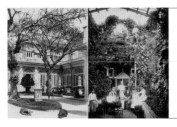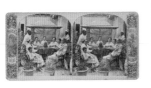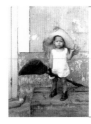

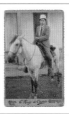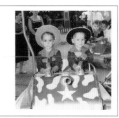

Attributed to Mackson. Courtyard of "Las Delicias," the residence of the Countess Abreu, El Cerro, Havana, ca. 1905. 5" x 7" gelatin silver print.

Photographer unknown. Courtyard of a Cuban house, Havana, 1900. 8¼" x 6" gelatin silver print.

Webster's Photograph Rooms. A well-to-do Cuban family gathered around a verdant patio for breakfast, from Tropical Series no. 9, "Breakfast Room," 1875. 3½" x 7" albumen print stereograph.

Photographer unknown. Titled "Forward March" on the photo, a boy mimics a horse and rider as if participating in the liberation against the Spanish army, ca. 1897. 5" x 7" gelatin silver print.

C. Ruíz de Castro. Teenager on a horse, Matanzas, ca. 1885. 6½" x 4½" gelatin silver print cabinet card.

Photographer unknown. Roy and René Cifuentes on a carousel toy tank, Camagüey, 1959. 8" x 10" gelatin silver print.

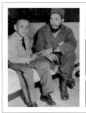
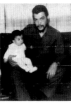
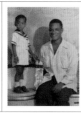
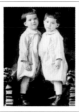
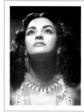

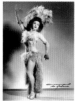
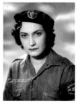
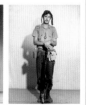

Corbis / United Press International. Castro and son Fidel Castro Díaz-Balart, 1959. Castro married Mirta Díaz-Balart in 1948 and their son was born in 1949. 8" x 10" gelatin silver print.

Photographer unknown. Ernesto "Che" Guevara with his daughter Celia, Nuevo Vedado, Havana, 1964. 16" x 12" gelatin silver print.

Diago. Pedro "Perucho" Formental, a Cuban baseball legend, with son Tomás. Havana, July 10, 1948. 8" x 10" gelatin silver print.

Commercial Photographic Co. The famed "Cuban Siamese Twins," Guadalupe and Josefina, born in Havana on November 15, 1912. Havana, ca. 1915. 3½" x 5½" gelatin silver print postcard.

Studio Armand. Portrait of singer Vivian Calero, Havana, 1958. 8" x 10" gelatin silver print.

Studio Armand. Portrait of a *miliciana,* a new breed of Cuban women who were proud to be photographed in military garb but in pre-revolutionary style glamour lighting, Havana, 1959. 8" x 10" gelatin silver print.

Studio Armand. Carlos "Bobby" de Castro, female impersonator, Havana, 1958. 8" x 10" gelatin silver print.

Studio Espinosa. Jesús Villafuente, a Castro militiaman who fell during the Bay of Pigs invasion of April 1961. Cienfuegos, dated 1962. 8" x 10" gelatin silver print.

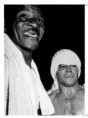
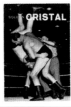

Photographer unknown. Boxer Antonio "Puppy" García (right) with trainer Gabriel López a.k.a. "WeWe" Barton, Havana, 1953. 8" x 10" gelatin silver print.

Photographer unknown. Cover of *Boletín Cristal* magazine published by La Tropical Breweries, Havana, November 1958. 7½" x 10½" offset litho.

Newton Estapé. Antonio "Puppy" García, featherweight boxer and one of the era's biggest crowd-pleasing idols, Havana, 1952. 5" x 8" gelatin silver print.

Photographer unknown. Bodybuilders, trainers, and friends, Nícaro, Oriente Province, 1952. 5" x 7" gelatin silver print.

Karóll. Manolo Zurita, bodybuilder, Havana, ca. 1955. 8" x 10" gelatin silver print.

Karóll. Studio portrait of an oiled bodybuilder, Havana, ca. 1956. 11" x 7" gelatin silver print.

 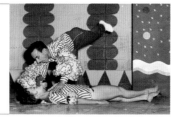

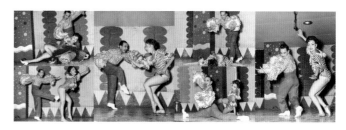

Photographer unknown. Wrestlers from *postalitas* (paste-on cards). Titled "Lucha" from Album Universal (Around the World) Sports Series no. 220, the album was published by Susini, the Cuban cigarette company, ca. 1915. 2" x 2½" offset litho.

Photographer unknown. "The Ana Gloria y Rolando Act," a rumba dance sequence that appeared in a Cubana Airlines inflight magazine promoting tourism to Cuba, Havana, 1957. 8" x 10" gelatin silver print.

Photographer unknown. A montage from "The Ana Gloria y Rolando Act," Havana, 1957. 8" x 10" gelatin silver prints.

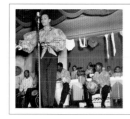 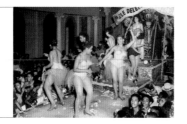

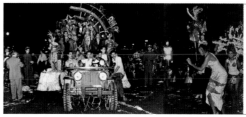 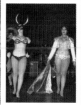

Vicente Muñiz. Legendary Cuban singer Luis Carbonell performing a folk musical number by a clothesline, which depicts a "solar," the communal shared area in a tenement. Havana, dated May 5, 1954. 8" x 10" gelatin silver print.

Foto Jiménez. A float of dancing girls during Carnavales (Easter) in Baracoa, Oriente Province, 1956. 8" x 10" gelatin silver print.

Vicente Muñiz. The Tropicana Nightclub and Casino float during Carnavales (Easter), Havana, 1954. 8" x 10" gelatin silver print.

Photographer unknown. Dancing in the streets during Carnavales (Easter), Havana, Cuba, ca. 1955. 11" x 14" gelatin silver print.

Photographer unknown. Nightclub act with Isaura Almageros (right) in a *torero* outfit, titled "Magia Española" (Spanish Magic), Havana, ca. 1956. 5" x 7" gelatin silver print.

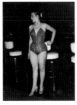
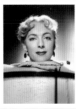
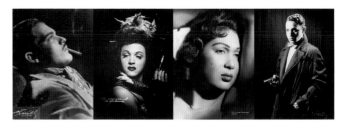

Cover art for the Sans Souci Nightclub and Casino souvenir photo. The cost per photo was $1.50, with a minimum purchase of two. Havana, 1957. 8½″ x 6½″ offset litho cardboard.

Photographer unknown. Lidia Milián, a nightclub personality, Havana, ca. 1958. 8″ x 10″ gelatin silver print.

Narcy Studios. Christine Jorgensen, the Danish-American born George William Jorgensen Jr. who became a media sensation upon her 1952 sexual reassignment operation. Jorgensen posed for Narcy in Havana while on a performing tour, 1955. 8″ x 10″ gelatin silver print.

Karóll. Portrait of model and actor Tito Ramos, Havana, 1957. 3½″ x 5½″ gelatin silver print postcard.

Studio Armand. The fabulous Bobby de Castro, female impersonator, Havana, 1959. 8″ x 10″ gelatin silver print.

Thomas. Legendary singer and performer Olga Guillot, "Queen of Bolero," ca. 1956. 8″ x 10″ gelatin silver print.

Karóll. Portrait of model and actor Juan C. Carlís, Havana, 1955. 8″ x 10″ gelatin silver print.

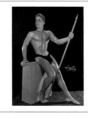
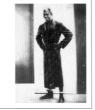
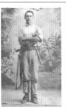
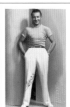
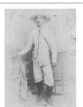

Photographer unknown. Silvia Aguirre, dancer and performer at the Tropicana Club, Havana, 1957. 8″ x 10″ gelatin silver print.

Juminil. Cuban boxing sensation Kid Chocolaté (Eligio Sardiñas), twice titled lightweight world champion photographed in Barcelona, 1933. 10″ x 6½″ gelatin silver print.

Karóll. Beefcake studio shot of Rolando Lopez. Note the modest bathing suit drawn in by a censor, Havana, 1958. 8″ x 10″ gelatin silver print.

Photographer unknown. A palm tree climber with belt and tools photographed in a studio, ca. 1890. 3½″ x 5½″ gelatin silver print postcard.

Merayo. Argentinian Tango singer and actor "Charlo" (Carlos Pérez de la Riestra), Havana, ca. 1930. 4″ x 6″ gelatin silver print.

J.M. Yzaguirre. Portrait of Cuban freedom fighter Lorenzo Dilla, Regla, Cuba, January 29, 1899. 4¼″ x 6½″ albumen print cabinet card.

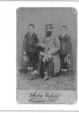
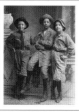
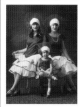
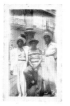
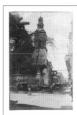
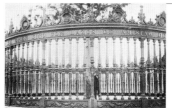

Andrés Cabeira. Andrés Díaz with his sons César and Octavio Díaz-Gómez, Cienfuegos, 1873. 4½″ x 6½″ albumen cabinet card.

Photographer unknown. Three friends: José, Alberto, and Humberto, Camajuaní, Province of Las Villas, September 21, 1912. 3½″ x 5½″ gelatin silver print postcard.

El Arte. Three sisters, Havana, ca. 1920. 5¼″ x 3½″ gelatin silver postcard.

Photographer unknown. Three teenagers in hats, Havana, 1953. 3″ x 4½″ gelatin silver print.

República de Cuba / Obras Públicas. Circular iron fence surrounding a Ceiba tree planted during the Pan-American Conference of 1929, Havana, ca. 1940. 8″ x 10″ gelatin silver print.

Javier G. Salas. René Portela Armengal, the Chess Champion of Guanabacoa, Havana, ca. 1900. 4½″ x 6½″ albumen print cabinet card.

Javier G. Salas. Portrait of Mario Portela, Havana, ca. 1900. 4½″ x 6½″ albumen print cabinet card.

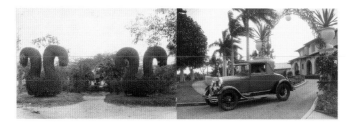
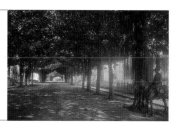

American Photo Studios. Topiary trees at the University of Havana Botanical Gardens, Havana, ca. 1925. 8″ x 10″ gelatin silver print.

American Photo Studios. Two female motorists, in a 1929 Model A Ford Cabriolet, Havana, 1930. 8″ x 10″ gelatin silver print.

Photographer unknown. The Church of Belén. Constructed between 1712 and 1718, it was the first baroque religious building in Havana. ca. 1905. 4½″ x 6½″ gelatin silver print.

Photographer unknown. A canopied lane in Colón Cemetery with a guardsman on the right, Havana, ca. 1925. 8″ x 10″ silver gelatin print.

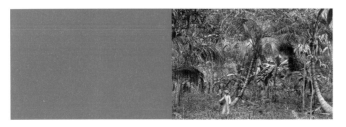

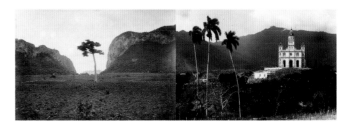

Miles. Tree-climber and fruit-picker in a wild grove of mango, banana, and coconut palms, ca. 1885. 8″ x 10″ platinum print.

American Photo Studios. A majestic Ceiba tree (silk-cotton tree) framed by the Valley of Viñales, Pinar del Rio Province, 1920. 8″ x 10″ gelatin silver print.

O. de la Torre / Govt. Public Works Office. Sanctuary of the Caridad del Cobre, Cuba's patron saint, seen from the main road, El Cobre, near Santiago de Cuba, Oriente Province, 1956. This picture is an example of the photography commissioned by the Ministry of Public Works to record historical structures throughout the island. 8″ x 10″ gelatin silver print.

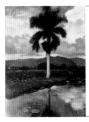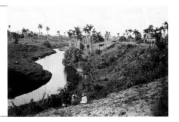

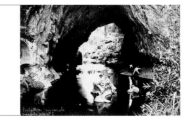

Photographer unknown. The Royal Palm Tree (*Roystonea regia*) is the country's most distinctive tree, appearing in Cuba's state seal, ca. 1930. 8″ x 10″ hand-tinted gelatin silver print.

José A. Soroa. Almendares River landscape, outside Havana, 1883. 8″ x 10″ albumen print.

José Gómez de la Carrera. Por-tales de Caiguanabo, southern entrance, Pinar del Río prov-ince, November 4, 1895. These limestone caves in the western part of the island were the hiding place of Che Guevara during the Cuban Missile Crisis of 1962. 8″ x 10″ gelatin silver print.

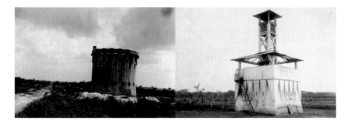

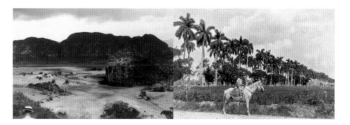

Mackson. A blockhouse. These Spanish army rural fortifications were built along the narrowest part of the island in order to keep Cuban insurgents (Mambíses) from marauding during the struggle for Cuban independence. Located between Júcaro and Morón, Camagüey Province, ca. 1896. 5″ x 7″ gelatin silver print.

Miles. A blockhouse located between Júcaro and Morón, Camagüey Province, 1883. 8″ x 10″ platinum print.

Photographer unknown. Viñales Valley, with indigenous limestone outcroppings called *mogotes* by the locals, is a UNESCO world heritage site and has always been a popular tourist destination, Pinar del Río Province, 1924. 8″ x 10″ gelatin silver print.

Photographer unknown. A youth with a milk canister on horseback, Pinar del Río, ca. 1925. 8″ x 10″ gelatin silver print.

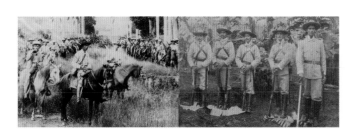

José Gómez de la Carrera. Cuban insurgents (Mambíses) fighting against Spanish rule in the War of Independence, 1895-1898, ca. 1896. 4″ x 5″ albumen print.

Photographer unknown. Cuban army officers during the War of Independence, neatly standing on banana leaves, ca. 1897. 8″ x 10″ albumen print.

José Gómez de la Carrera. Four children paired with four Royal Palms, Havana, 1891. 8″ x 9″ albumen print.

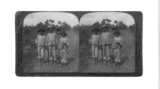

H.C. White Co. Publishers.
A shaded tobacco field within a palm grove, Province of Havana, ca. 1905. 3½" x 7" gelatin silver print stereograph.

H.C. White Co. Publishers.
Cuban boys, Province of Havana, Cuba, ca. 1905. 3½" x 7" gelatin silver print stereograph.

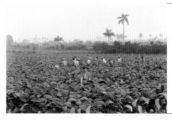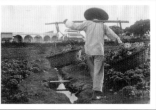

G. Blaín. A field overseer amidst a tobacco crop with workers in the background, Pinar del Río, 1900. 5" x 7" gelatin silver print.

Mackson. Chinese field worker in a lettuce patch, outside Havana, 1905. 5" x 7" gelatin silver print.

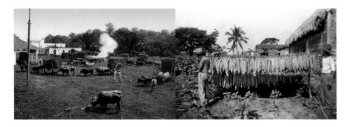

Detroit Photographic Co.
"Weighing sugarcane before unloading it at a mill," 1904. 8" x 10" photochrom. The Swiss "Photochrom" process, later known as Aäc, was used for converting black-and-white photographs to color prints. The prints were made by a photo-mechanical process using multiple lithographic stones.

American Photo Services.
Tobacco leaves drying, Havana Province, ca. 1920. 8" x 10" gelatin silver print.

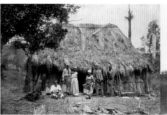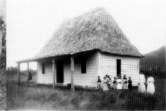

José Gómez de la Carrera.
A rural Cuban-African family. Titled "Los Mas Viejos" (The Elders), 1886. 8½" x 6½" albumen print.

Barrie. A rural schoolhouse with palm thatched roof and a Spanish tiled porch overhang, Oriente Province, 1905. 5" x 7" gelatin silver print.

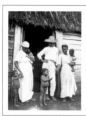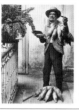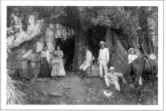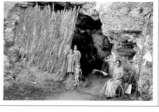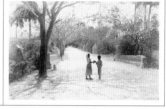

American Photo Studios. Rural household, Havana Province, ca. 1920. 8″ x 10″ gelatin silver print.

Published by Norddeutscher Lloyd, Bremen. Tobacco vendor, from a postcard series published in Germany on Cuba's folkways. Havana, February 14, 1914. 3½″ x 5½″ gelatin silver print.

Miles. Cuban family living in a limestone cave with a palm frond front, Pinar del Rio, 1885. 9½″ x 7½″ platinum print.

Miles. Cuban mother and her children recently freed from a Spanish concentration camp, living in a limestone cave with a front constructed of tree branches, 1885. 8″ x 10″ platinum print.

Angel Mental. Two children by a bridge exchanging a plant cutting, outside Havana, ca. 1890. 5″ x 7″ albumen print.

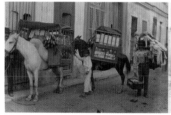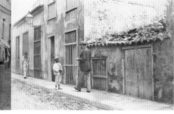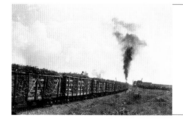

José Gómez de la Carrera. Door-to-door street vendors making house calls, 1891. 8″ x 10″ albumen print.

Pérez-Beato Collection. A sidewalk exchange in front of the well-documented "smallest Colonial house in Havana," ca. 1910. 3½″ x 5″ gelatin silver print.

Mackson. A train car loaded with cut sugar as it heads for a mill, 1905. 5″ x 7″ gelatin silver print.

Photographer unknown. A Union soldier escorting a Cuban family left homeless due to the Spanish-American war, ca. 1899. This photo came from a U.S. soldier's album. 4″ x 4½″ gelatin silver print mounted on board.

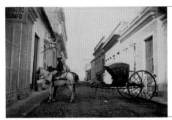 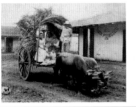

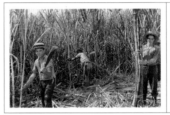 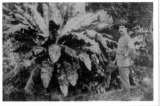

Photographer unknown. A *calesero*, or carriage driver, with an empty *volanta* (an indigenously designed carriage with two oversized wheels made to go through deep mud), Matanzas Province, ca. 1880. 9" x 6³/₄" albumen print.

José Gómez de la Carrera. Family outing on ox-driven cart near Havana, 1888. 7¹/₂" x 9¹/₂" albumen print.

Photographer / publisher unknown. Boys cutting sugarcane, ca. 1956. 3" x 5" gelatin silver print postcard.

Photographer unknown. A man poses with a giant fern at the University of Havana botanical gardens, Havana, 1888. 9³/₄" x 7³/₄" albumen print.

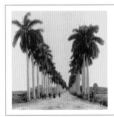 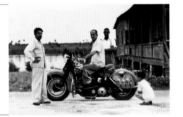

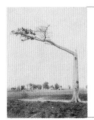 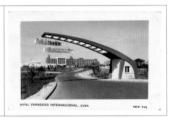

José Gómez de la Carrera. Avenue of Royal Palms, the stately driveway to the "Quinta de los Palatinos" residence, also known as "Las Delicias," El Cerro, Havana, 1889. 9¹/₂" x 7³/₄" albumen print.

Photographer unknown. A Harley-Davidson motorcycle owner shows off his embellished bike, ca. 1948. 13¹/₂" x 10¹/₂" gelatin silver print.

Photographer unknown. A hangman's tree near Havana, where many Cubans were hanged by the Spanish, 1900. 4" x 5¹/₂" gelatin silver print.

Foto Cue. Entrance to Hotel Varadero Internacional. Written on the postcard: "We are having a delightful time and really living like millionaires. This place is paradise. Love Martha Stevens." 1958. 3¹/₂" x 5¹/₂" gelatin silver print postcard.

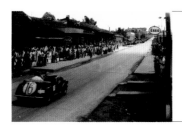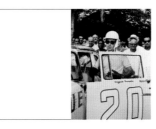

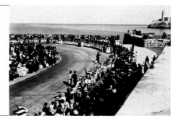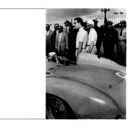

Romay Laboratorio Fotográfico. Cuban driver Manuel Edesio Muñiz in a 1952 MG-TD driving through Artemisa, Pinar del Río Province, on the Pinar del Río–Havana Race, May 20, 1954. 8″ x 10″ gelatin silver print.

M. Lavieler. Cuban racer Santiago "Chaguito" González about to enter his Ford during the Sagua-Havana race, October 1956. 8″ x 10″ gelatin silver print.

Foto Dano. Alfonso Gómez-Mena, Cuba's premier driver, in a Jaguar D Type car on El Malecón during the I Gran Premio (Grand Prix), Havana, February 17, 1957. 8″ x 10″ gelatin silver print.

Photographer unknown. A crowd-drawing event with Cuban flags at the harbor's entrance (La Punta) with El Morro castle seen in the background, Havana, February 24, 1902. 8″ x 10″ gelatin silver print.

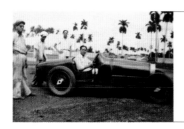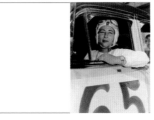

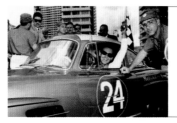

Photographer unknown. Raul Franco Reinoso, Cuban racecar driver and maker, in a Bugatti T37, near Havana, 1932. 8″ x 10″ gelatin silver print.

Albuquerque Foto. Cuban female racecar driver Lutgarda Montero during the Sagua-Havana Race, 1955. 8″ x 10″ gelatin silver print.

Aurelio González. Santiago "Chaguito" González in his Mercedes 300SL Gullwing after winning one of the races at the I Gran Premio (Grand Prix), Havana, February 17, 1957. 8″ x 10″ gelatin silver print.

Paco Miralles. Italian racer Eugenio Castellotti by his Ferrari 860 Monza during the I Gran Premio (Grand Prix), Havana, February 17, 1957. 8″ x 10″ gelatin silver print.

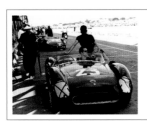

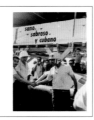

Ted Walker/Ferret Photographics. Cuban driver Elías Regalado in a Ferrari #23 at the Gran Premio Libertad, the last grand prix car race before they were suspended by Castro, Havana, February 1960. 8" x 10" gelatin silver print.

Tita Fernández. Alfonso Gómez-Mena with his Ferrari GT-250 at the Gran Premio Libertad Grand Prix Race, Havana, February 28, 1960. The young Ramiro Fernández can be seen standing in the pits behind the driver. 8" x 10" gelatin silver print.

Leonar. Cutout studio photo of a teenager aboard a bi-winged plane with the El Morro Castle backdrop. The words "Cuba" and date "1925" appear on the back of the fuselage. 5¹/₂" x 3¹/₂" gelatin silver print postcard.

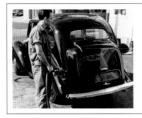

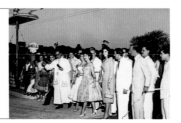

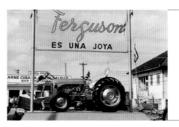

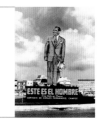

Photographer unknown. A man filling up a new English-made 1948 Hillman Minx with gas, Havana, 1949. 8" x 10" gelatin silver print.

Augusto Photo Comercial. A priest and his fashionable flock attend the opening ceremony and blessing of a new Shell gas station near Havana, ca. 1957. 5" x 7" gelatin silver print.

Photographer unknown. A Massey Ferguson 35 Diesel Tractor for sale under a sign that states: "It's a Jewel," Havana, 1960. 5" x 7¹/₂" gelatin silver print.

Corbis / United Press International. A 35-foot presidential campaign sign of Cuba's president-dictator, Fulgencio Batista. The sign reads, "This is The Man." In the right background, the U.S. embassy can be seen, Havana, August 1954. 8" x 10" gelatin silver print.

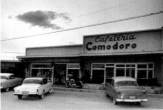

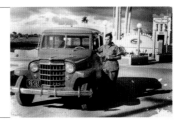

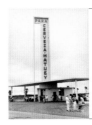

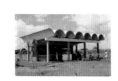

Laboratorios Milton, S.A. A pharmaceutical promotional card for "Broncominal" bronchitis drops, 1950. The company was founded and operated by J. Ramiro Fernández, father of the collector. 4″ x 8″ plastic coated board.

Cooperativa Fotografica. Comodoro Cafetería, an example of 1950s modern-styled shopping establishments, Miramar, December 17, 1953. 5″ x 7″ gelatin silver print.

Paco Altuna. Modernist bus station with a large Hatuey Beer sign incorporated into its design, Manacas, Santa Clara, 1954. 8″ x 10″ gelatin silver print.

Photographer unknown. A driver stands beside his Jeep Willys station wagon on the Central Highway, 1958. 3½″ x 5½″ gelatin silver print postcard.

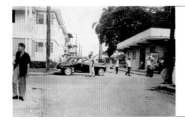

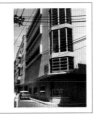

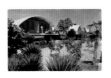

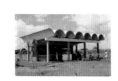

Photographer unknown. A car accident at a neighborhood intersection, Varadero, Matanzas Province, 1954. 8″ x 10″ gelatin silver print.

Photographer unknown. Modernist building with jalousie windows, Central Havana, 1956. 8″ x 10″ gelatin silver print.

Arti-Krome for Artes Graficas S.A. Modernist beach houses for tourists, Jibacoa, ca. 1956. 3½″ x 5½″ offset litho postcard.

Arti-Krome for Artes Graficas S.A. Sanguily Cafeteria, built by the Cooperative Agricola, Camagüey. This outdoor café was an example of early revolutionary architecture, ca. 1964. 3½″ x 5½″ offset litho postcard.

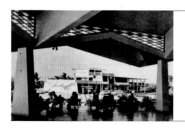

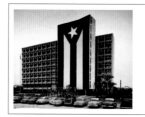

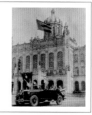

Ministerio de la Construcción. "Guarda La Barca" beachside accommodations, Banes, Oriente Province, ca. 1964. 3¹/₂″ x 5″ offset litho postcard.

Servifoto. The nearly completed FOCSA apartment building at night. Built by Ernesto Gómez Sampera and Martin Domínguez, the building boasted 28 floors and 375 apartments, Vedado, Havana, 1955. 8″ x 10″ gelatin silver print.

Tribunal Newspaper Archives. An enormous Cuban flag adorns the Office of the Comptroller, a Havana Gold Medal prize-winner for Architecture in 1953 by Aquiles Capablanca, Havana, 1955. 8″ x 10″ gelatin silver print.

Photographer unknown. Friends out for a drive in a 1926 Studebaker Big-6 touring car displaying American flags, in front of the Presidential Palace, Havana, 1929. 3″ x 4¹/₂″ gelatin silver print.

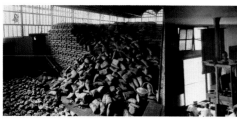

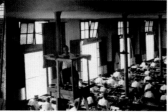

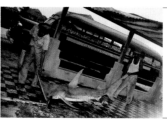

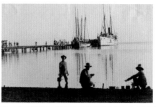

American Photo Studios. Sugar warehouse where linen sacks await shipment to the ports for export. Sugar was Cuba's leading cash crop. Havana, ca. 1925. 8″ x 10″ gelatin silver print.

Ewing Galloway, N.Y. A reader above a cigar-rolling factory floor. Many classics were read aloud in order to keep the laborers from idle conversation, and for some it became intellectual stimulation, Havana, 1933. 8″ x 10″ gelatin silver print.

Photographer unknown. Two commercial fishermen with a hammerhead shark, whose value was in its skin, fat, and meat. Playa Cajío, Havana Province, ca. 1953. 5″ x 7″ gelatin silver print.

Mackson. Three fishermen after a meal, Batabanó, Havana Province, 1905. 5″ x 7″ gelatin silver print.

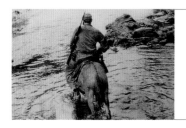

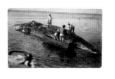

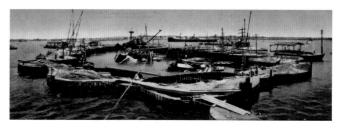

Photographer unknown. Fidel Castro on horseback in the Sierra Maestra Mountains, Oriente Province, 1958. 8″ x 10″ gelatin silver print.

Luis Sánchez Fotógrafo. A stranded Sei whale being climbed upon on the northern coast of Pinar del Río. Inscribed "dedicated to my brother," signed Higinio Ruiz, January 31, 1922. 3¹⁄₂″ x 5¹⁄₂″ gelatin silver print postcard.

Published by The Parthenon Souvenir Shop. The battleship U.S.S. *Maine* with its salvage drydock, Havana, 1899. The ship was destroyed in an explosion on February 15, 1898. 3¹⁄₂″ x 11″ offset litho joined postcards.

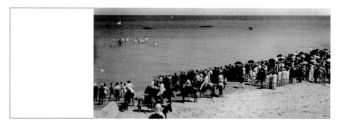

Photographer unknown. Horses bathing at La Punta, the entrance to the Havana harbor, ca. 1885. 8″ x 10″ albumen print.

American Photo Company. Spectators, some on horseback, watch a rowing race, Marianao, ca. 1920. 8″ x 10″ gelatin silver print.

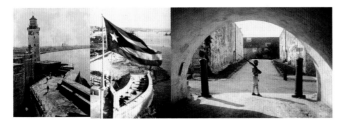

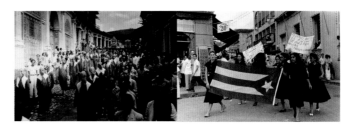

American Photo Studios. Tourists on El Morro ramparts with the view of Havana in the background, 1924. El Morro was built in the sixteenth century by Juan Bautista Antonelli, an Italian military architect. 8″ x 10″ gelatin silver print.

Photographer unknown. Tourist snapshot of the Cuban flag at El Morro Castle looking toward Havana Harbor, from a family album, 1932. 8″ x 10″ gelatin silver print.

Brown & Dawson. An armed guard framed by two cannons at El Morro, Havana, ca. 1920. 8″ x 10″ gelatin silver print.

Photographer unknown. Good Friday procession during Holy Week coming down Desengaño Street with hooded Catholic members of the brotherhood accompanying the Holy Sepulcher (seen in the center background), Trinidad, Las Villas, ca. 1954. 5″ x 7″ gelatin silver print.

Carlos and Guillermo Morales. Protesters during the Batista regime, with placard reading, "Against the assassination of our sons," signed "Cuban Mothers," Santiago de Cuba, 1957. 5″ x 7″ gelatin silver print.

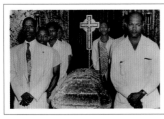

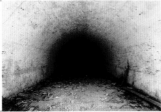

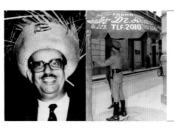

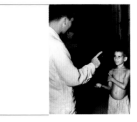

Photographer unknown. Unidentified wake with Cuban boxing legends Kid Chocolaté (left foreground) and Kit Tunero (right foreground) with other pallbearers, Havana, ca. 1946. 8″ x 10″ gelatin silver print.

U.S. Corps of Engineers. A littered tunnel within the Morro Castle compound, Havana, 1901. 8″ x 10″ gelatin silver print.

Studio Naranjo. Dr. Osvaldo Dorticos Torrado, who served as President of Cuba under Fidel Castro during the first years of the Revolution and later ended his own life, Havana, 1960. 3½″ x 5½″ gelatin silver print.

Photographer unknown. A traffic policeman under an ad-filled umbrella for a pharmacy owned

by Dr. Álvarez Fuentes, known for his comments comparing then-president Ramón Grau San Martin's gestures to those of a chicken, Camagüey, 1947. 8″ x 10″ gelatin silver print.

Photographer unknown. Public service photo advising citizens to discourage begging, Havana, 1950. 8″ x 10″ gelatin silver print.

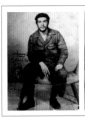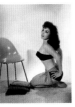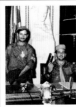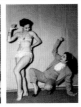

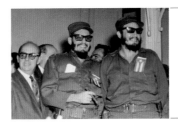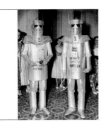

Studio Naranjo. Ernesto "Che" Guevara in a rare studio photo session, Havana, 1959. 8" x 10" gelatin silver print.

Narcy Studios. Mary Esquivel, model, Havana, 1958. 8" x 10" gelatin silver print.

Corbis / United Press International. Castro's militiamen occupying the desk of President Fulgencio Batista, Presidential Palace, Havana, January 10, 1959. 6½" x 7" gelatin silver print.

Mayea Rodríguez. Two performers practicing their stage act, Havana, ca. 1957. 8" x 10" gelatin silver print.

B. Corrales. Castro impersonator Armando Roblán (center) and Fidel Castro during one of several appearances together in Havana, 1959. Roblán later left Cuba and took up his routine in the United States. 8" x 10" gelatin silver print.

Jesús Busto Santiago. Silver spacemen from Mars with the slogan "On Mars We Drink Hatuey" written on their costumes to promote the locally produced beer, Camagüey, ca. 1954. 8" x 10" gelatin silver print.

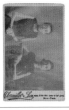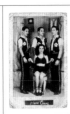

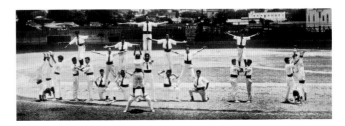

Obermüller and Son. George and Emma Martín, brother-and-sister survivors of Spanish concentration camps in Cuba. Photographed at the Pan-American Exposition of 1901, New York. 4¼" x 6¼" gelatin silver cabinet card.

News clipping about George and Emma Martín pasted on the back of the cabinet card.

Julio Álvarez. "The Changs," a Chinese-Cuban acrobat brother-and-sister team, Cárdenas (Matanzas Province) ca. 1925. 3½" x 5½" gelatin silver postcard.

J. Segovia (La Artística). Familia Pacheco, a Cuban acrobat family, Pinar Del Río, 1919. 3½" x 5½" gelatin silver print postcard.

Photographer unknown. High school students practicing their acrobatic routines on the Polar Brewery grounds, Havana, ca. 1930. 17" x 3½" joined gelatin silver prints.

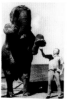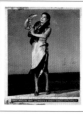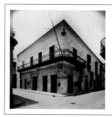

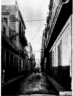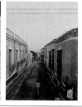

Photographer unknown. "Chiquita," the Cuban Atom. Alice Espiridiona was 26″ tall and weighed 18 pounds. 4¼″ x 6½″ gelatin silver cabinet card.

Pepe Miralles. Ernest Hemingway with an elephant from the Ringling Bros. and Barnum & Bailey Circus on El Malecón, Havana, 1955. 4¾″ x 7″ gelatin silver print.

Ringling Bros. and Barnum & Bailey. Snake charmer Carmen María Josefina on the seawall of El Malecón, Havana, ca. 1950–51. 8″ x 10″ gelatin silver print.

Moré. "The Brinets" telepathic duo, who performed with the Cuban circus "Santos y Artigas," Havana, ca. 1952. 3½″ x 5½″ offset litho card.

American Photo Studios. Casa de Marqués de Almendares, at the intersection of Mercaderes and Amargura streets. This building is a fine example of a Colonial-era house built from local Coquille stone during the late eighteenth century, Havana, ca. 1920. 8″ x 10″ gelatin silver print.

American Photo Studios. Rain-soaked Cuba Street looking north, where El Morro can be seen in the background, Havana, 1924. 8″ x 10″ gelatin silver print.

Photographer unknown. Overhead view of San Pedro Street from Plaza de Armas, Santiago de Cuba, Oriente Province, ca. 1880. 8″ x 6″ albumen print.

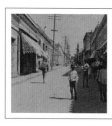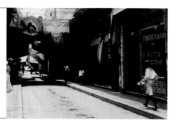

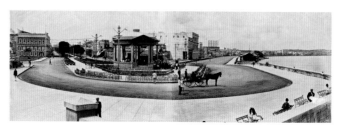

Photographer unknown. Enramadas Street, Santiago de Cuba, Oriente Province, 1898. 3½″ x 4″ cyanotype mounted on cardboard.

Ángel Mental. A boy glances fleetingly at the camera on Obispo Street, Havana, ca. 1905. 5″ x 7″ gelatin silver print.

Photographer unknown. La Punta, with the La Glorieta bandshell in the center, El Paseo del Prado on the left, and the beginning of El Malecón on the right, Havana, 1895. 9¼″ x 17½″ albumen silver print diptych.

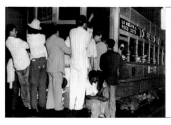 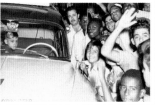

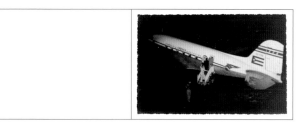

Photographer unknown.
Hangers-on aboard a Havana
inner-city-line streetcar, ca. 1955.
8″ x 10″ gelatin silver print.

Foto Mencho. Crowds gather
around a car with a loudspeaker
system as it moves through the
streets, Camagüey, ca. 1953.
8″ x 10″ gelatin silver print.

Photographer unknown. Night
departure of a Cubana Airlines
DC-3 from Rancho Boyeros
Airport, outside of Havana, 1933.
4″ x 6″ gelatin silver print.

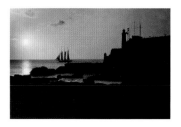

Charles DeForest Fredricks.
Rider refreshing and cleaning his
horse at "La Punta," the entrance
to the Havana harbor, ca. 1858.
Note the full-masted sailboat
in the far distance. 8½″ x 6½″
albumen print.

American Photo Studios. Sailing
past El Morro Castle and out of
the Havana harbor at sundown,
1925. 8″ x 10″ gelatin silver print.

ABOUT THE COLLECTOR

Ramiro Fernández was born in Havana to a family involved in the pharmaceutical industry. He left Cuba in 1960, settling first in Palm Beach County and then in New York, where he was a photography editor at Time Inc. for 25 years. He was involved in the launches of *Entertainment Weekly* and *People en Español* magazines, and worked at *Sports Illustrated* and *People*. As a witness to the revolution in his youth, Fernández's consuming passion has been to build a photography collection that can serve as a testament to the Cuba he remembers. He began collecting photographs in 1981, and today the collection numbers over 3,000 works.

ACKNOWLEDGMENTS

First of all, I wish to thank the individuals who have made this book a reality: Kevin Kwan, for your unflagging vision in bringing this book to life. Peter Castro, for your enthusiastic support, insight, and contribution from the beginning. Alan Rapp at Chronicle Books, for believing in this project. René Cifuentes, for introducing me to Reinaldo Arenas and so thoughtfully bringing his words into the book. Dolores Koch, for adding your knowledge and your talented translations, and the estate of Reinaldo Arenas, for allowing us to use his precious works. Lara Harris, for your keen eye and attention to detail.

So many have played a role in the formation of this collection over the past 25 years. I am immensely grateful to the following people: Carlos Alfonzo, Guilio V. Blanc, Juan Boza, Juan González, Ana Mendieta, and Gustavo Ojeda. You were the early supporters of this collection and your spirits will forever be a part of it.

With special admiration for all the kind helpfulness of painter Eduardo Michaelson, whose insight into the Cuban spirit has always helped my collecting along.

A special thanks to Martha Nelson, who kickstarted this project, and to all my fellow associates at *People* magazine: Chris Dougherty, Cutler Durkee, Beth Filler, Larry Hackett, Rina Migliaccio, Richard Sanders, and Larry Sutton.

Thanks to Ramón Alonso, Marcos Ansia, Jay Baker, Martine Barrat, Melina Gerosa Bellows, Doris Brautigan, Gibert Bureau, Dick Burgheim, Gloria Caballero, El "Gallego" Cabrera, Olimpia Castro, Donna Cohen, Carmelina Cousins, Paquito D'Rivera, Keith DeLellis, Arnold Drapkin, Mary Dunn, Jill and Elin Elisofon, Maura Foley, Fotofusion, Stephen J. Freeburg, Melchor Rodríguez García, Santiago Garza, Chaguito González, Isabel González, International Center of Photography, Mark Jacobson, Susan Jonas, Park Kerr, Katherine King, Birge Kinne, Susan Kismaric, Dr. Gary Libby, Gigi Loizzo, Hermes Mallea, Cathy Mather, Nesti Mendoza, Eduardo Michaelson, Terry and Walter Miller, Jennifer Napoli, Gloria Ramirez, Alina Fernandez Revuelta, Naty Revuelta, Francisco Echevarria Saumell, James W. Seymore Jr., Peter Stephanatos, Miguel Sirgado, Morris Swartzon, and Julian Valdes.

To Carole Kismaric and Michael Hoffman, who gave me my first job in photography at *Aperture*.

A special nod goes to The Great Ganga Hotel, Rishikesh, India, and to Aaron Starr and the Himalayan Trekking Boys of 2006. Julian Valdes at the Museo Historico Cubano for providing invaluable historical information. Brian Belovitch for keeping this ship afloat, and Cesar Trasobares for always maintaining a godfatherly eye on the project.

Alexis Rodriguez-Duarte and Tico Torres, for your constant support and whose love for all things Cuban would not have forgiven me if I didn't attempt to show my collection. To Reina Canto Mondello, Gloria Gomez-Mena Marina, and Andres Gomez-Mena, who have always been there for me as well.

Last but not least, thanks to my family for all their support: Ramiro, Sara, Sara Sylvia, Mark, and Hortensia "Nena" Machado. I would like to dedicate this collection to the loving memory of Hortensia Lisazo Machado, who was the inspiration to begin with.

Ramiro Fernández

SPECIAL THANKS

I am so grateful to the following individuals, all of whom were instrumental in making this book possible:

Michael Rauner for first championing the cause.

Alan Rapp for being the guiding light and the coolest editor one could ever wish for.

Alexis Rodriguez-Duarte and Tico Torres for making a brilliant introduction, for your constant insights, and for being such bon vivants.

Jorge Camacho and the estate of Reinaldo Arenas for graciously allowing us to use his brilliant words.

René Cifuentes for all your support, expertise and advice.

Dolores M. Koch for your skilled translations and wise counsel.

Steven Rubin for your infinite patience, hospitality, and culinary genius.

Dibi Harris-Rubin for having nine lives and a forgiving heart.

David Sangalli for your legal guidance and limitless support.

Peter Castro for your dashing wit and for diving into the deep end with us.

Lara Harris for bravely joining me on this adventure, and for your dedication, resilience, and astounding talent.

And most of all, Ramiro—thank you for taking a giant leap of faith and allowing me to share your treasures, your singular vision, your Cuba with the world.

Kevin Kwan

Library of Congress Cataloging-in-Publication Data available.

ISBN-10: 0-8118-6053-1
ISBN-13: 978-0-8118-6053-6

Manufactured in China.

Design and Art Direction by Lara Harris
Concept and Creative Direction by Kevin Kwan

The endpapers are adapted from the original 1959 packaging of El Encanto,
once Havana's most glamorous department store. On April 13, 1961, the store
burned down.

10 9 8 7 6 5 4 3 2

Chronicle Books LLC
680 Second Street
San Francisco, California 94107

www.chroniclebooks.com